FOR SHARON, WHO BROUGHT ME BACK TO LIFE

ISBN 9781848562295

Published by
Titan Books
A division of
Titan Publishing Group Ltd
144 Southwark St
London
SE1 0UP

First edition September 2009
10 9 8 7 6 5 4 3 2

Visit our websites:
WWW.TITANBOOKS.COM
WWW.HAMMERFILMS.COM

Did you enjoy this book? We love to hear from our readers. Please e-mail us at:
readerfeedback@titanemail.com or write to Reader Feedback at the above address.

ACKNOWLEDGEMENTS

My thanks to everyone who spared time to be interviewed: Roy Ward Baker, Stephanie Beacham, Martine Beswicke, Brian Clemens, Vera Day, Renée Glynne, Suzanna Leigh, Valerie Leon, Caroline Munro, Jacqueline Pearce, Ingrid Pitt, Jimmy Sangster, Barbara Shelley and Madeline Smith.

I am also grateful to the late Tom Edwards and the late John Jay, Hammer's leading stills photographers, who shared their memories with me in the 1990s.

Hammer Film Productions allowed access to stills and paperwork from their archive, and Coolabi's Janet Woodward made it all possible. For additional images I am very grateful (as ever) to John Herron at Canal Plus Image UK; Glen Marks and Tom Watkins at Rex Features; Liz Ihre, Jennifer Jeffrey and Charles Merullo at Endeavour; and Nigel Arthur, Jo Botting and Dave McCall at the British Film Institute.

Jonathan Rigby offered valuable suggestions about the manuscript, Peri Godbold advised me on the scanning and digital restoration, and Denis Meikle kindly loaned images belonging to the late Michael Carreras. My thanks also to Don Fearney, John Gibben, Stephen Jones, Joe McIntyre, Gareth Owen, Robert Ross and Neil Vokes, who helped with queries and offered items from their collections.

Richard Klemensen, editor of Hammer fanzine *Little Shoppe of Horrors*, answered numerous questions. Other gaps were filled with quotes from interviews and articles by Nicolas Barbano, Mark Davies, David Gregory, Gil Lane-Young, Mark A Miller, Joe Nazzaro and Tom Weaver.

Finally, my thanks to editor Adam Newell, designer Martin Stiff and their colleagues at Titan Books: David Barraclough, Jo Boylett, Bob Kelly and Katy Wild.

It has not always been possible to identify photographers, but the pictures in this book include those taken by Albert Clarke, Tom Edwards, Ray Hearne, John Jay, Ben Jones, Arthur Lee, Pierre Luigi, Joe Pearce, Robert Penn, Ronnie Pilgrim, Curtis Reeks, Marc Sharratt, Ricky Smith and George Whitear.

Jacket front: Madeline Smith photographed by Marc Sharratt in 1973 (© Rex Features). Jacket back: Veronica Carlson in a publicity shot from 1968 (© Hammer Film Productions). Case front: Yutte Stensgaard in a publicity shot from 1970 (© Hammer Film Productions). Case back: Barbara Shelley photographed by Hammer's Tom Edwards in 1967 (© Canal Plus Image UK). Previous page: Veronica Carlson and Kate O'Mara from *The Horror of Frankenstein* (1970). Opposite: Jenny Hanley in *Scars of Dracula* (1970).

Hammer
Glamour

MARCUS HEARN

TITAN BOOKS

CONTENTS

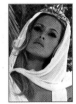

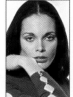
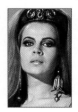
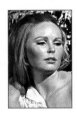
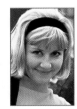
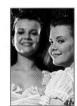
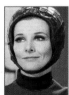
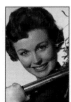
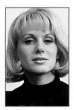
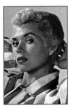

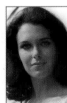
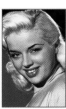 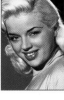
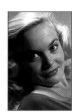

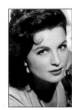
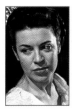
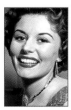

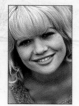

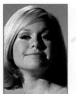
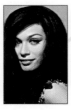
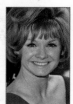
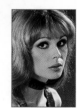

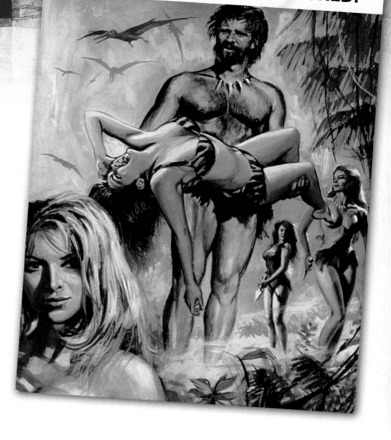

HAMMER Film Productions acquired an international reputation with their radical reinvention of the horror film in the late 1950s. The company's powerful formula of colour, horror and eroticism proved irresistible to cinema audiences in austerity Britain and caused a sensation in America too. *The Curse of Frankenstein* was released in 1957 and initiated a series of films that lasted for almost 20 years.

The company would come to rely on Peter Cushing and Christopher Lee for starring roles, but the female victims of their monsters and madmen would generally be cast on a film-by-film basis. Continental sex kittens, Hollywood film stars and provincial English girls would all become leading ladies. Hammer glamour went hand in hand with Hammer horror, until what was considered daring in both inevitably became dated.

The company originally favoured statuesque girls who could project a teasing yet vulnerable femininity. Their voluptuous figures became less fashionable after the rise of such gamine models as Twiggy and Jean Shrimpton in the mid-1960s, but a cunningly upholstered décolletage remained a prerequisite for most Hammer actresses well into the next decade.

"It's very difficult to be precise about what qualities of a girl catch my interest," said Hammer's chairman James Carreras. "A good face and figure, of course. But it's more than that; she has to have a special kind of magnetism. I can't describe it, but I know it when I see it."

Carreras was the public face of Hammer's various campaigns to discover new female talent but his son, Michael, was the man who brought many of those women to the screen. As the executive producer of the original Hammer horrors, Michael paid actresses overtime to disrobe for 'Continental versions' of *The Man Who Could Cheat Death* and *The Mummy* (1959) that were only screened in more liberal-minded territories. He produced *She* (1965) and *One Million Years B.C.* (1966), two films largely sold on their female stars, and in 1966 he wrote, produced and directed *Slave Girls*, a film predicated on warring tribes of scantily clad blondes and brunettes.

The mid-1960s was the heyday of Hammer glamour, but the company had been commissioning cheesecake photo sessions long before any of their films earned an X certificate. In the 1950s they imported notorious bad girls Barbara Payton and Eva Bartok to star in their films, as well as exploiting the reputation of the similarly scandal-prone Diana Dors.

One of Hammer's first pin-ups was Vera Day, an actress and cabaret artist who starred in horror films and comedies for the company from the mid-1950s to the early '60s. "In those days glamour photography was tits, teeth and arse," she says. "There wasn't much finesse about it."

While Vera was working for Hammer there was no nudity

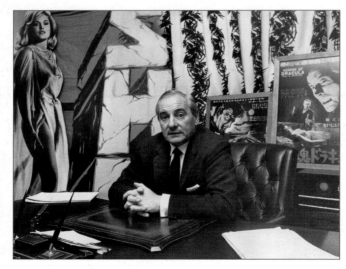

Top: A page from a 1965 brochure announcing pre-production of *One Million Years B.C.* The illustration is by Hammer's leading poster artist Tom Chantrell.
Right: James Carreras in his office at Hammer House, pictured just before the release of *She* in March 1965.
Opposite: Raquel Welch, Hammer's most successful leading lady, on location for *One Million Years B.C.* in 1965.

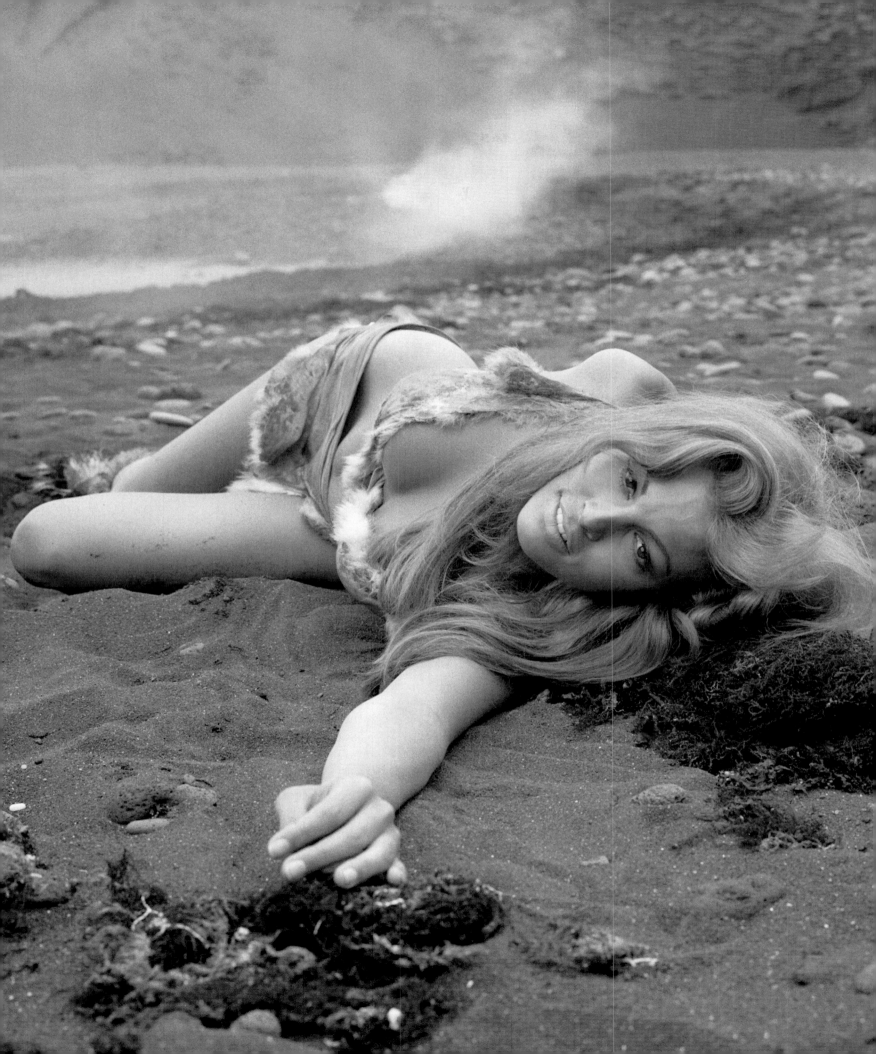

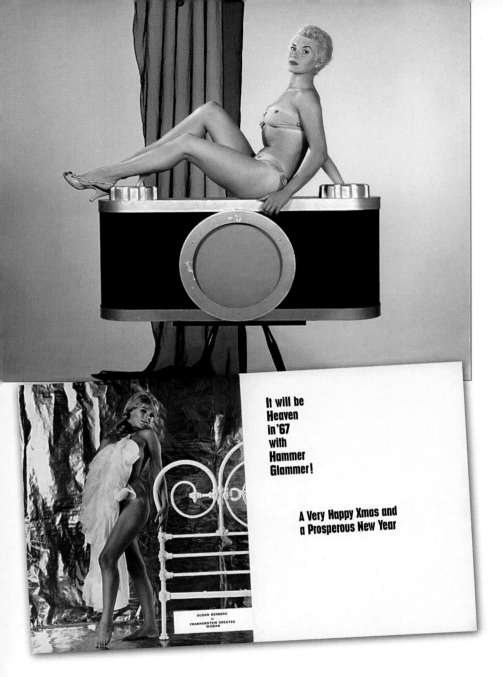

It will be
Heaven
in '67
with
Hammer
Glamour!

A Very Happy Xmas and
a Prosperous New Year

SUSAN DENBERG
in
FRANKENSTEIN CREATED
WOMAN

Top: Vera Day grins and bares it for a cheesy mid-'50s glamour shoot. **Above:** Susan Denberg is the present inside Hammer's 1966 Christmas card.

involved, at least in the English versions of the films, but actresses were still expected to participate in glamour shoots for such magazines as *Photoplay*, *Titbits* and *Parade*. "I don't want to sound blasé about the stills, but when I was working on a film my main preoccupation was my performance," she remembers. "People were always taking pictures of me and it became quite a chore. They'd ask you for glamour pictures, but you couldn't always get in the mood. I'd be sitting on the set having a cup of tea and the stills photographer would expect me to go into my handbag and produce my bikini so I could put it on for him. I used to say, 'Do you think I carry it everywhere?' and one photographer actually said, 'Well you should!'"

The release of *Et Dieu... créa la femme* (*And God Created Woman*) in 1957 spelt trouble for Vera and many other actresses who specialised in saucy girl-next-door types. Brigitte Bardot caused a sensation and English producers scrambled to find lookalikes for their own films. "They started bringing all these

Italian and French actresses over for the glamour girl parts I used to do," says Vera, who played second fiddle to Liliane Sottane in Hammer's *Up the Creek* (1958).

Now ravenous for Continental crumpet, Hammer helped themselves to three leading ladies called Yvonne over the next few years. Yvonnes Furneaux and Monlaur were French, and Yvonne Warren changed her surname to Romain to add a touch of sophistication to the films' posters.

In 1964 Hammer built a movie around a female star for the first time since their pre-horror days. Their adaptation of Rider Haggard's *She* would be their most expensive project to date, with location filming in southern Israel and a cavernous set at Elstree Studios, far larger than anything that could be achieved in the company's own facility at Bray. The centre of all this attention was Ursula Andress, the Swiss-born actress who had helped to launch the James Bond series when she emerged from the sea in *Dr. No* (1962).

Ursula considered that working for Hammer was a backwards step after the relatively lavish Bond film, but was contractually bound to co-operate. Hammer had secured her casting through some canny manoeuvring with their distribution partners in America, but later boasted that they had actually been instrumental in launching her career.

The stills budget on *She* was almost £800, around twice the amount spent on most other Hammer films of the time, and it was Ursula who became the focus of publicity campaigns in the London *Evening Standard* and elsewhere, rather than the movie itself.

Hammer were vindicated with a healthy box-office return, and Michael Carreras raised hopes that this marketing-led approach could lead to bigger budgets and a more diverse roster of subjects. He would prove his point with his next film, *One Million Years B.C.* Although dominated by the special effects of Ray Harryhausen, this dinosaur adventure was marketed on the sex appeal of its bikini-clad star Raquel Welch.

Another actress touted as a Hammer discovery, Raquel had in fact already been discovered by the company's American distribution partner Twentieth Century-Fox. Like Ursula Andress, Raquel resented the fact she was contractually obliged to appear in a film being made by someone else. In this instance, however, Raquel's career would genuinely be launched by Hammer. Such was the efficiency of the company's publicity machine that she achieved iconic status before *One Million Years B.C.* was even released.

Hammer hired stills cameraman Pierre Luigi to cover the location filming in the Canary Islands in 1965. A picture that he took of Raquel on the blasted landscape later formed the basis of the film's poster, and became one of the most recognisable images in film history. She vividly remembers how it came about: "They

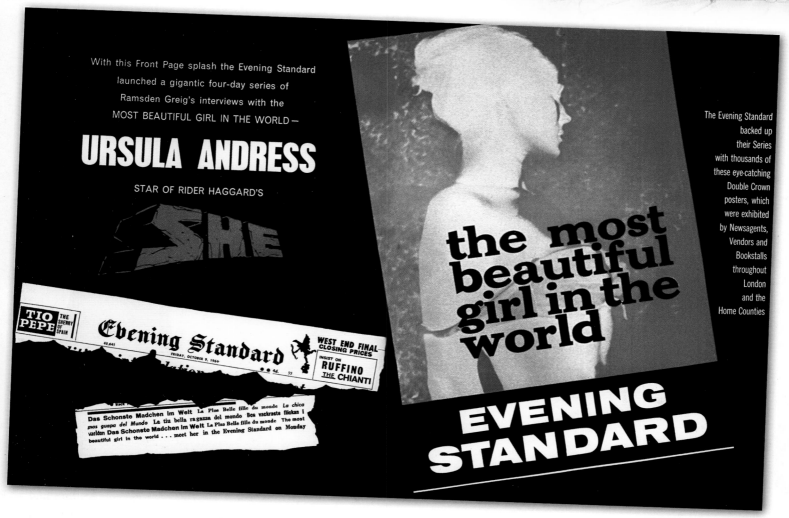

With this Front Page splash the Evening Standard launched a gigantic four-day series of Ramsden Greig's interviews with the MOST BEAUTIFUL GIRL IN THE WORLD—

URSULA ANDRESS

STAR OF RIDER HAGGARD'S

SHE

TIO PEPE — THE SHERRY OF SPAIN

Evening Standard

FRIDAY, OCTOBER 9, 1966

WEST END FINAL CLOSING PRICES

INSIST ON RUFFINO THE CHIANTI

Das Schonste Madchen im Welt La Plus Belle fille du monde La chica mas guapa del Mundo La tiu bella ragazza del mondo Bos vackraste flickan i varlden Das Schonste Madchen im Welt La Plus Belle fille du monde The most beautiful girl in the world . . . meet her in the Evening Standard on Monday

the most beautiful girl in the world

The Evening Standard backed up their Series with thousands of these eye-catching Double Crown posters, which were exhibited by Newsagents, Vendors and Bookstalls throughout London and the Home Counties

EVENING STANDARD

would light up these sulphur bombs and this slightly amber-coloured smoke would be coming into the frame all the time. That was one of the ways I guess they could make it look like the lava was still steaming. The unit photographer shot a picture of me out there in this lava desert, with these smoke bombs coming up, and caught me in this position where I turned with my legs akimbo. When I got off the plane, six or seven weeks later, my whole life had changed because of this picture. It had gone everywhere, and later became the subject of a Christmas card for Hammer Films. Overnight everybody knew who I was and I became a star."

One Million Years B.C. was the most commercially successful film in Hammer's history, and sealed the company's new reputation for 'discovering' glamorous stars. From the mid-1960s to the early '70s the company's corporate Christmas cards showcased their latest finds. Raquel shared the 1966 card with Susan Denberg, an Austrian actress who suffered a drug-induced breakdown after appearing in *Frankenstein Created Woman* (1967), and Carita Järvinen, a Finnish model who took the title role in *The Viking Queen* (1967). Neither would go on to have film careers.

The success of *She* dictated a sequel, but Hammer were unable to persuade Ursula Andress to return. They instead pinned their hopes on Olinka Berova, a Czechoslovakian actress described by

Playboy as possessing a "tantalising earthiness". Like Andress, Denberg, Järvinen and Welch, Berova was actually under contract to an American distributor, but Hammer were given the task of bringing her to the public.

Olinka was cast in *The Vengeance of She* and taken under the wing of Hammer producer Aida Young. The associate producer of *She*, *One Million Years B.C.* and *Slave Girls*, Young had served her apprenticeship in British studios starved of manpower during the

Top: In 1965 Hammer mocked up this poster to promote the *Evening Standard*'s serialised interview with *She* star Ursula Andress. **Left:** Edina Ronay, Aida Young and Martine Beswick between takes on the set of *Slave Girls*.

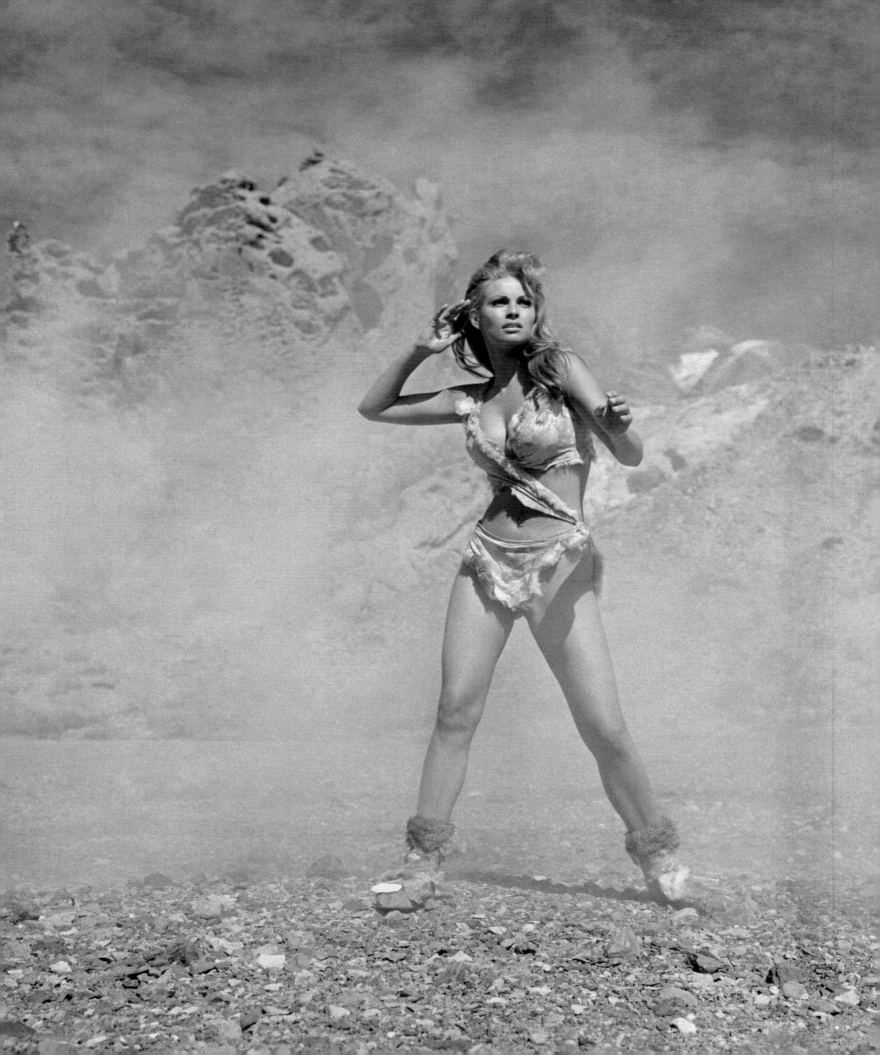

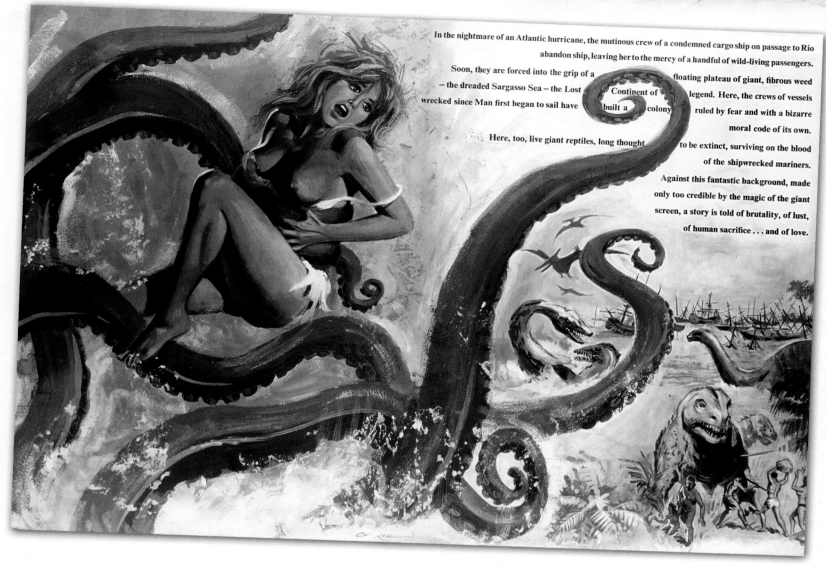

In the nightmare of an Atlantic hurricane, the mutinous crew of a condemned cargo ship on passage to Rio abandon ship, leaving her to the mercy of a handful of wild-living passengers. Soon, they are forced into the grip of a floating plateau of giant, fibrous weed – the dreaded Sargasso Sea – the Lost Continent of legend. Here, the crews of vessels wrecked since Man first began to sail have built a colony ruled by fear and with a bizarre moral code of its own. Here, too, live giant reptiles, long thought to be extinct, surviving on the blood of the shipwrecked mariners. Against this fantastic background, made only too credible by the magic of the giant screen, a story is told of brutality, of lust, of human sacrifice . . . and of love.

war. She already had 25 years' experience when she adopted a matter-of-fact approach to the casting and promotion of Hammer starlets. In 1968 she told *The Times* she was looking for "beautiful, talented girls who don't look as if they came out of a band-box." Aside from James Carreras, she would become the Hammer producer most closely associated with nurturing female talent.

Young's greatest success was with Veronica Carlson, an English rose she first cast in *Dracula Has Risen From the Grave* (1968) and who went on to co-star in *Frankenstein Must Be Destroyed* (1969) and *The Horror of Frankenstein* (1970). Veronica's tenure with Hammer would probably have been longer had the company continued making the traditional Gothic horrors with which she became associated.

After the failure of *The Vengeance of She* Hammer entrusted Young with the unenviable task of recapturing the success of *One Million Years B.C.* without Raquel Welch. She oversaw *When Dinosaurs Ruled the Earth* (1970) featuring Victoria Vetri, and Michael Carreras produced their next prehistoric epic, *Creatures the World Forgot* (1971) with Julie Ege. Both girls were subjected to fierce promotion and achieved fleeting recognition.

Hammer's ability to pre-sell films was renowned within the industry – posters for proposed subjects were liberally adorned with half-naked women in an effort to persuade distributors to back films that hadn't yet been scripted. With the starlets that followed Ursula Andress and Raquel Welch, Hammer applied the same acumen in carefully packaging the finished product for the public.

Although Pierre Luigi had taken the legendary shots of Raquel Welch on location for *One Million Years B.C.*, Hammer had generally relied on staff photographers to take the glamour stills they needed for publicity campaigns. Their most prolific stills man from the late 1950s and throughout much of the 1960s was Tom Edwards. His most famous picture was taken during the making of *Dracula* in 1957, and was the inspiration for the film's poster. In 1995 he remembered how he devised this specially posed shot. "I had a bed assembled in the stills studio, and placed Melissa Stribling lying on it, on her back, with her head hanging over the edge towards camera, and blood on her neck. Christopher Lee was on top of her, with blood coming from his mouth. It must have been extremely uncomfortable for the artistes, but they did it

Opposite: One of Pierre Luigi's iconic pictures of Raquel Welch, taken on location in Lanzarote during the making of *One Million Years B.C.*
Top: Typically lewd Tom Chantrell artwork from a 1967 brochure promoting *The Lost Continent*.

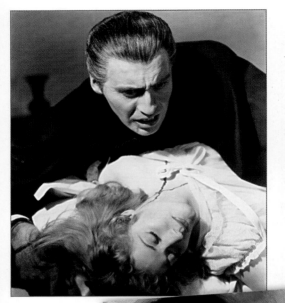 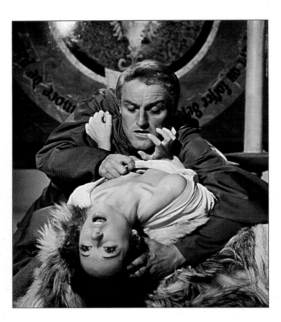

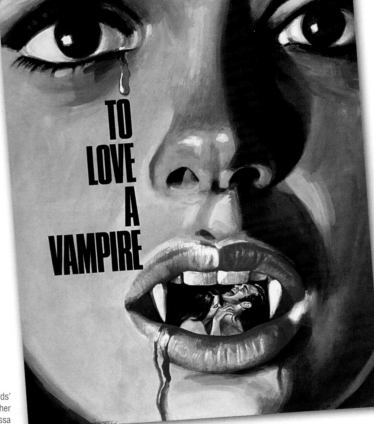

TO LOVE A VAMPIRE

Top (l-r): Tom Edwards' portrait of Christopher Lee and Melissa Stribling in *Dracula* was so successful that the pose was recreated with Oliver Reed and Shirley Anne Field in *The Damned* and with Charles Gray and Niké Arrighi in *The Devil Rides Out.*
Above: In 1970 Tom Chantrell created this poster artwork for the film that became known as *Lust for a Vampire.*

press releases that accompanied the stills. Girls had their names changed, and were frequently made out to be younger than they actually were. The biography accompanying Julie Ege's appearance in *Creatures the World Forgot* was a typical whitewash, losing two years off her age, forgetting that she had already been married twice and neglecting to mention that she had a baby daughter. In the place of hard facts was a lyrical tribute to the star with "the cascade of untrammelled honey-coloured hair, the distinctive cheek bones and the wide-set sea-coloured eyes characteristic of her Scandinavian descent."

Julie was promoted by Hammer as 'The Sex Symbol of the 70s' but they were never able to transform the huge amount of press attention she received into box-office success. In 1969 *One Million Years B.C.* was re-released on a successful double-bill with *She* (the poster proclaimed 'Hammer glamour! Hammer spectacular!') and the shadow of Raquel Welch loomed well into the new decade. Although Hammer would never make another prehistoric film, as late as 1971 Valerie Leon was posing for stills dressed as a cavegirl and being compared to Welch in the press release that accompanied *Blood From the Mummy's Tomb.*

In 1970 the relaxation of censorship prompted Sir James Carreras (newly knighted for his services to the Variety Club) to commission increasingly sexually explicit films. Independent producers Harry Fine and Michael Style stepped in to make *The Vampire Lovers* (1970), a film that reinvented J Sheridan Le Fanu's *Carmilla* as a bare-breasted romp. The film's old-school director Roy Ward Baker was appalled to discover that Style's on-set reading included copies of the pornographic magazine *Screw.*

In common with much of the black-or-white characterisation in their films, Hammer had often promoted the female stars of their Gothic horrors as virgins or sexual predators. *The Vampire Lovers'*

without fuss." The picture proved so successful that the pose was recreated with different actors in *The Damned* (filmed in 1961) and *The Devil Rides Out* (filmed in 1967).

The retouching of photographs, especially to smooth the complexions and slim the features in actresses' portraits, was commonplace in the 1950s but the practice became increasingly rare as a more naturalistic beauty became the vogue. Hammer were never averse, however, to airbrushing the biographical details in the

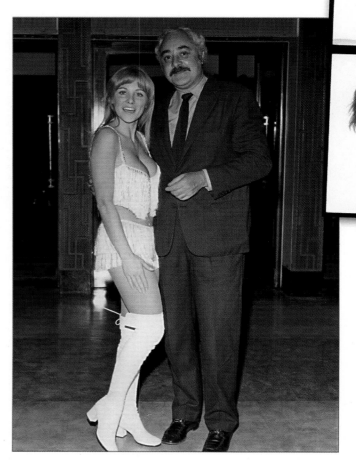

major asset was a performance of unbridled relish from Ingrid Pitt, who fell into the latter category as the rapacious Carmilla.

Madeline Smith has fond memories of appearing alongside her in *The Vampire Lovers*. "Ingrid was very big sisterly towards me, and was a great encouragement insofar as she was completely un self-conscious about taking off her clothes, which she did without any fuss whatsoever. I was so dim I didn't know what I was doing when I was showing my bosoms, so I didn't mind. And the truth is I don't particularly mind the film today."

She admits, however, that *The Vampire Lovers* was considered quite shocking at the time. "I don't think my father saw it. My mum saw it and she went with my grandmother. We never talked about it."

Ingrid Pitt is proud of her work on the movie, and dismisses accusations that it was exploitative. "I never saw it as a lesbian film," she says. "Carmilla didn't love her victims from a human point of view because she was no longer human – she was undead."

Fine and Style's follow-up to *The Vampire Lovers* was originally called *To Love a Vampire* and resurrected Carmilla (this time played by Danish actress Yutte Stensgaard) in a girls' boarding school. The ultimate title, *Lust for a Vampire*, was a more accurate summation of the film's crude sensibilities. The nadir of Hammer horror, *Lust for a Vampire* was promoted with a trailer that described the film's setting as "the finishing school where they really do finish you."

Acclaimed writer and producer Brian Clemens devised *Dr Jekyll & Sister Hyde* (1971) and the following year's *Captain Kronos Vampire Hunter*, two of the best films Hammer made in the 1970s, but even he couldn't prevent them spicing up the former with scenes of previously unscripted nudity. "Things were loosening up at that time," he says. "I think sex was introduced to Hammer horror mainly as a dying gasp, because they could see that their kind of film was not going to last much longer."

Martine Beswicke, who had appeared in *One Million Years B.C.* and *Slave Girls*, starred as Sister Hyde and fought with Hammer over the imposition of nude scenes. "I think that approach was destructive to them in the end, because they did it in such a way that it took over. All the other things Hammer had – the finesse that they'd had in their earlier films – was undermined by this need to be more explicit. It didn't marry well."

Just as the films were changing, the publicity stills started to reflect the more graphic images of women that were appearing in the tabloid press. In the 1970s Hammer employed numerous unit photographers including Joe Pearce, Ronnie Pilgrim and George Whitear. For glamour portraits they would often commission freelance photographer Ben Jones, one of the pioneers of *The Sun*'s Page Three and a popular figure with many of the girls who worked on the films.

"I loved Ben," says Madeline Smith, who posed for Jones during the making of *Frankenstein and the Monster From Hell*.

"He was quite a privileged gentleman because he photographed me in my bedroom several times. He coaxed some great shots out of me. He could create magic with his lighting, even in my awful little bedroom. He made me look like a saint!"

In 1971 Sir James Carreras handed control of Hammer to prodigal son Michael, but once the novelty of the lesbian vampire films had worn off he found it impossible to come up with a new direction for the company. His final horror film, *To the Devil a Daughter*, was released in 1976 and starred Nastassja Kinski in some uncharacteristically cynical scenes. A process that had started with coy cheesecake shots in the 1950s had now reached its grim conclusion with a naked teenage nun.

Hammer would diversify into television, and in 2008 made a belated return to feature film production. But the reign of Hammer glamour as the company's most valuable marketing tool was over, a victim of political correctness and demystifying over-exposure.

The legacy is hundreds of photographs, the best of which have been selected for this book. They evoke a distant and naïve era when sex really was safe, and the time to be glamorous was always. ∾

Above: Caroline Munro poses for Hammer photographer George Whitear away from the set of *Dracula A.D. 1972*.
Left: An early '70s shot of Michael Carreras with Hammer starlet Luan Peters.

URSULA ANDRESS

SHE

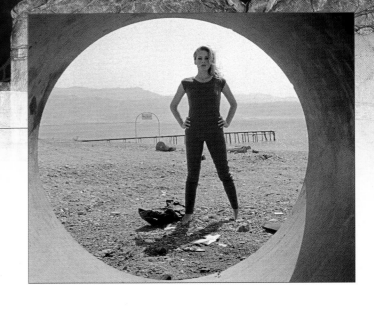

THE 1965 epic *She* was a bold declaration to the film industry and the public that Hammer was a versatile studio, capable of more than just the horror films that had dominated their output for the last eight years. *She* would be the company's most expensive film to date, and the first since the 1950s to be built around a female star.

Hammer began developing the script for the film in late 1962, and the following year their American production partners Seven Arts proposed that Ursula Andress should be cast as the supernatural Ayesha – She Who Must Be Obeyed.

Ursula was born on 19 March 1936 in Bern, Switzerland. Her mother was Swiss and her father German. "I was blessed by my parents with classical looks," she later said of the slanting eyes and

Right: One of the most striking publicity pictures taken during the filming of *She* in southern Israel.
Below: Ursula wears an elaborate gown designed by Carl Toms for *She.*

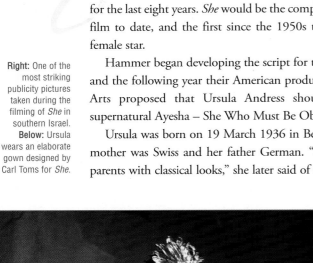

high cheekbones that helped her to become an artists' model when she left home in 1952. She went to Paris to be with the French heart-throb Daniel Gélin, and then followed him to Rome, where she also made a handful of films. A meeting with Marlon Brando led to a contract at Paramount Pictures, but Ursula's career stalled in Los Angeles. She hated the acting classes Paramount asked her to attend and "couldn't be bothered" to learn English. Ursula bought herself out of her contract and fell into the arms of actor and photographer John Derek. They married in Las Vegas in 1957.

Although she apparently didn't have strong ambitions to resume acting, in 1961 a modelling job granted her the biggest break of her career. In the office of Twentieth Century-Fox president Darryl F Zanuck, British director Terence Young spotted a photograph of Ursula in a clinging wet t-shirt. Zanuck assured Young that he didn't intend to offer her anything, so Young took the picture back to London and cast Ursula in *Dr. No*, the first James Bond film.

In *Dr. No* Ursula was dubbed by Monica van der Zyl, but it wasn't the dialogue that made her opening scene so distinctive. Emerging from the sea in a home-made bikini, Ursula created perhaps the most iconic moment in 1960s cinema. The original 'Bond girl' is still widely regarded as the best.

After *Dr. No*, Ursula's career faltered once again. She co-starred with Elvis Presley in *Fun in Acapulco* (1963) and was so unhappy with the way she was made to dress that she cried in the producer's office every day. In 1964 she appeared in John Derek's directorial debut *Nightmare in the Sun*. "After *Dr. No* he couldn't afford me," she joked, "so I dropped my price."

She was Ursula's first starring role, but it didn't make the prospect any more appealing. "I did *She* because John wanted to make some films," she claimed. "Seven Arts financed them. I had to guarantee that I would work in case those films did not make back the money. So I guaranteed two films. The first one they put me in was *She.*"

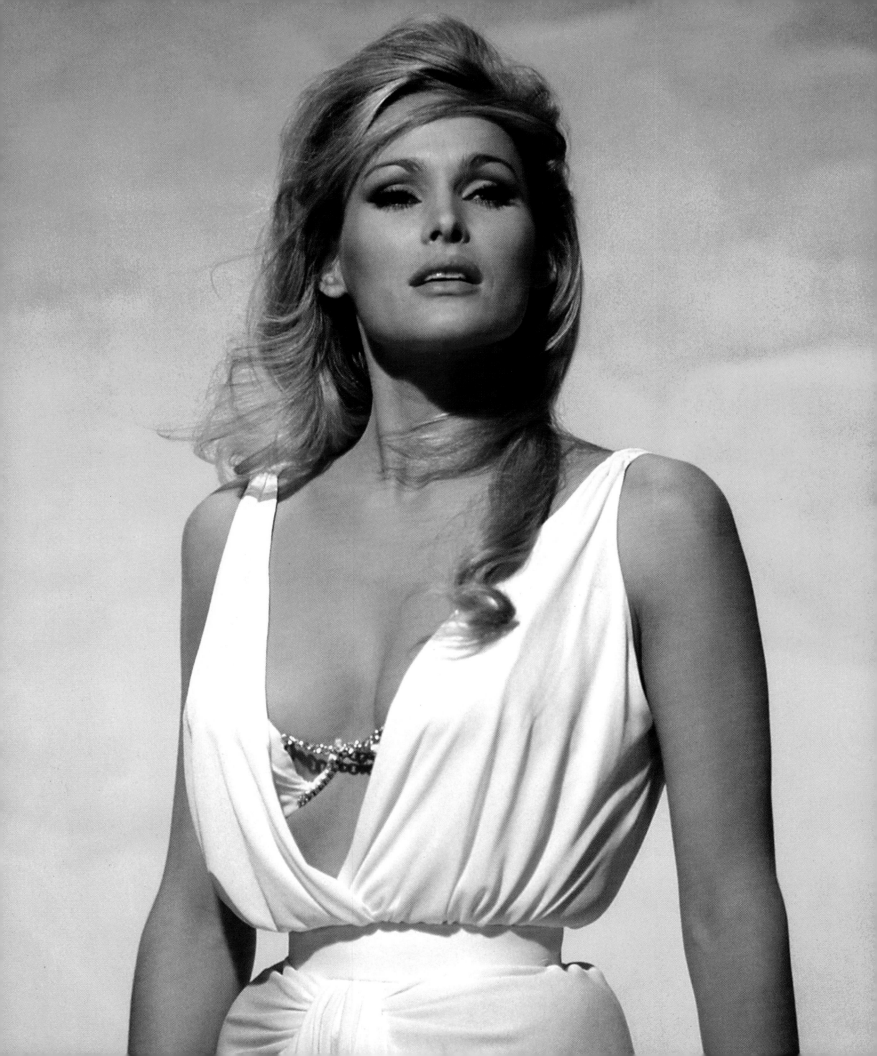

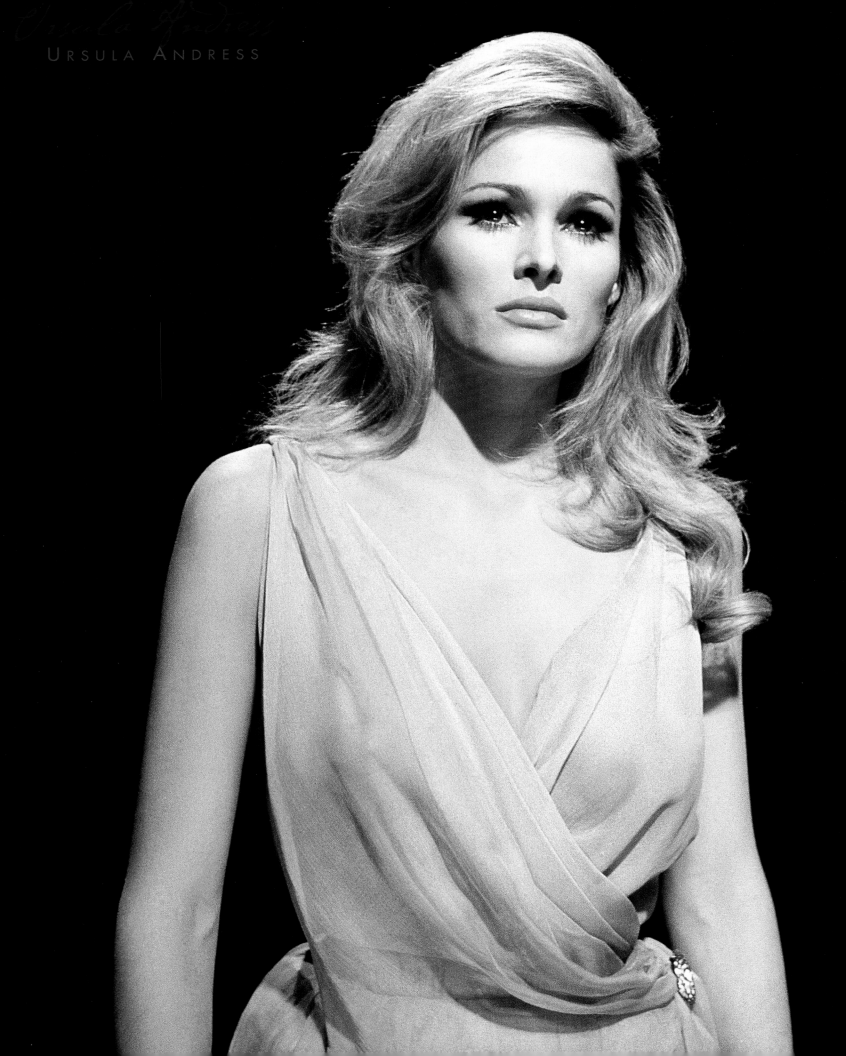

In August 1964, several weeks before she started filming, she told the *Sunday Express* that she was concerned about a scene she had read in the script where her character, Ayesha, had to age two thousand years. "It is something I am not looking forward to," she said. "Growing old slowly is bad enough."

In *Dr. No* Ursula brought an alluring sensuality to the role of Honey Ryder, providing a self-assured role model for all the Bond girls that would follow. In *She*, Ursula possesses the same glacial beauty but her performance is strangely remote throughout. An imperious presence as the regal She Who Must Be Obeyed, she is less convincing when required to tenderly confide in Leo (John Richardson), whom she believes to be the reincarnation of her long-dead lover. There was help at hand in the form of a supporting cast that included Peter Cushing, Christopher Lee and Bernard Cribbins. Ursula was dressed in an array of magnificent gowns designed by Carl Toms, and Monica van der Zyl was once again called upon to dub her voice. The film was further enhanced when James Bernard added what was possibly the most melodic score to grace any Hammer film.

A huge publicity campaign included posters that declared Ursula to be 'The world's most beautiful woman!', and while she was flattered, she was aware it gave her a lot to live up to. "I don't say myself that I'm the most beautiful girl in the world," she said in 1965. "I never have. But I know I'm not ugly."

She was released in April 1965, and Ursula helped to promote the film by posing nude in *Playboy* shortly after its release. John Derek took the pictures, but that November it was revealed that Ursula and her husband were undergoing a trial separation. She divorced Derek in 1966, amid rumours that she was now involved with French star Jean-Paul Belmondo. She was now free from any obligations, moral or otherwise, to star in Hammer's ill-conceived follow-up, *The Vengeance of She*.

Ursula was choosy about the roles she accepted in the 1960s, often accepting parts that would pay enough to facilitate her independence. She never again found anything as memorable as *Dr. No* or *She*, but was acclaimed for her performance in *The Blue Max* (1966) and happy to appear in the incomprehensible James Bond satire *Casino Royale* (1967). Film roles became infrequent in the 1970s, and in 1980 she gave birth to her only child, Dimitri. Her career became less important as she devoted herself to his upbringing. Ursula now claims that she is embarrassed by her films and never went to the cinema to see them. She continues to single out *She* as a disappointment, which is surprising considering that her subsequent movies included such dubious efforts as *The Sensuous Nurse* (1975) and *Prisoner of the Cannibal God* (1978).

"I was forced to do *She*," she said in 2002. "It was a very cheap Hammer film and the only thing I adored was the costumes. I was just lucky to look good in it because they photographed me beautifully." ∞

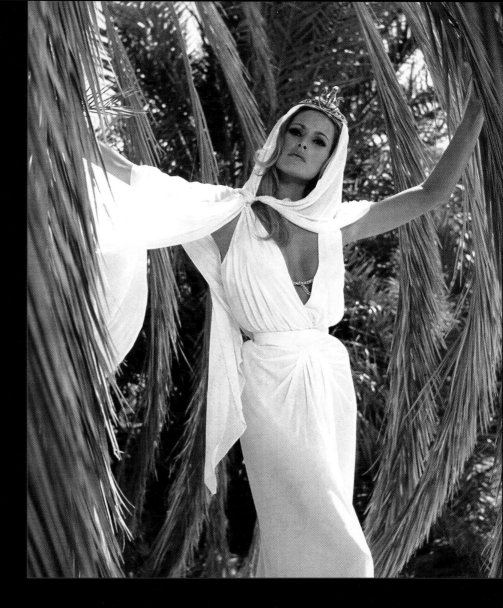

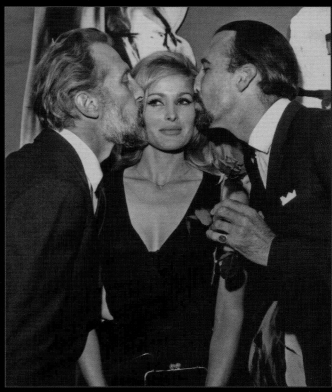

Left: At a party to promote *She* in 1965, with co-stars Peter Cushing and Christopher Lee.

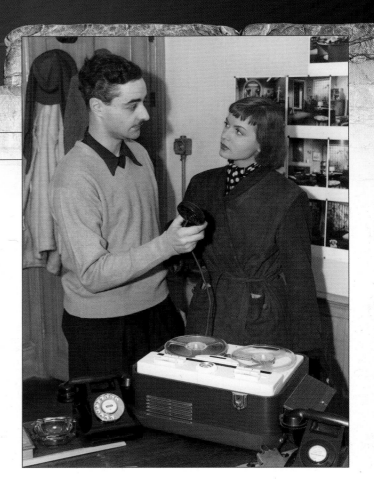

EVA BARTOK

EVA Bartok was eccentric casting in two films for Hammer – as a beautiful mathematician in the whodunit *Spaceways* and as a British spy in the espionage thriller *Break in the Circle* – but her exotic presence did much to enliven both.

She was born Eva Martha Szoke in Keoskemet, Hungary, on 18 June 1926. During the war she was condemned to a concentration camp and married the Nazi Giza Kovas. She described the experience as a "series of brutal rapes worse than death" and the marriage was later annulled on the grounds that she had only been 15 at the time of the ceremony.

Eva escaped from communist Hungary with the help of film producer Alexander Paal, who coincidentally would later produce several films for Hammer. The couple married, but shortly after Paal brought her to England and gave her a starring role in *A Tale of Five Cities* (1951) she divorced him. In 1951 she married her third husband, the publicist William Wordsworth. Fellow Hungarian expatriate Alexander Korda put Eva under contract to his company London Films but she still struggled to make an impact.

Right: Eva with Michael Carreras at Bray Studios during the making of *Spaceways* (1953).
Opposite: A publicity portrait from *Spaceways*.

Her career peaked when she was chosen by Burt Lancaster to appear alongside him in the swashbuckler *The Crimson Pirate* (1952). The film was a huge hit, and Eva was hailed as a major new star. Her career faltered, however, and her private life was similarly unfulfilled. She divorced William Wordsworth and was inbetween husbands when she went to Bray Studios to make *Spaceways* in November 1952.

The *Spaceways* cast and crew held their Christmas party in the flat belonging to Hammer director Francis Searle. Eva became the target of studio gossip when she attended the party accompanied by her married lover, the Marquess of Milford Haven.

Filming was interrupted when Eva had to undergo throat surgery, but *Spaceways* was eventually completed in January 1953. The film languished until December that year before it was released to generally hostile reviews.

Break in the Circle was filmed in 1954, and around this time Eva made a number of films with her fourth husband, the German star Curt Jurgens. In 1957, shortly after her divorce from Jurgens, Eva was the subject of another scandal when she gave birth to a daughter out of wedlock. She named the child Deana Jurgens, but later claimed that Frank Sinatra was actually the father.

In 1964 she starred in Mario Bava's seminal giallo *Sei donne per l'assassino* (*Blood and Black Lace*) but in 1968 she retired, taking Deana to Jakarta with the aim of living a life of "peace and tranquillity". She later opened a school of Subud philosophy in Honolulu.

Eva Bartok died on 1 August 1998, at which time she was reportedly struggling to make ends meet, living under the name 'Dr Jurgens' in a Paddington hotel. Her Hammer films were largely overlooked by obituaries that preferred to recall her scandalous private life rather than her acting achievements. ∞

STEPHANIE BEACHAM

ONE of the best-known of all Hammer's leading ladies, glamourpuss Stephanie Beacham never intended to become an actress at all.

Stephanie was born in Barnet, Hertfordshire, on 28 February 1947. Her mother contracted chickenpox during her pregnancy, and as a result Stephanie is deaf in her right ear and has only 75 per cent hearing in her left. As a teenager she had ambitions to become a teacher for deaf children, and studied at the Etienne de Creux school of mime in Paris in 1964. Shortly afterwards she went to Liverpool to be with her boyfriend and passed an audition at the Everyman Theatre. From there she went to RADA, and received her first television break when Hammer director Roy Ward Baker cast her in a 1967 episode of *The Saint*.

On graduating from RADA Stephanie had a choice of five different contracts to choose from. "They were still offering five-year deals in those days," she says, "but I didn't want to be attached to any of the studios. That was arrogance. I didn't realise how soon that whole system was going to come to an end."

For Stephanie, the decision to appear in horror films produced by Hammer and its rival Amicus was largely pragmatic. "I became conscious that fewer films were being made in this country. We had been making films with the Americans all through the 1960s, and suddenly the dollar to the pound wasn't so favourable and films became more expensive for them to make over here. So they left us."

One of the few American-sponsored films in production at Elstree in 1971 was the Hammer horror ultimately known as *Dracula A.D. 1972*. Hammer became the latest company to offer Stephanie a contract, and even though she turned them down she was given a part in the film without having to audition. She was cast as Jessica Van Helsing, who was initially scripted as the daughter of Peter Cushing's legendary vampire hunter. Stephanie is clearly moved by her memories of the actor. "Daddy Cushing," she says. "I just loved working with that man. He was such a sweet, gentle person. Until two weeks before we started the film

I was meant to be playing his daughter. His wife, Helen, had died and he lost so much weight. When they saw how gaunt he had become they changed the script to make me his granddaughter. He told me that waiting to join Helen was a bit like having a toothache and waiting to go to the dentist."

Stephanie enjoyed a close relationship with Cushing, and lasting friendships with her co-stars Marsha Hunt and Janet Key. She appeared in fewer scenes with Christopher Lee, who struggled to preserve his diligent interpretation of Count Dracula amid Hammer's garish vision of early '70s youth culture. "Christopher said, 'This is one of the most difficult pieces of acting ever.' And I thought, Darling, you just put your teeth in and put your cloak on and you're away, aren't you? I suppose it's because one just accepts him as Dracula that one doesn't think it could be difficult, but he does bring enormous dignity to the part."

In *Dracula A.D. 1972* Stephanie's clothes and hair are rather more up to date than the hipster dialogue, which seems to have been drafted way back in the previous decade. She surmounts the script to create a touching rapport with Cushing, and a tangible dread of Lee. Despite her success in the role, she declined to appear in the film's sequel. "I was shown the script," she says. "I found it

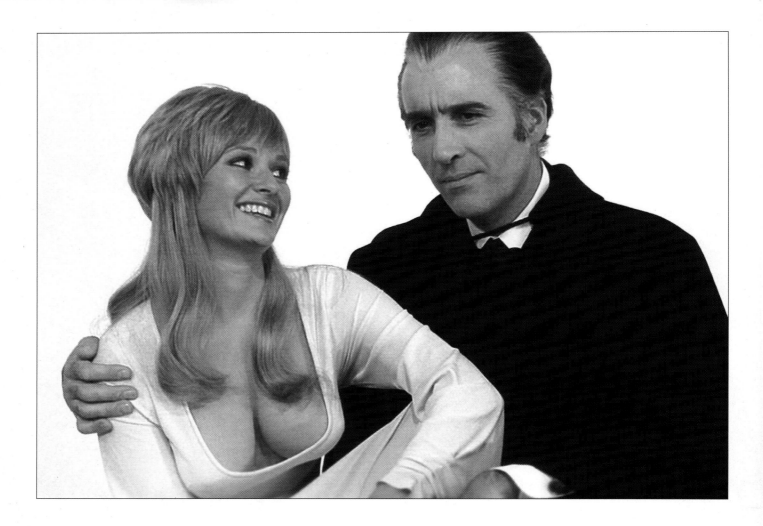

Above: Stephanie with *Dracula A.D. 1972* co-star Christopher Lee. **Opposite:** Laced up by Constance Luttrell, who played the Van Helsings' housekeeper in the same film.

very funny. I wasn't sure that I could be convinced by it. But at any rate, I was busy with something else at the time and I had to turn it down."

In summer 1972 Roy Ward Baker cast Stephanie in the central role of Amicus' Gothic horror *Fengriffen*. This fine film was blighted by the absurd title *--And Now the Screaming Starts!* on its eventual release, but Stephanie's performance as the tormented Catherine Fengriffen more than justified Baker's continuing faith in her. Before she started work on the film, Stephanie met up with Janet Key. "I bumped into her one day and said, 'Hello darling! What are you up to?' and she said, 'I'm playing the maid in a movie.' I joked, 'What, upstaging the lady of the manor?' and she said, 'I expect so.' And of course it turned out that the movie was *Fengriffen* and the lady of the manor was me!"

In 1973 Stephanie married the actor John McEnery and the couple had two children before divorcing in 1978. Stephanie brought Chloe and Phoebe up herself, balancing her responsibilities with her continuing career.

In 1983 she returned to Hammer for a starring role in 'A Distant Scream', one of the creepiest episodes of the anthology series *Hammer House of Mystery and Suspense*. "It was lovely to work with all the people from Hammer again," she said shortly after filming wrapped. "It was real 'blast from the past' time because all the technicians were the same people with slightly more crows' feet and pot bellies."

A lead role in the first two series of BBC drama *Tenko* (1981-82) had confirmed her status as a star on British television, and in 1985 she became a star in America when she joined the cast of glossy soap operas *Dynasty* and *The Colbys*. In the States she is still best known for her portrayal of rich bitch Sable Colby, but in England she has remained in demand for more down-to-earth ITV dramas such as *Bad Girls* and *Coronation Street*.

Now delighted to be a grandmother, Stephanie has homes in London, Malibu and Morocco and is working on her autobiography. She can reflect on a career that has included collaborations with such diverse stars as Joan Collins and Marlon Brando, and is also proud to have worked with the legends of Hammer horror. "At the time the genre was not so highly thought of – the Hammer school of filmmaking was considered rather 'B movie'," she says. "But now youngsters adore these movies. When I tell people I worked with Cushing and Lee people think it's fantastic, amazing." ∞

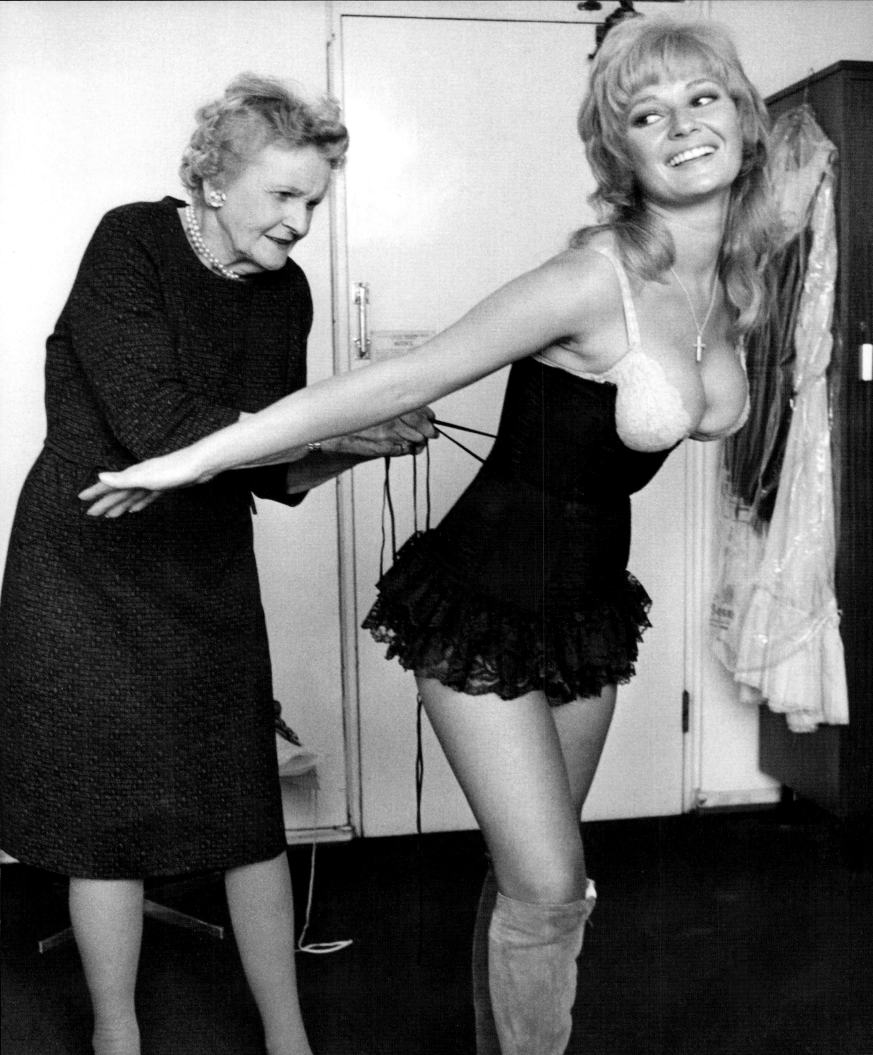

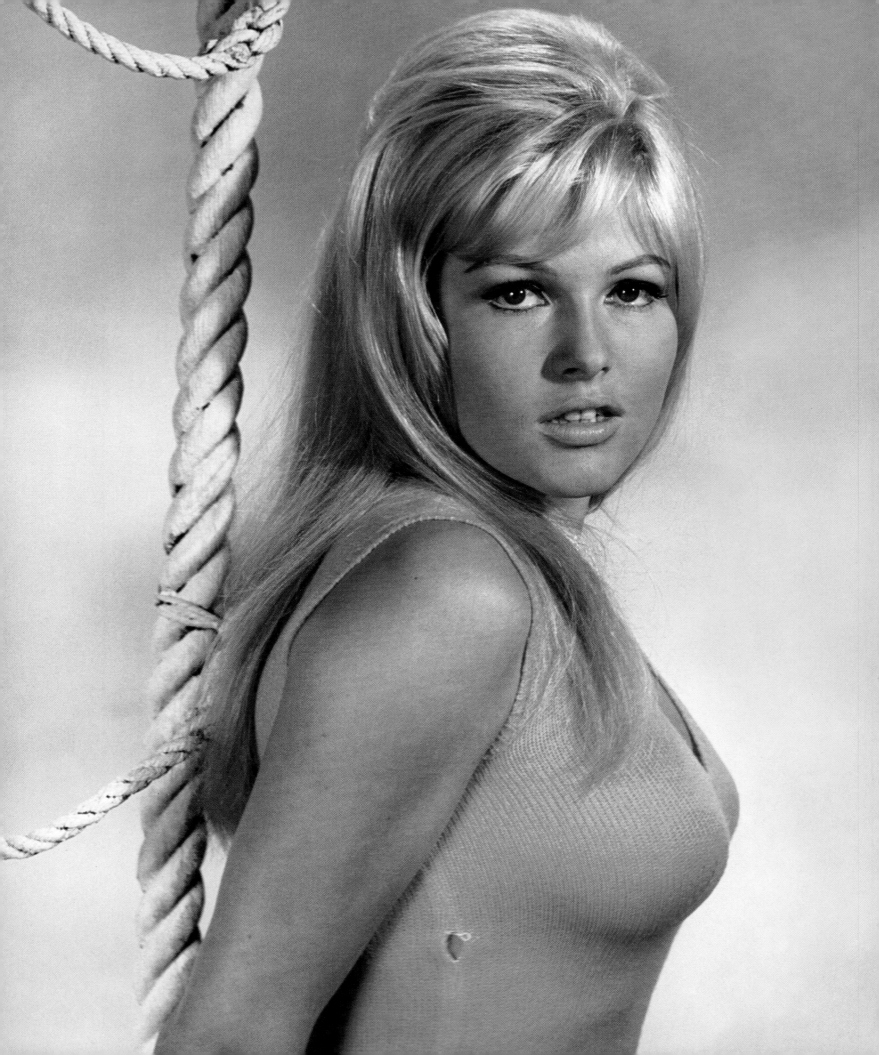

OLINKA BEROVA

THE VENGEANCE OF SHE

HAMMER had famously touted Ursula Andress, the star of *She*, as 'The world's most beautiful woman!' Such a boast made it difficult to fill her shoes when Andress refused to appear in the film's sequel.

The list of actresses Hammer wanted to audition for the part in 1967 included Britt Ekland, Sonia Romanoff, Camilla Sparv and Barbara Bouchet, but American distributor Twentieth Century-Fox brought its influence to bear with the ultimate casting of 24 year-old Olga Schoberová. Born in Czechoslovakia on 15 March 1943, Olga had appeared in some 14 Continental films since 1963, and in March 1964 was the cover star of a *Playboy* devoted to 'Girls of Russia and the Iron Curtain Countries'.

One of Olga's most recent Czechoslovakian films was a comedy called *Kdo chce zabit Jessii?* (*Who Wants To Kill Jessie?*), which had been released in 1966 and attracted the interest of Fox. The distributor had plans for an American remake, retaining Olga in the role of Jessie but headlining Jack Lemmon and Shirley MacLaine. While discussions continued Olga went to London, where it was felt she bore a close enough resemblance to Ursula Andress. Hammer took three years off her age and changed her name to Olinka Berova.

The press were informed that Olinka meant 'little baby', but it was considered that the actress's image wasn't racy enough. One of Hammer's publicists complained that the stills of Olinka they had received in advance were "a bit starchy", so she was taken on a spending spree. By the time she was unveiled to the press at the Savoy on 22 June, she had swapped her apparently sober wardrobe for a collection of mini-skirts and short dresses. A journalist from the *Guardian* noted that she made her entrance "in a white silk creation about two feet above the knee," but that she soon changed into an orange creation "at least two inches longer". Olinka told reporters that her vital statistics were "93-60-92" before adding that she was, of course, working in centimetres.

Four days later location filming for *The Vengeance of She* started in Monte Carlo, before moving on to Almería, Spain, and six weeks of studio interiors at Elstree. One of the film's less significant costs was Olinka's fee, which was under half the £9,000 paid to leading man John Richardson. As a Czechoslovakian national,

Olinka was reportedly obliged to transfer the money home, where she ultimately received 40 per cent of it in cash, and the remainder in vouchers to be used on imported goods.

The Vengeance of She proved a critical and commercial disappointment, but Olinka kept her stage name and appeared in a handful of further films in Europe and America. In November 1967 she married her long-time boyfriend, American actor, stuntman and bodybuilder Brad Harris. They settled in Los Angeles and had a daughter, Sabrina, but divorced in 1969. In 1972 she married John Calley, the executive vice-president in charge of production at Warner Bros. He subsequently named his 65-foot boat, *Olinka*, after her.

The couple were divorced in 1992, and Olinka eventually returned to Prague. Her days as the 'second' Ayesha now a distant memory, she has apparently reverted to her original name, Olga. ∞

Below: Olinka dedicated this photograph to Hammer's Michael Carreras.

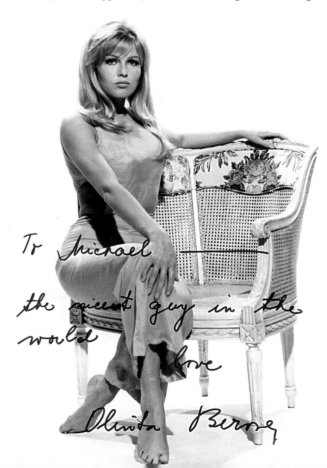

To Michael — the nicest guy in the world love Olinka Berova

MARTINE BESWICKE

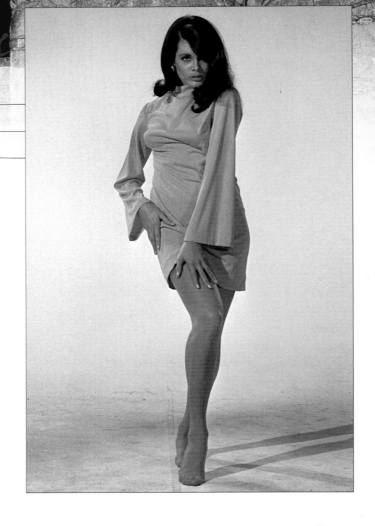

A lithe Jamaican cast by Hammer in aggressive, self-assured roles, Martine Beswicke was born in Port Antonio on 26 September 1941.

Martine made an incendiary screen debut in the second James Bond film, *From Russia With Love* (1963). Credited under her original surname, Beswick, she played Zora, one of the wrestling girls at a Turkish gypsy encampment. Martine's provocative catfight with Vida (Aliza Gur) earned her a fearsome reputation as 'Battling Beswick'.

She remained a favourite of the film's director, Terence Young, who cast her as 007's field assistant Paula Caplan in *Thunderball* (1965). This was the most lavish Bond film to date, and Martine enjoyed the high life with the rest of the cast and crew while shooting on location in Nassau.

Hammer took Martine to the Canary Islands for her role as the ferocious Nupundi in *One Million Years B.C.* The freezing location proved rather less comfortable than Nassau, but there were compensations for Martine when she met her future husband, the film's leading man John Richardson.

The scenes where the jealous Nupundi clashes with Loana (Raquel Welch) were clearly a more feral evocation of the grapple in *From Russia With Love*. This time Martine's character came off worse, but she had already made a significant impression on producer Michael Carreras. "He had a wicked sense of humour and I adored him, absolutely adored him," she says. "We kind of tickled each other, really."

One Million Years B.C. was still in production when Carreras devised a knock-off support feature tailored around the film's standing sets and skimpy costumes. The film would ultimately be titled *Slave Girls*, and he selected Battling Beswick for the lead.

Despite boasting probably the finest array of top drawer totty ever assembled at Elstree Studios, *Slave Girls* is depressingly tawdry. The film adopts the 'blondes versus brunettes' plot from *One Million Years B.C.* but supplants athletic dinosaurs with a laughable statue of a white rhinoceros.

Top: A picture from a 1966 studio shoot to promote *Slave Girls*.
Right: Martine as Nupondi in *One Million Years B.C.* (1966).
Opposite: Kari tests the water in *Slave Girls*.

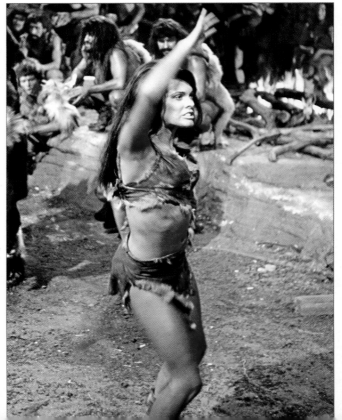

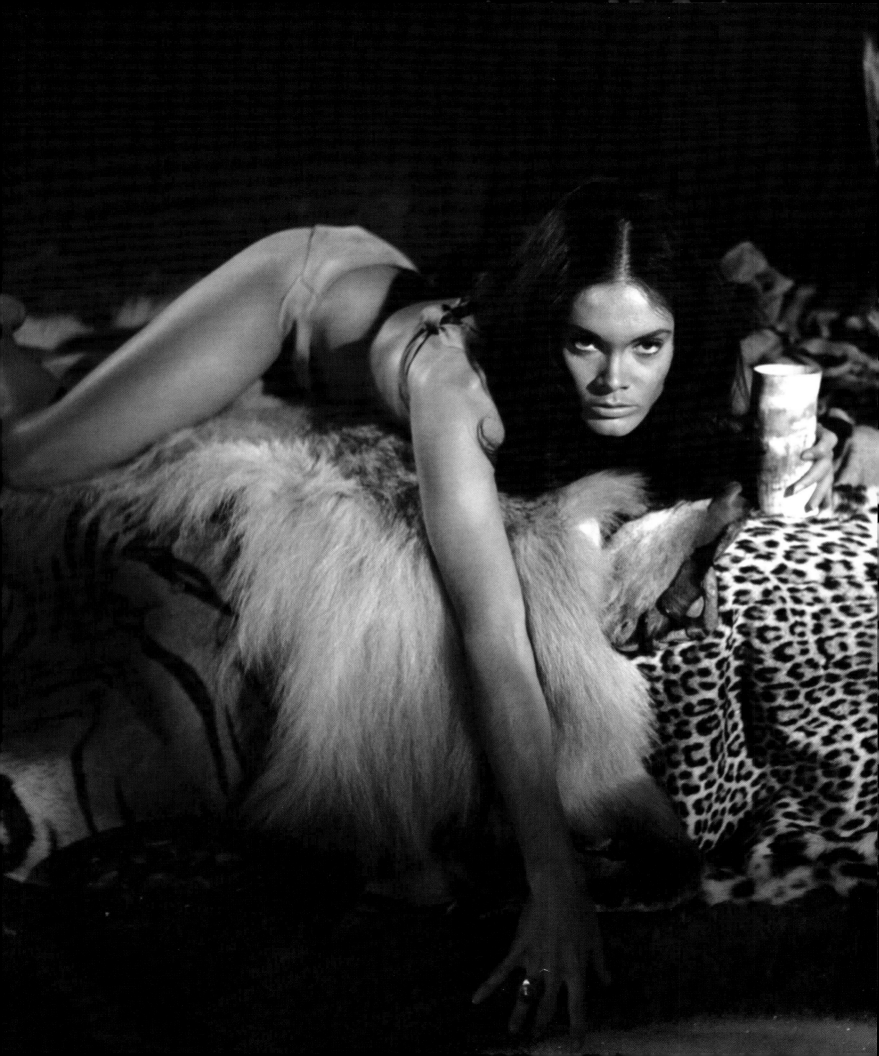

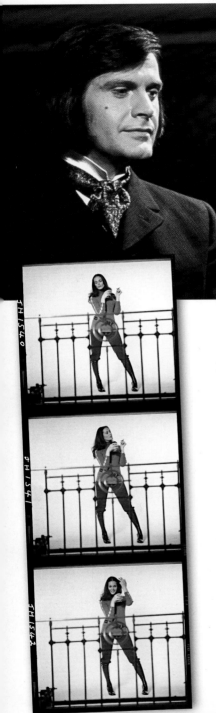

money-wise. She told me I had to add something to my name and suggested I put an 'e' on the end. So I added an 'e' to my name and interestingly enough it did make a difference for a while."

In early 1971 Martine was near the end of a holiday in London when she paid a visit to her agent's office. "They said, 'My God, you're just in time.' They told me that Hammer were making a film called *Dr Jekyll & Sister Hyde*, and that's when I started laughing. They said Hammer had cast Ralph Bates as Dr Jekyll but they'd been looking for months and hadn't found a girl to play Sister Hyde. So I went to see Hammer the next day, and there was a whole group of people waiting for me – [writer/producer] Brian Clemens, Sir James Carreras, Michael and [director] Roy Ward Baker. They asked me if I'd like to do it and I said 'Of course!'"

Hammer were enthused by what they saw as a strong resemblance between Martine and Ralph Bates, while Martine was intrigued by the idea of Jekyll's transformation from a man to a woman. "I discussed it with Ralph," she remembers. "We talked about the male and female within each of us, and how he would feel if he was me."

When filming got underway she was rather less enthused about proving that the transformation had taken place. "Hammer were pushing for full nudity, even though it wasn't in the script. Roy and I stopped speaking for a while and then I turned around and said, 'This is silly, let's just stop this.' So I agreed to strip off for the scene where Sister Hyde is revealed. I understood that it was extremely important for that scene because she is birthed and she has no shame. Roy and I came together and worked it out, and he was cool after that."

Brian Clemens' arch screenplay might have seemed ludicrous, but Roy Ward Baker plays the film with a straight bat and Martine brings a chilling conviction to the spidery Sister Hyde. Arguably Hammer's most successful attempt to combine the gore and eroticism newly allowed by censors, *Dr Jekyll & Sister Hyde* is one of the outstanding films in the company's early '70s catalogue.

Martine returned to America after *Dr Jekyll & Sister Hyde* ("I should have stayed in England while I was hot again") and in 1972 her marriage to John Richardson came to an end. Oliver Stone sought her out for his feature debut *Seizure* (1974) and she continued to work steadily in film and television throughout the 1970s and '80s.

Martine is now content to refer to her career in the past tense. "Parts were getting smaller and smaller in LA, so I came back to England in 1998 to be with my family. That's basically when I retired. I would have had to start all over again here and I just didn't feel like it.

"I may have lost my passion for acting but I haven't lost my passion," she says. "I'm not wealthy by any means but I'm very happy. I have wonderful friends, I love my garden and I enjoy my dinner parties. My passion now is for life." ∞

The highlight of the film is undoubtedly Martine's portrayal of the ruthless and child-like Queen Kari. She asserts her dominance over the rebellious Gido (Carol White) with yet more catfighting, and stakes her claim to bewildered stranger David Marchant (Michael Latimer) in a bizarre mating dance.

Kari rules a savage jungle kingdom where men are virtually banished, but the film's message of female empowerment is rather compromised by the fact that the girls worship a rhino with a magic horn. And it is surely no coincidence that Kari meets her doom impaled on this phallic symbol.

Martine laughs uproariously at the mere suggestion that the film is worthy of such analysis. "We took it seriously insofar as we went at it full tilt, but we knew it wouldn't be award-winning," she says. "We had a lot of fun between takes. I remember Michael asked me to stroke the rhinoceros horn and everyone collapsed in hysterics."

The film's significantly longer American print is entitled *Prehistoric Women* and would tax even the most dedicated Hammer scholars. Martine cheerfully describes it as "one of the worst films ever made".

Martine and John Richardson moved to Los Angeles in 1967, where Martine forged a new career in American television. While in California she changed her surname on the advice of an unorthodox source. "I met a numerologist, who was also a terrific astrologer. She did a chart on me and told me I was blocked

Top: Martine with co-star Ralph Bates during the making of *Dr Jekyll & Sister Hyde* (1971). **Above and opposite:** A light-hearted publicity shoot for *Dr Jekyll & Sister Hyde.*

CARITA

THE VIKING QUEEN

HAMMER'S *The Viking Queen* was a misguided effort to present another pseudo historical adventure in the tradition of *She* and *One Million Years B.C.* And once again, the film was considered a vehicle for contract artists supplied by an American distributor.

By 1966, when Hammer co-produced *The Viking Queen* with Twentieth Century-Fox, the days of the Hollywood studio system were numbered. There were, however, still a significant number of actors tied to contracts. Such artists could be sub-contracted to other studios or production subsidiaries, especially if they were considered difficult to place in A-list productions. In 1966 Fox supplied Hammer with two very different contract artists, and Hammer built *The Viking Queen* around them.

Don Murray was born in California on 31 July 1929 and had starred opposite Marilyn Monroe in *Bus Stop*. Carita Järvinen was born in the Sipoo district of Finland on 20 May 1943. While Fox paid Murray $75,000 to appear in *The Viking Queen*, Carita received just $5,000.

In England Hammer's publicists proclaimed Carita as the company's latest star discovery. Whereas *She* had featured the more established Ursula Andress, Carita was a genuine unknown. She had previously appeared in the French film *Lemmy pour les dames* in 1962, but a press release issued shortly after her arrival pretended that *The Viking Queen* would be her debut. "Carita is a Finn with blond hair and blue eyes and with an accent like La Garbo," announced Hammer. "Six years ago she was a young peasant girl in the country of 80,000 frozen lakes and came to live in Helsinki with her parents. At 17 she wanted to be a dress designer but she was spotted by photographers and became a cover girl by 20. She landed in Paris a bit later and a film mogul noticed her. She had six months training in New York and then was signed up on a seven-year contract."

Carita was presented to the press on 31 May 1966 at a cocktail party hosted by Hammer and their partners at Les Ambassadeurs. Journalists from the trade and national papers interviewed the mystery girl, who revealed that one of her ambitions was to host a dinner party where she would serve a perfect example of Finland's national dish – sugared herring with fresh cream.

Carita wore a peppermint-striped dress to meet her co-star, Don Murray, at Heathrow Airport on 8 June. The two posed for photographers before heading into London for their costume fittings at Berman's.

Filming of *The Viking Queen* took place at Ardmore Studios in County Wicklow, Ireland, from 15 June. It fell to *One Million Years B.C.* director Don Chaffey to generate some chemistry between the two actors in a tale of the doomed love between an idealistic Roman and a warrior queen. He was armed with a larger than usual budget of £350,000 and an extended filming schedule of eight weeks. It wouldn't be enough.

Carita was cast as the Celtic princess Salina. Surprisingly her 'La Garbo' accent would be left intact by Hammer's dubbing department, the script justifying both this and the film's title by explaining that Salina was of Viking descent. Sadly it was not felt necessary to explain Don Murray's equally baffling American accent.

Top: Carita meets co-star Don Murray at Heathrow Airport.

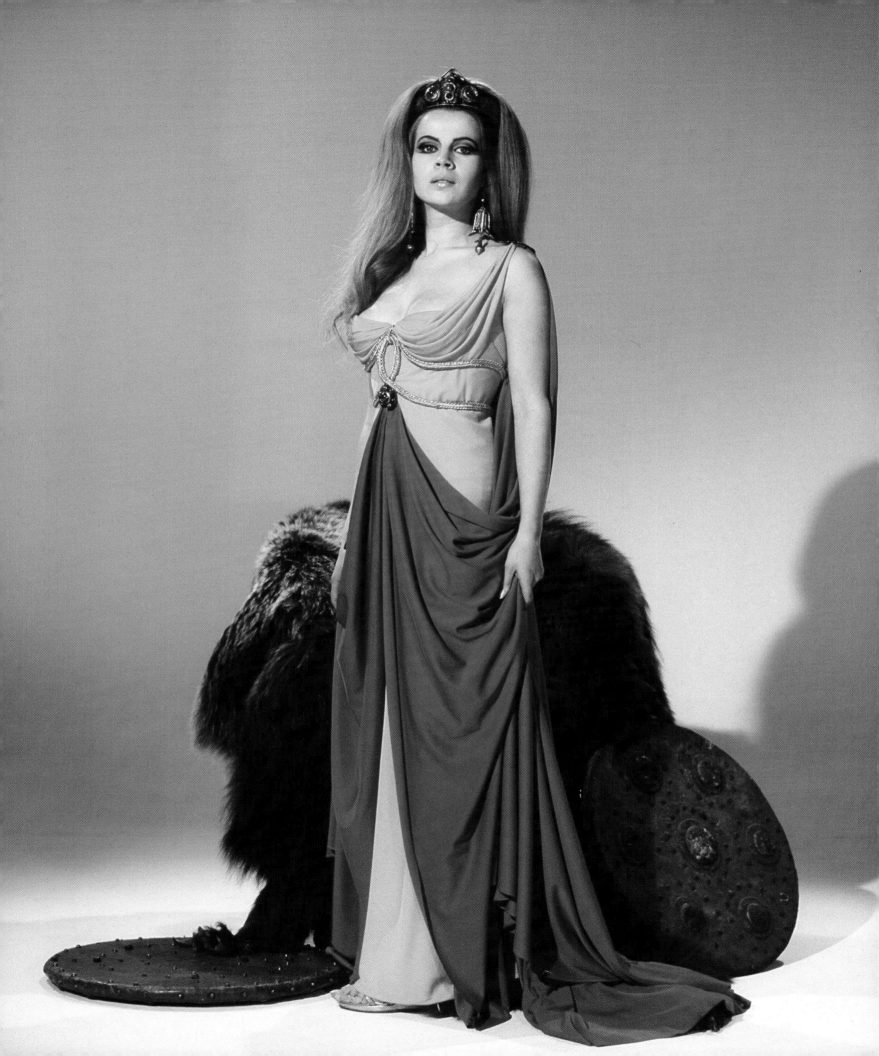

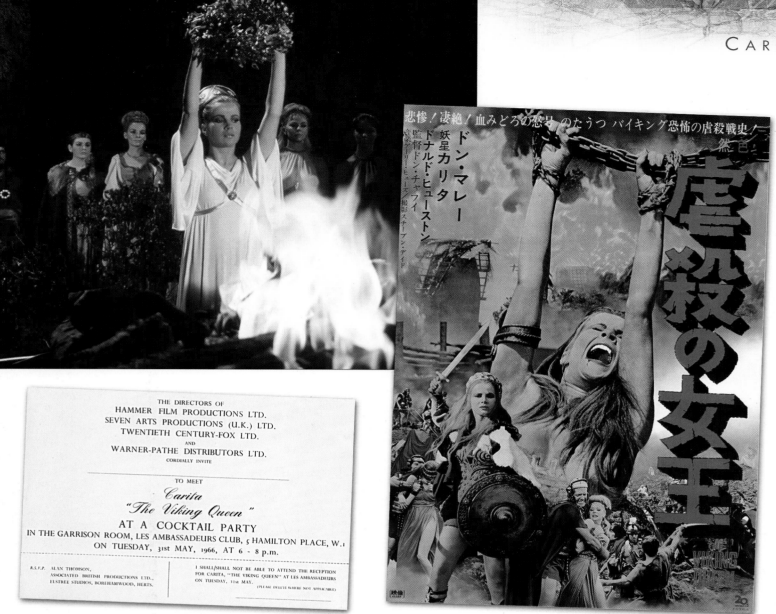

Carita threw herself into the role, receiving lessons in how to drive a chariot from the film's master of horse, Frank Hayden. The cost of the film meant that Hammer's board of directors afforded the project a special scrutiny: Anthony Hinds contributed an early draft of the script (the final draft was by American Clarke Reynolds) and even James Carreras visited the set in Ireland.

Unfortunately the production suffered labour relation problems and Hammer underestimated the expense of the battle scenes. The bill for the crowd of extras was just one of the additional costs that helped to take the film over-budget by more than £60,000, a percentage of which Fox held Hammer liable for.

The result of Chaffey's labours was compromised by a script that clumsily crossed *Romeo and Juliet* with the legend of Boadicea. Uneven in its casting and production values, *The Viking Queen* is both endearingly old-fashioned and surprisingly sadistic. The film veers unpredictably from high adventure to Hammer horror, especially in the scene where Salina is stripped topless, bound and flogged by sadistic Romans. The brutality and insinuations of sexual violence, not to mention the 'wet t-shirt' clinch between Carita and Don Murray, are wholly at odds with the first part of the film's Robin Hood spirit.

"Stand fast – they're only women!" says the scheming Octavian (Andrew Keir), but he hasn't counted on warrior bitch Salina and her psycho sister Beatrice (Adrienne Corri). The influence of *Romeo and Juliet* is preserved right up until the tragic and surprisingly abrupt climax. And with the end of *The Viking Queen* came the end of Carita's film career. Fox released her from her contract and by 1968 she was devoting herself to her husband, a French photographer, and their child. She expressed the ambition to resume acting, but it was not to be.

Carita at least has the consolation that the failure of *The Viking Queen* wasn't her fault, and that she acquitted herself well in one of the daftest films Hammer ever made. ∽

Opposite: Carita puts her back into promoting *The Viking Queen* at the cocktail party launch held in May 1966.
Top: Salina (Carita) offers her father's spirit to Zeus in *The Viking Queen*.
Above: The Japanese poster highlighted the most sadistic scene in the film.

VERONICA CARLSON

DRACULA HAS RISEN FROM THE GRAVE

FRANKENSTEIN MUST BE DESTROYED

THE HORROR OF FRANKENSTEIN

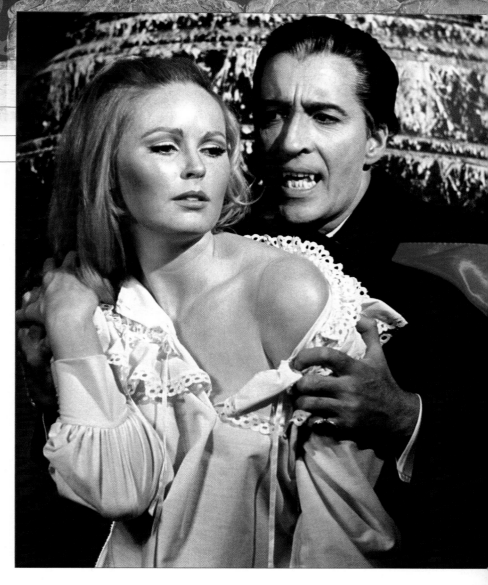

VERONICA Carlson's appeal lay in a homespun innocence that, combined with her classical beauty, made her one of the best-loved of all Hammer's leading ladies. She arrived in 1968 and became the first English actress to be aggressively promoted by the company in over a decade.

"With her naturally blonde hair, peach cream complexion and vivid blue eyes Veronica might be described as a typical English beauty," declared her first Hammer press release. "She is very tall, five feet nine inches, and has the shape to go with it."

She was born Veronica Mary Glazer in Yorkshire on 18 September 1944. Her father was in the RAF and the family moved wherever he was stationed until they settled in High Wycombe in Buckinghamshire. After leaving school Veronica studied art, ultimately gaining a National Diploma in design. Her careers as an artist and actress were launched at the same time – in early 1967 she made an uncredited appearance in the Morecambe and Wise film *The Magnificent Two* and patented her own cartoon character 'Algerwol'.

Veronica was also a model, and later that year posed for glamour photographer Ben Jones on the south coast. A shot of her wearing a bikini from that session ended up on the front page of *The Sunday Mirror*, and was spotted by James Carreras. A fan of Hammer films since her student days, Veronica was delighted when producer Aida Young and director Freddie Francis invited her to audition for *Dracula Has Risen From the Grave*.

Dressed in a pink gown and ribbons, Veronica's character Maria was the virtuous opposite of wanton barmaid Zena (Barbara Ewing). When Dracula tires of Zena he seduces Maria, and her loss of innocence is clumsily symbolised when she discards a childhood doll from the side of her bed. More haunting are the subsequent shots of Maria caressing Dracula's coffin, and her trance-induced journey through the forest on the way to his castle.

"When I look back at my Hammer days, I always think how pathetic I was," says Veronica. "I was thrilled to be cast in the films, but being a nice middle-class girl, I refused to do anything too revealing. They wanted to undo my dress and get a shot of my back. The cut of the dress meant I couldn't wear a bra and I pleaded with them to do it tastefully. It makes me blush to think about it."

The trailer for *Dracula Has Risen From the Grave* proclaimed Veronica as "Hammer's new star discovery; Dracula's most beautiful victim". She adorned the cover of Hammer's 1968 Christmas card and won a role in the company's next film, *Frankenstein Must Be Destroyed*, without having to audition.

Veronica gave her most accomplished performance as the tragic Anna Spengler, a young woman with the misfortune to unwittingly invite Baron Frankenstein (Peter Cushing) into her guest house. Frankenstein blackmails Anna and her fiancé Karl (Simon Ward) into helping him with his latest brain transplant experiment.

This visceral and unrelenting film saw Hammer's most ruthless depiction of the Baron so far. Anna's torment is most memorably

Opposite: Veronica wore pink in all her Hammer films, beginning with *Dracula Has Risen From the Grave* (1968).
Top: The virginal Maria is coveted by the vampire Count (Christopher Lee) in this publicity shot from *Dracula Has Risen From the Grave*.

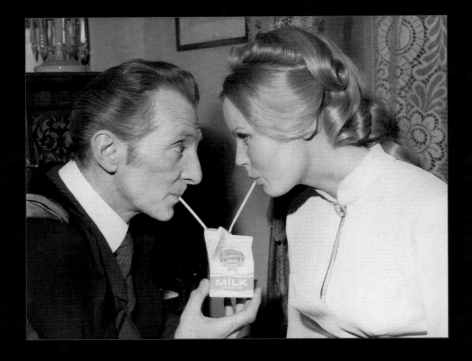

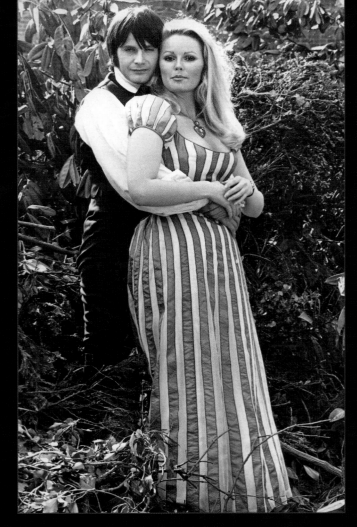

Top: Veronica and Peter Cushing pose for the Milk Marketing Board on the set of *Frankenstein Must Be Destroyed* (1969).
Right: With Ralph Bates, who played the Baron in *The Horror of Frankenstein*.
Opposite: Veronica as the naïve Elizabeth in *The Horror of Frankenstein* (1970).

evoked by Veronica when a burst water main beneath her garden exposes the mutilated corpse of Frankenstein's latest victim. The most arduous scene, however, was a hastily written addition to the end of the schedule. Bowing to distributors' pressure, James Carreras ordered director Terence Fisher to shoot a sequence showing the Baron's rape of Anna. It proved a harrowing experience for everyone involved, although its damage to the film's narrative has been overstated.

Veronica describes Peter Cushing as "an exquisite man", and the two began a long and sincere friendship on the set of *Frankenstein Must Be Destroyed*. For Veronica's third and final Hammer film, however, Cushing stood aside as the younger Ralph Bates played the title role in 1970's *The Horror of Frankenstein*.

Writer/director Jimmy Sangster's disenchantment with the genre was held at bay by the chance to present the Baron's origins in the style of a bawdy comedy. A fan of the traditional Hammer horrors, Veronica was disapproving of the new film's flippancy but enjoyed working with Sangster and Bates. The feeling was mutual, and Sangster recalls that both he and Bates "fell in love" with her during the course of filming.

Cast once again as a naïve innocent, Veronica admits to being slightly envious of her co-star Kate O'Mara, who got to play the Frankenstein family's randy retainer Alys. As the 1970s continued, Hammer's films offered increasingly empowered roles for women, but Veronica claims she was not considered for any of them because managing director Michael Carreras was aware of her aversion to appearing nude.

In January 1974 Veronica married businessman Sydney Love, and in March that year was reunited with Freddie Francis and Peter Cushing on the set of *The Ghoul*, a valiant attempt by Francis' son Kevin to produce a period horror in the Hammer style. *The Ghoul* was released in 1975, by which time Carlson and Cushing were indelibly associated with a style of horror film that belonged to another era.

Veronica left acting behind and she and Sydney moved to Hilton Head Island in South Carolina. "I never told anybody about these movies," she says. "I thought I'd walked away from it. I was raising my family, I was painting – my artwork was very important to me – but then people on the island started recognising me. The films were cropping up on HBO, TNT, Cinemax, so word got out and all of a sudden I was a celebrity on Hilton Head."

Veronica continues to paint, and happily maintains her association with Hammer at fan conventions. Her portrait of Hammer's prolific character actor Michael Ripper was the centrepiece at his memorial service in London in 2000.

"I do miss the vibrancy and creativity of my acting days," she says. "My life now is fabulous, but just occasionally when I'm cleaning the house I look back at my Hammer films and wish that I had carried on." ∞

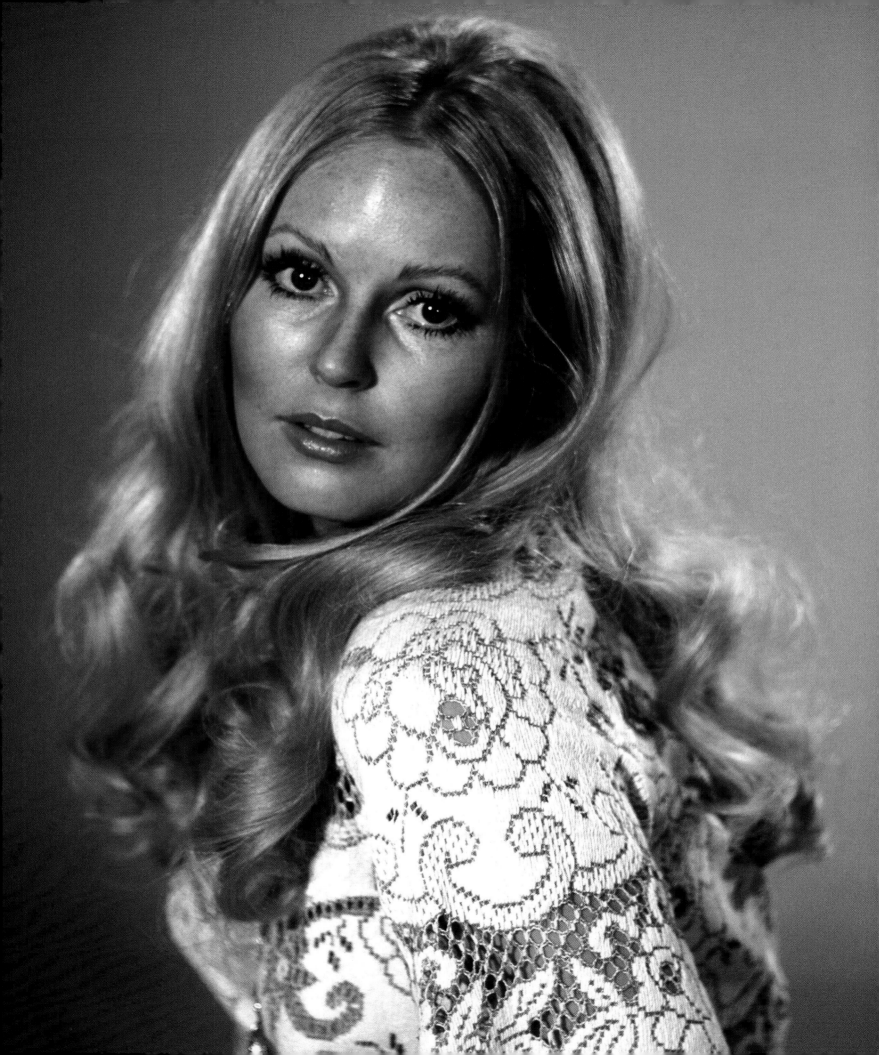

DIANE CLARE

IT was typical of the sometimes haphazard casting at Bray Studios that an actress who went uncredited playing a secretary in an episode of *The Avengers* could, within the space of months, be second-billed to the mighty André Morell in a Hammer horror. In 1965 this is exactly what happened to *The Plague of the Zombies* star Diane Clare.

Despite this seemingly meteoric promotion, Diane was no beginner. Born in London on 8 July 1938, she had in fact been appearing in films from the age of two. She was descended on her mother's side from Buffalo Bill Cody. Her Hungarian father, Baron A Dirsztay, was the son of Olga Berger, prima ballerina of the Vienna Opera.

Diane attended Sunningdale School for Girls and had ambitions to be a dancer, but in 1953 she enrolled at the Royal Academy of Dramatic Art. While still at RADA she played opposite fellow student Peter O'Toole in the Malvern Festival's production of *The Young Elizabeth*. Her first film proper was the 1958 comedy *The Reluctant Debutante*, and she followed it up with a brief but poignant performance as a traumatised nurse in *Ice-Cold in Alex* (1958).

Although not yet a star of horror films, Diane appeared in one of the decade's most important when director Robert Wise gave her a small role in *The Haunting* (1963). She was much higher-billed in the following year's rather less memorable *Witchcraft*.

"Diane's quality of innocence is precisely the reason why she was cast in those roles," says her husband, the playwright and novelist Barry England. "I think innocence is also a key element in Diane's own character and one of her most endearing qualities."

Diane brought a breezy, almost child-like naïveté to her portrayal of Sylvia Forbes in *The Plague of the Zombies*, her only Hammer film. Her air of playful innocence is sharply contrasted with the cynicism of her father Sir James (André Morell), who at one point casually regrets not having drowned his daughter at birth. It's similarly difficult to imagine what the happy-go-lucky Sylvia could ever have had in common with her old school friend, the dour Alice (Jacqueline Pearce).

It's been reported that neither André Morell nor Jacqueline Pearce was very impressed with Diane. Her performance may have lacked their sophistication, but she is the perfect foil to the cantankerous Sir James and the world-weary Alice. When Sylvia is captured by Squire Hamilton (John Carson) and his predatory gang, her virginal innocence makes their threatened abuse all the more distressing.

Diane was only 29 when she decided to retire from acting to raise her family. Her television career ended on a high with a regular role in the second season of ITC's *Court Martial*. Her final films include two little-seen horrors, *The Hand of Night* (1966) and the best forgotten *The Vulture* (1967).

Diane never returned to acting, but in 2000 expressed no regrets about her past life. "I look back only with pleasure," she said. "And gratitude. I had a chance to do a job I loved." ∞

Right and opposite: Diane poses outside one of the sound-stages at Bray Studios. **Below:** With André Morell on the Bray backlot in 1965.

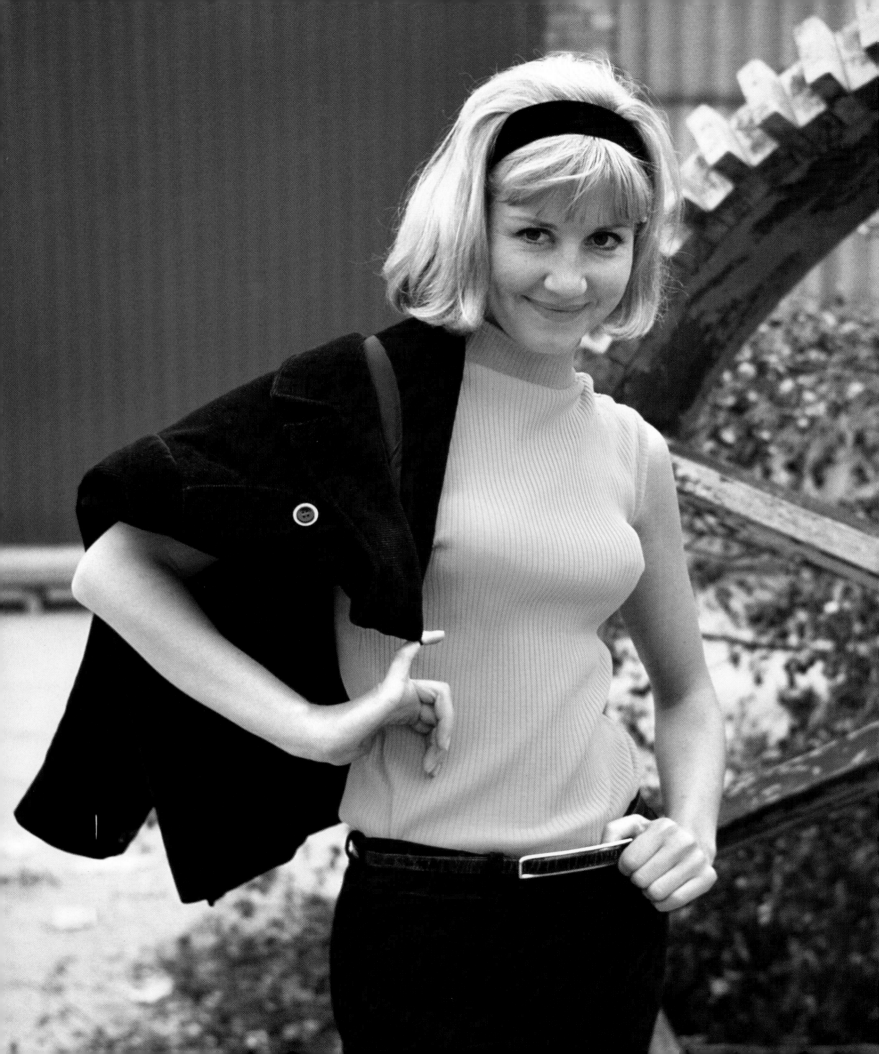

TWINS *of Evil* is the quintessential early '70s Hammer horror. Peter Cushing, once the hero of Hammer's original *Dracula*, was now cast as the wicked puritan determined to put a stop to any notions of the permissive society. The dangers of sexual decadence found their expression not in the familiar routine of a good girl turned bad, but in twins who provide a simultaneous contrast between naughty and nice archetypes. In drawing upon both *Witchfinder General* and *The Vampire Lovers*, *Twins of Evil* was a film designed to appeal to young horror fans at one end of the scale and the dirty mac brigade at the other.

The casting of the twins was crucial, and Hammer's solution turned out to be one of their greatest publicity gimmicks. The answer lay in the pages of *Playboy*, copies of which were never far from Hammer House. Mary and Madeleine Collinson were the magazine's first twin Playmates, and in 1971 Hammer groomed them as their latest star discoveries.

Born in Sliema, Malta, on 22 July 1952, Mary and Madeleine Collinson were the second pair of twins in their family. Their father was former Royal Navy officer John Collinson, but they were largely raised by their mother, ex-model Adelaide.

The girls reluctantly made their showbusiness debuts when they were just seven, performing at a concert on the island. "I suppose we looked pretty in identical party frocks and big bows in our hair," Mary told Hammer publicist Dan Slater in 1971. "Our mother was very proud of us and she naturally wanted to show us off but that concert and a few more that followed convinced us that we would never be entertainers."

The sisters were educated separately – Madeleine at a convent and Mary at a commercial college – and they initially followed separate careers. Madeleine became a secretary while Mary moved to London in early 1969 to become a model. Three months later Madeleine followed her and they began looking for assignments that would exploit their novelty value.

It wasn't long before they were noticed. In the King's Road, Chelsea, two teenage boys came a cropper when they were distracted by the girls. Their scooter hit the kerb and they were taken to hospital with concussion. The twins were by their bedsides when they came round, presumably to reassure them that

Opposite: Seeing double – the Collinson twins pose on the Pinewood set of *Twins of Evil*.

they weren't seeing double. "We felt somehow responsible and the least we could do was call and see them," said Mary.

In 1969 the girls attended a party where they met Victor Lownes, the head of Playboy's British and European operations. Lownes recommended them to the company's chief executive Hugh Hefner, who liked what he saw.

Playboy sent photographer Dwight Hooker to England in May 1970 to capture the girls during a modelling assignment in Ipswich, and at a meeting in their Carnaby Street agency. Hooker later followed them back to the Playboy building in Chicago, and took the centrefold picture that earned them the unique distinction of 'Misses October'. Full frontal nudity had not yet been introduced to *Playboy*, so the topless sisters were strategically positioned behind a brass bedstead and made what looked like a half-hearted raid on a dressing-up box.

In September, the month the magazine was published, their Stateside fame reached its peak when they were interviewed by Johnny Carson on *The Tonight Show*.

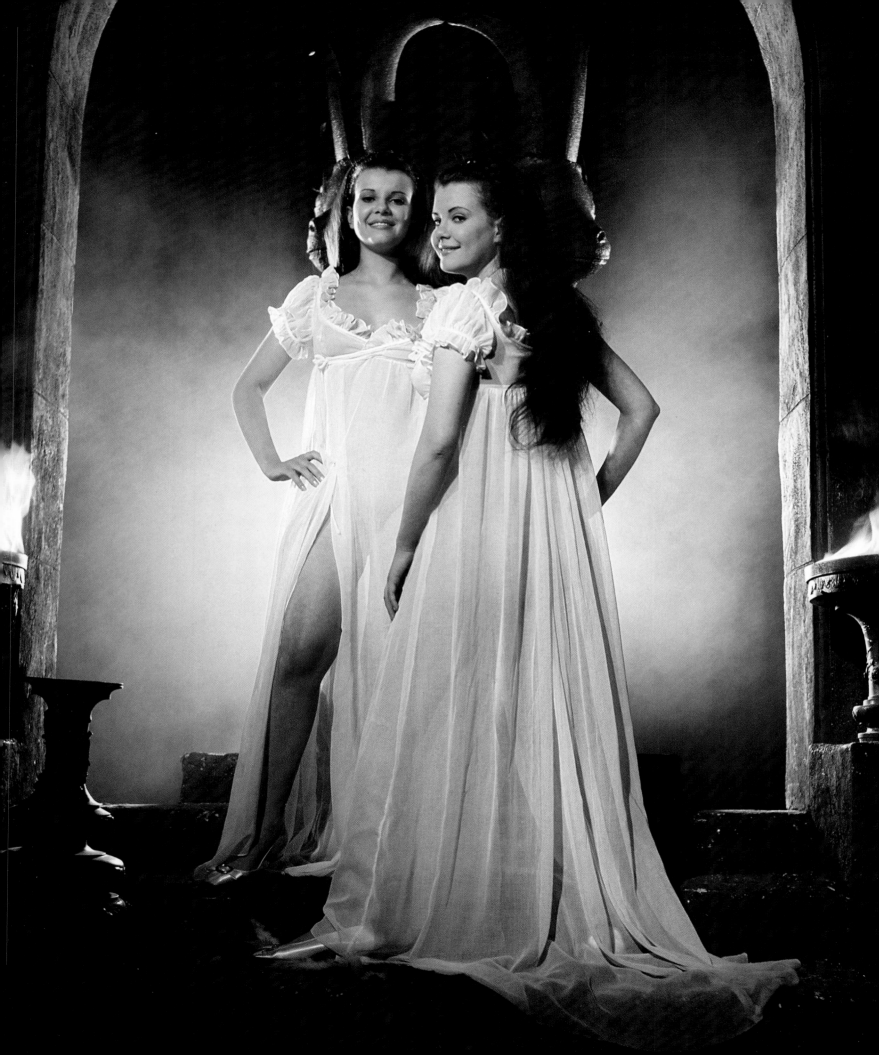

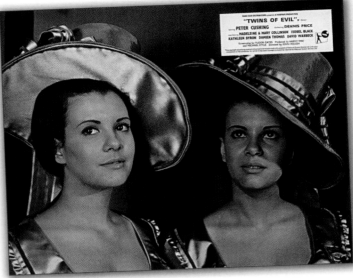

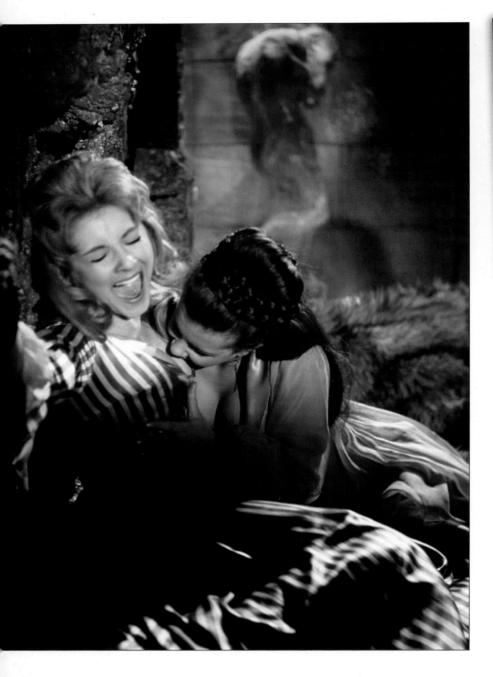

Above: The newly
vampirised Frieda
(Madeleine
Collinson) claims
Gerta (Luan Peters)
as her first victim.
Opposite: Katya
Wyeth (who played
the resurrected
Mircalla) and the
Collinson twins
perch on the castle
altar from *Twins
of Evil*.

March and April, and for the Collinsons it ended all too soon. "When the filming was over we both cried for a week," says Mary. "I just couldn't get used to not seeing everybody again."

Madeleine gave her fangs to Victor Lownes, who kept them in a special case. Peter Cushing wrote to the girls' mother in Malta to say that he had admired their performances. Or, as Mary modestly puts it, "that we weren't such bad actors as we thought."

In October 1971 the sisters wore matching tartan mini-skirts to the relatively informal première of *Twins of Evil* at London's New Victoria cinema. They were photographed with Peter Cushing, and posed alongside life-size cardboard cut-outs of themselves. Despite Mary and Madeleine's ambitions, the release of *Twins of Evil* would mark the end of their brief acting careers.

"There is no hope of a steady succession of parts for the pair of us if we stay together," Madeleine told Dan Slater in 1971. "In any case, we see our cinematic future differently. I would like meatier, more dramatic roles, while Mary wants to do comedy."

"It will be sad when it happens," added Mary. "You see we are not simply twin sisters. We are and always have been the closest friends."

The sisters moved to Italy and continued modelling. They retired in 1978, and turned down an offer from Columbia to star in an American television pilot. Mary stayed in Milan, while Madeleine returned to Malta to care for their mother and work for the British Council. She has now settled in England.

Twins of Evil is a film that rises above its cynical intentions. John Hough elicits a performance of startling ferocity from Peter Cushing, placing less emphasis on the twins' unsophisticated story of corruption and mistaken identity. The film remains a favourite with fans, and still occupies a special place in the hearts of its stars. "Acting was quite different from modelling," says Mary, "but *Twins of Evil* turned into what I still think of as the best experience of our lives." ∽

Back in London, the Collinson twins' exposure had not gone unnoticed by Hammer. Following a convoluted development, the script for *Twins of Evil* was submitted to distributor Rank at the end of 1970. Shortly afterwards, Hammer decided to overlook more experienced actresses in favour of casting real-life twins in the lead roles.

Mary would play the virtuous Maria Gellhorn, while Madeleine (credited in the film as 'Madelaine') would play her flirtatious vampire twin Frieda. The girls were sent for their costume and fang fittings in January 1971, and were tutored to improve their English.

Director John Hough shot *Twins of Evil* at Pinewood over

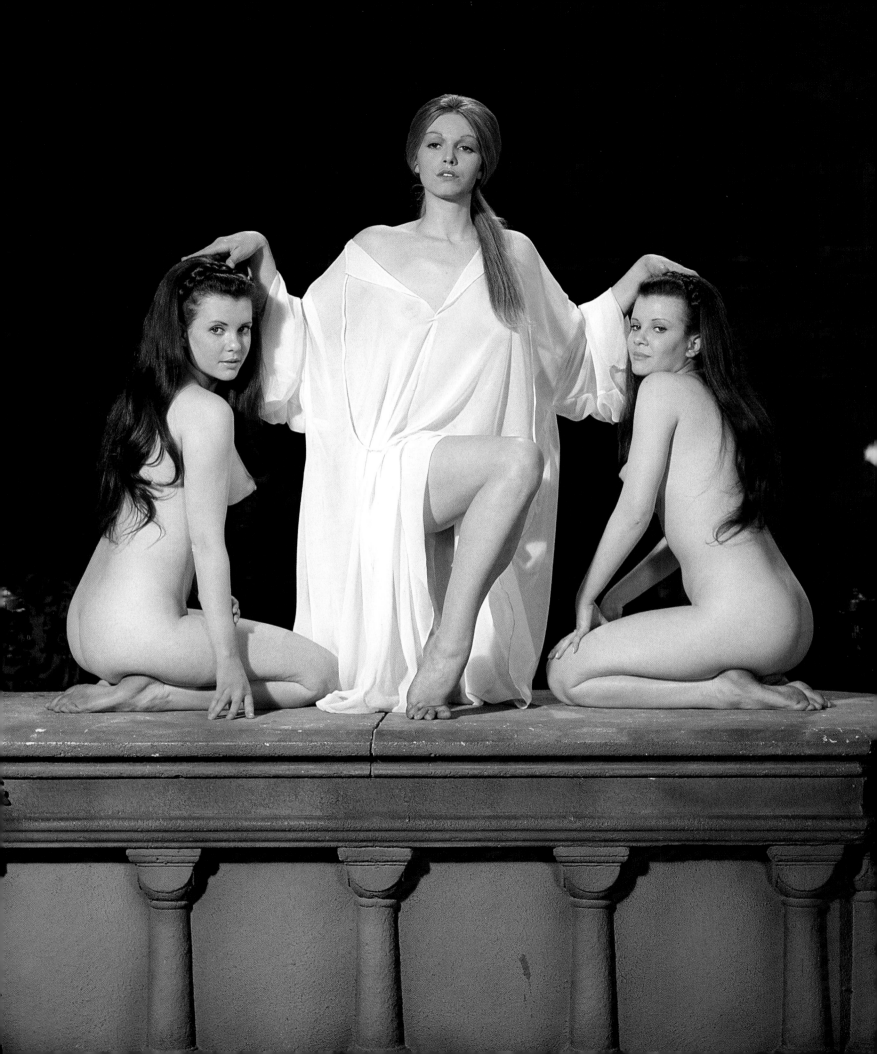

ADRIENNE CORRI

BORN in Edinburgh on 13 November 1931, Adrienne Riccoboni (her parents were Italian) was a seasoned veteran of stage, screen and tabloid newspapers by the time she made the first of four Hammer appearances in 1967.

She was expelled from school at 13 and ran away to London to become an actress. "It seemed the only job where I could enjoy myself without too much pain, earn the money I needed to live, and be my natural lazy self," she later said.

In the 1950s she caused a minor scandal by having two children before she married her first husband, Daniel Massey, in 1961. Adrienne was remorseless, and told the *Daily Sketch* she was coping perfectly well with the help of a nanny.

In 1964, she guest starred opposite Patrick McGoohan in the first of two episodes of *Danger Man*. Don Chaffey, the director of both shows, remembered her in 1966 when he needed a fiery actress to play the warlike Beatrice in *The Viking Queen*. Adrienne's vigorous performance provided some of the film's spikier moments, but was ultimately lost amid the general silliness.

'The New People', an unsettling episode of the 1968 anthology series *Journey to the Unknown*, was Adrienne's next assignment for Hammer. She played the tragic Terry, a gin-soaked divorcee at the heart of a community of swingers led by the sadistic Luther (Patrick Allen). This kinky British take on *Rosemary's Baby* is one of the neglected gems in Hammer's archive.

Adrienne's diverse career at Hammer continued when she played James Olson's love interest in the psychedelic space Western *Moon Zero Two* (1969). As Elizabeth Murphy of the Lunar Bureau of Investigation she is first seen lounging around in little more than her bra and knickers, even when she's apparently in a hurry to get back on duty. Once out of bed and into uniform – in this case a purple mini skirt and thigh-length PVC boots – she's no longer willing to turn a blind eye to dodgy space exploration in return for sexual favours. It's too bad she ends up copping it in a Wild West-style shoot out with Carry On star Bernard Bresslaw.

Director Stanley Kubrick had long been an admirer of Adrienne and in 1971 cast her as Mrs Alexander in *A Clockwork Orange*. The scene in which she is attacked, stripped and raped by Alex (Malcolm McDowell) is perhaps the most disturbing incident in this complex and morally ambiguous film. At the time Adrienne joked that "I must be the first natural redhead in Britain to do a full strip", but privately she was traumatised by the 39 takes that Kubrick demanded.

Hammer's filming schedules were rather more brisk. *Vampire Circus*, Adrienne's only fully-fledged Hammer horror, was shot in just six weeks over summer 1971. Adrienne was top-billed as the gypsy woman Anna, returning to a plague-ridden village in order to fulfil her undead lover's vengeance. This was Adrienne's most powerful Hammer role, and she seemed to relish its intensity.

By the mid-1980s Adrienne had become an acknowledged expert in the more genteel field of art history and restoration. Her published work includes the 1984 book *The Search for Gainsborough*, notable for its original research into the painter's early life. ∽

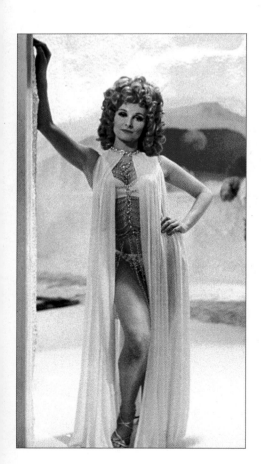

Right: Adrienne and Anthony Corlan in *Vampire Circus* (1972). **Below and opposite:** Modelling some of Carl Toms' costumes in *Moon Zero Two* (1969).

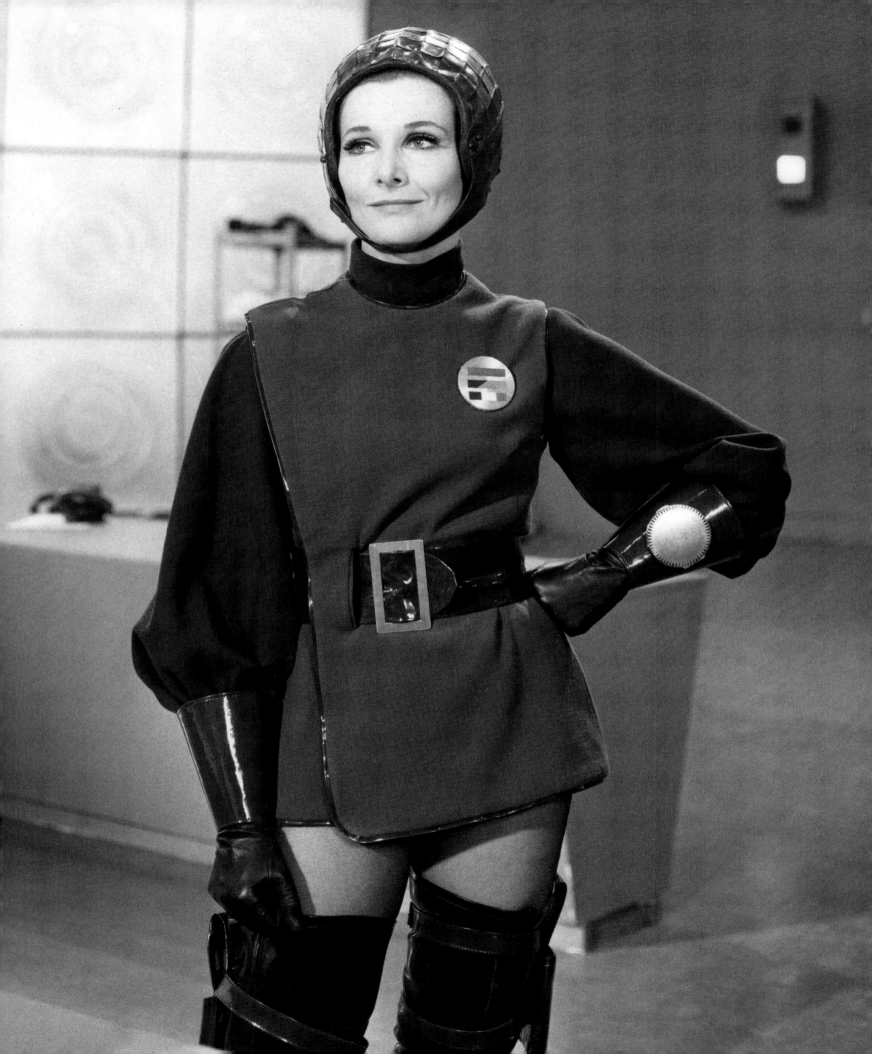

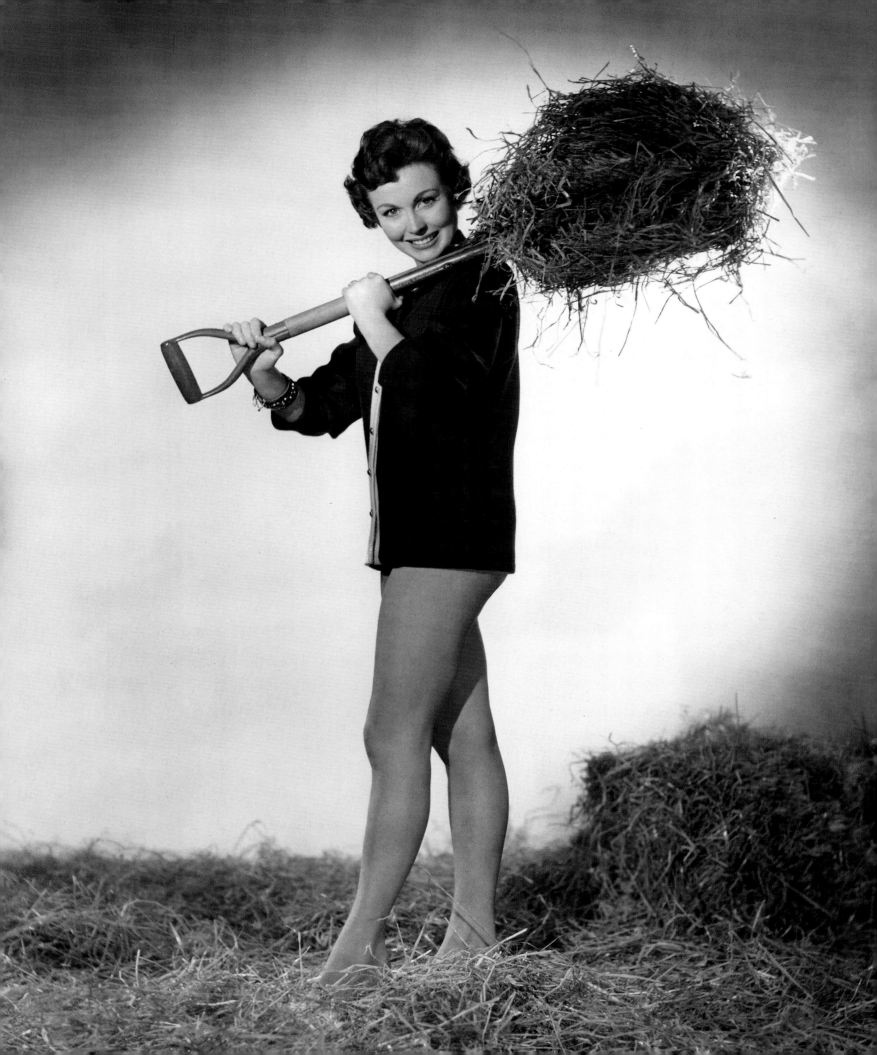

HAZEL COURT

HAMMER horror's first pin-up girl only made two films for the company, but her starring role in the seminal *The Curse of Frankenstein* gave her career a second wind and sealed her reputation. Her autobiography, published shortly after her death in 2008, was aptly entitled *Horror Queen*.

A buxom redhead with striking green eyes and rounded cheeks, Hazel Court was born in Birmingham on 10 February 1926. Hazel was proud of the fact that she was the first actress J Arthur Rank put under contract, and although she starred in numerous films for his company the first big hit of her career came when she was loaned to Gainsborough. *Holiday Camp* was released in 1947 and featured Hazel as the daughter of Jack Warner and Kathleen Harrison in their first appearance as the Huggetts.

She took time off to marry Irish actor Dermot Walsh and raise a daughter, Sally, but her career suffered as a result. Hazel was the best thing in the schlocky *Devil Girl From Mars* (1954) but did little else of note until Rank loaned her to Hammer to star as the prim and blissfully ignorant Elizabeth in *The Curse of Frankenstein*. This was, of course, the film that launched a long and colourful series of Hammer horrors, but although Hazel fondly remembered "fun and laughter" at Bray Studios, she only returned to Hammer once.

Visiting the set of *The Man Who Could Cheat Death*, a reporter from *The Sunday Dispatch* found Hazel in a bitter mood. Reflecting on her time with Rank she grumbled that "I've never had what amounted to a decent part. I was 'promising', they said. I've been 'promising' ever since." She admitted that recent years had been difficult, and asked not to be described as the breadwinner in her relationship. "That would just about kill poor Dermot."

The interview ended when producer Michael Carreras, presumably unable to stand any more, intervened and assured Hazel that she would look "luscious" in *The Man Who Could Cheat Death*. "You can work for me any time," he reassured her. "I thought you had never looked lovelier than in *The Curse of Frankenstein* – and they went mad over that in America."

This was no idle flattery on Carreras' part. During the making of *The Man Who Could Cheat Death* he paid Hazel extra to appear

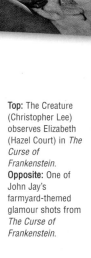

topless in an alternate version of a scene that would only be included in prints distributed outside England and America.

When filming was complete Hazel went to Hollywood for an engagement on *Alfred Hitchcock Presents*. The first of her four episodes was directed by Don Taylor, who became her second husband.

The reputation of *The Curse of Frankenstein* revitalised Hazel's career in the United States and she starred in three Gothic horror films for director Roger Corman. The last of these, alongside Vincent Price in *The Masque of the Red Death* (1964), would also be her final major film role.

An acclaimed sculptress in her later years, Hazel claimed she only occasionally missed the world of acting. She was happy to attend conventions and answer fan mail. "They say some beautiful things," she said. "They tell me how their children have been brought up watching the horror films and that they will keep going on. That's very rewarding, and I feel it makes it all worthwhile." ∽

Top: The Creature (Christopher Lee) observes Elizabeth (Hazel Court) in *The Curse of Frankenstein.*
Opposite: One of John Jay's farmyard-themed glamour shots from *The Curse of Frankenstein.*

47

JENNIFER Daniel starred in two very different Hammer horrors, *The Kiss of the Vampire* and *The Reptile*, but played resourceful newlyweds in both.

Jennifer was born in Pontypool, South Wales, on 23 May 1939. She showed early promise as a musician, and was selected to play clarinet in the Welsh National Youth Orchestra. When she left home she moved to London and spent three years studying at the Central School of Speech and Drama. Her course culminated in her receiving the Hazel Douglas Prize and a six-month contract with a repertory company in Dundee.

She stayed with the company for 18 months before returning to London and finding her first roles in television. In 1958 she briefly appeared in Rudolph Cartier's production of *A Midsummer Night's Dream* and in 1959 played Clara in an adaptation of *Great Expectations*. Pip was played by the 26 year-old Dinsdale Landen. He and Jennifer fell in love and were married that year.

In the early 1960s Jennifer worked steadily for both television channels, with guest appearances in *Maigret, Suspense, No Hiding Place* and *Ghost Squad*. Her first film was the Edgar Wallace drama *Marriage of Convenience* in 1960 (directed by Clive Donner and co-starring *Dracula's* John Van Eyssen). She made two further instalments in the Edgar Wallace series, but her Hammer assignments represented the only feature film work in her career.

In *The Kiss of the Vampire* Jennifer was cast as Marianne Harcourt, whose honeymoon is rudely interrupted when she and her husband Gerald (Edward de Souza) are separated at a masked ball in Bavaria. Gerald is drugged and she is taken prisoner by the vampire Dr Ravna (Noel Willman). A power struggle ensues as Gerald enlists the help of the resourceful Professor Zimmer (Clifford Evans) to rescue his wife.

The Reptile, Jennifer's next Hammer film, was made almost exactly three years later and once again pitted her against Noel Willman. Jennifer was cast as Valerie Spalding, whose husband Harry (Ray Barrett) inherits his dead brother's cottage in the plague-ridden village of Clagmoor Heath in Cornwall. *The*

Right and opposite: Publicity shots taken during the 1965 filming of *The Reptile*, inside and outside Bray Studios.

Reptile gives Jennifer rather less to do than *The Kiss of the Vampire* but she has a particularly uncomfortable scene where her husband staggers home from an encounter with the snake-like Anna Franklyn (Jacqueline Pearce) and tells his wife to cut the poison from the incisions in his neck. And at the end of the film Valerie is suitably anguished as Dr Franklyn (Willman) forces her to witness his confession regarding his daughter's terrible affliction.

Jennifer's character is the star of *The Kiss of the Vampire*, and this is the film she will be remembered for: mesmerised by a piano rhapsody at the chateau, succumbing to Dr Ravna and, in the vampire's thrall, spitting in her husband's face. These are not only some of her finest moments, but some of the most memorable scenes in all of Hammer's vampire films. ∞

VERA DAY

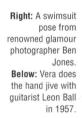

"YOU'RE not using that one!" says Vera Day, scrutinising one of the photographs provisionally selected for this book. It's an awkward-looking portrait of the young Vera wearing a *very* tight sweater. "Pictures like that make me squirm. Look at those pointy boobs!"

The offending shot is excised, and we're left with a variety of images that better illustrate Vera's journey from cheeky chorus girl to smouldering sexpot.

Vera was born in London's East End on 4 August 1935, and aspired to showbusiness from a young age. "I was always in school plays and asking teachers how I could become an actress," she says. "They said I had to go to RADA but my parents couldn't afford that. The day after I left school I went straight to work at a shop in Marble Arch in order to pay my way."

Vera made the most of her fashionable shape by becoming a model. "At that time boobs were very in. But a lot of the girls who had big boobs had a big everything else. I was fortunate to have a 36-22-34 hourglass figure but in miniature, because I'm only 5' 2". They used to call me the Pocket Venus!"

In summer 1953 Vera's then boyfriend, actor Arthur Mason, was aiming for a part in Harold Rome's holiday camp musical *Wish You Were Here* at the London Casino (now the Prince Edward Theatre). He suggested that Vera auditioned to join the chorus line of the same show. "I was working in a hairdresser's salon before the audition, and the next thing I knew I was running around the stage in a bikini."

Wish You Were Here opened in October 1953, and Hammer film director Val Guest was in the audience. He spotted some potential in Vera, and gave her a part in his film *Dance Little Lady* (1954). When *Wish You Were Here* closed, Vera

Right: A swimsuit pose from renowned glamour photographer Ben Jones.
Below: Vera does the hand jive with guitarist Leon Ball in 1957.

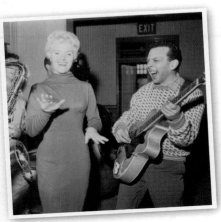

followed it with a role in *Pal Joey* before two years of twice-nightly mayhem with The Crazy Gang. During the day she appeared in films, and on Sundays she recorded episodes of the radio comedy *Meet the Huggetts*.

In 1956 Guest cast her in Hammer's *Quatermass 2*, and bowed to her wishes when her character was infected by one of the alien meteorites showering the new town of Winnerden Flats. The disintegrating capsules scar most victims on the face, but Vera pulls her hand away to reveal a v-shaped blister just beneath her neck. "There was a reason for that," she says, smiling broadly. "I refused to have the mark on my face. I told them it would spoil my looks, so I had it on my chest instead!"

Vera was under no illusion that her beauty had enabled her to enter showbusiness without any formal training. Any unwelcome attention her looks may have attracted was seen off by Mason, who was by now her husband. Arthur's psychotic jealousy made him notorious in the gossip columns and served as handy insurance against lecherous producers. Unfortunately, it also led him to attack entirely innocent actors who happened to appear alongside Vera in romantic scenes. When Arthur started hitting her as well, she summoned the courage to leave him.

Vera remembers little about her lead role in Hammer's 1957 short *Clean Sweep*, but insists that none of the parts offered to her

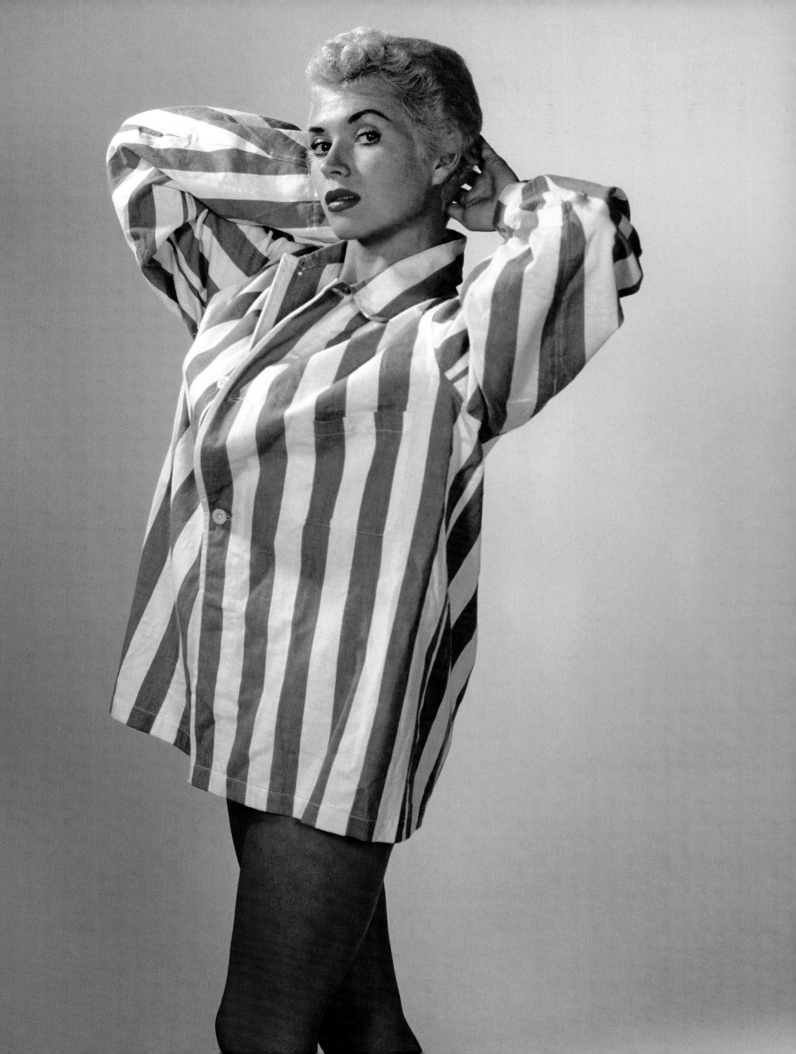

by Hammer or any other film company gave her anything to be proud of. Her best roles were in live television programmes that were sadly never preserved. These included the lead in Gerard Glaister's 1957 production of *The Red-headed Blonde*. "It was a vehicle for me," she says. "I was on all the time, but it was fantastic. The next day I went to Elstree to play a barmaid in *Up the Creek*. I sat on the train reading the wonderful reviews I got for *The Red-headed Blonde* the night before. I remember one of them said, 'Vera Day is no lingerie lass now'. And I was almost in tears, thinking here I am, back to square one, doing two days' work as a barmaid. But I had to do it. It was money." Another naval comedy, *Watch It Sailor!*, was filmed at Bray Studios in early 1961. This gave Vera her biggest role in a Hammer film, so it's not surprising that it remains her favourite among those she made for the company.

By this time she was mainly working as a cabaret artiste, playing everywhere from working men's clubs in Manchester ("absolutely dire" she grimaces) to luxurious nightspots in Boston, Massachusetts. She was out of step with the trend for kitchen sink drama, and turned down the role that Rachel Roberts went on to play in *Saturday Night and Sunday Morning* (1960). "The script described the character as 'slatternly'. I took one look at this and said, 'You must be joking! Do you think I'm going to play a slatternly housewife? You're talking to Britain's Marilyn Monroe here!' What a mistake that was."

In 1963 Vera married photographer Terry O'Neill and became pregnant soon after. She took her cabaret act to South Africa but retired after losing her first child. She went on to have a daughter and a son, by which time O'Neill had become one of the most sought-after celebrity photographers in the world. "There was no need for me to work anymore, because for the first time in my life I had a man looking after me," she says. "I didn't want to stop working but it was easier that way. I stopped trying."

Vera's marriage to O'Neill foundered after his affair with Hollywood actress Faye Dunaway in the late 1970s and the couple eventually divorced. Vera never remarried – "I didn't fall in love again, it was as simple as that" – but made a remarkable acting comeback when Guy Ritchie cast her in his 1998 gangster thriller *Lock, Stock and Two Smoking Barrels*.

"Guy said he wanted an attractive, faded blonde to play Tanya in *Lock, Stock*. He saw my CV, looked at my picture and apparently said, 'I'm not going to look any further – she's for me.' I didn't even audition. I only had a little part in that film but, my God, everybody knows *Lock, Stock*. I'm eternally grateful to him."

Vera has since appeared in an episode of television series *The Bill* and the 2007 thriller *The Riddle*. Admitting that she "loved showbusiness", she seems keen to make up for lost time.

She returns her gaze to the photographs on the table and shakes her head. "You should never have given up your career, girl." ∞

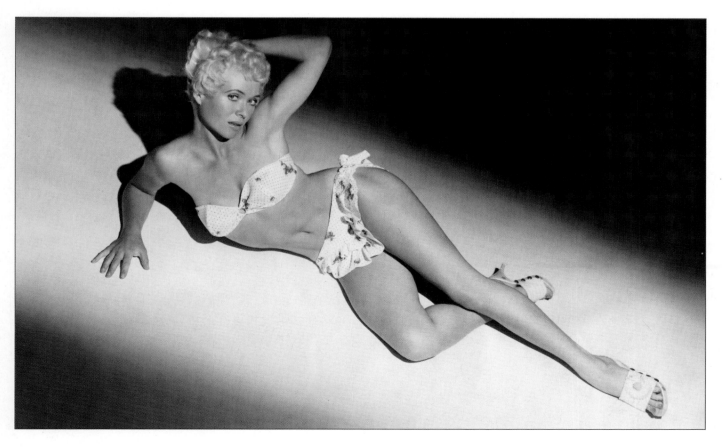

Opposite: A Tom Edwards portrait of Vera from her favourite Hammer film, *Watch It Sailor!* (1961).
Left: A bikini shot used by Hammer to promote Vera's appearance in *Quatermass 2* (1957).

SUSAN DENBERG

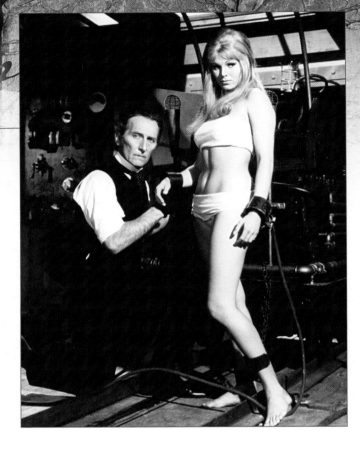

SUSAN Denberg only made one film for Hammer, but the nature of the role, and the iconic photographs that she posed for during filming, established her as one of the company's greatest female stars of the 1960s. Tragically, Susan was swept away by the excitement of her adventure and, unable to cope with the pace and pressure of her new life, succumbed to a breakdown from which her career never recovered.

Dietlinde Ortrun Zechner was born in Poland on 2 August 1944. After the war her family relocated to Klagenfurt in Austria, where her father established a chain of electrical shops. Bored of her family's provincial lifestyle, she moved to London in 1962. She worked as an au pair and had a relationship with an airline steward until a "rich sugar daddy" established her in a flat in Chelsea.

A chance meeting with a dancer in Hyde Park led to her joining the renowned Bluebell troupe. Recalling what she could of her childhood ballet lessons she joined the Bluebells' London chorus line and later performed at the Stardust Hotel in Las Vegas. She met and fell in love with Tony Scotti, a singer at the Desert Inn, and was delighted when they were invited to a party hosted by Elvis Presley. Tony and Dietlinde were married on 15 October 1965, after which she resigned from the Bluebells and left for Hollywood with her new husband.

Dietlinde adopted the stage name Susan Denberg for her first role, as Ruta the German maid in Norman Mailer's *An American Dream*. Her marriage to Tony fell apart after just six months and she embarked on an affair with *American Dream* lead Stuart Whitman. "I knew this man had fallen for me," she later said. "I knew, too, that if I was nice to him it could do my career a lot of good. This and the fact that I really was attracted to him made me a pushover."

She split up with Whitman a few weeks later, and after the filming of *An American Dream* began a relationship with an unnamed star who introduced her to marijuana, amyl nitrate and orgies. He also bullwhipped her across the back when he became jealous of the attention she was receiving from other men.

Top: Misleading publicity stills and posters from *Frankenstein Created Woman* (1967) appeared to show the Baron (Peter Cushing) producing Christina (Susan Denberg) in a machine.

Susan moved to Beverly Hills, attended drama lessons and landed a role in the *Star Trek* episode 'Mudd's Women'. She dated Sammy Davis Jr and Richard Pryor, and posed topless for *Playboy*. Her notoriety was increasing, even though she was only ever offered small roles in television series and minor films.

Hammer frequently cast actresses from the pages of *Playboy*, and it was decided that Miss August 1966 should be the star of *Frankenstein Created Woman*. Susan did well in a screen test for the role, and before she left for England performed an impromptu striptease at a poolside party held by Frank Sinatra.

Susan arrived in England on 22 June 1966 and Hammer ensured that photographers were waiting for her. She was provided with a flat in St James's Street, Mayfair, and promised a fee of £12,000 – an astronomical figure compared to the salaries earned by most actors at Hammer.

Susan was cast as the initially disfigured Christina, and Robert Morris played her boyfriend. "She was very sweet, very friendly," he says of his co-star. "I liked her very much. She was very mixed up with that rather fast Polanski crowd, and also very much into the drug scene. She'd often arrive on the set in the mornings somewhat the worse for wear, but she was no trouble really."

Although her voice was dubbed in the *Frankenstein* picture, Susan managed a convincing transformation from timid waitress to vengeful murderer, ruthlessly slaying the bullying toffs responsible for her boyfriend's death.

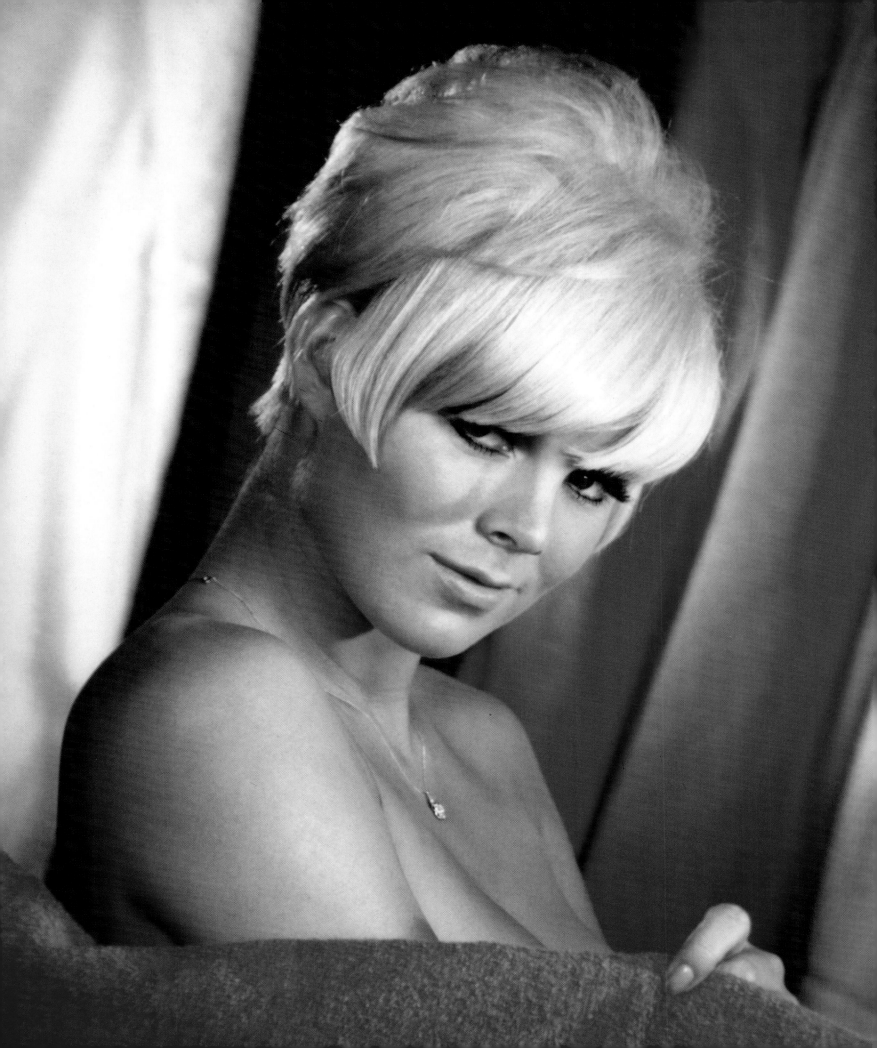

The film was released in May 1967 and proved popular enough on a double bill with *The Mummy's Shroud*. Susan should have capitalised on her success, but she continued to make bad choices. She dated Charles Bronson, Sidney Poitier, Jim Brown and Roman Polanski, staying up until the small hours at the White Elephant club in Curzon Street and Dolly's discotheque. She started using LSD and fell behind on her rent, eventually having to leave her Mayfair flat.

By now incapable of working, and very difficult to find, Susan lost out on a major part in *The Girl On A Motorcycle*, the psychedelic drama starring Alain Delon. In his autobiography *Magic Hour*, director Jack Cardiff remembered, "I cast a German girl to play the lead. She was perfect for the role. A few days after engaging her she was rushed to the hospital with a drug overdose and I never saw her again." The part went to Marianne Faithfull instead.

Eventually Susan's father heard about his daughter's plight and came to London. They returned to Klagenfurt together, where Susan told a specialist that a cousin had repeatedly sexually abused her as a child. She was sent to a psychiatric clinic in Vienna for two months, where she underwent agonising electro-convulsive therapy. She was then committed to a nervous disorder hospital in her home town, where she recalled that a nurse ordered her to "Stop crying! You stupid double-nothing. You're not an actress any more. In here, you live like a nun!" She was relieved to be locked alone in a cell at nights.

In November 1969 Susan sold her story to the *News of the World*, whose sensationalised account was dressed up as a cautionary tale about the dangers of promiscuity and drug-taking in the permissive society.

"Hollywood ruined my daughter," said Susan's mother in 1968. "Money-mad agents used her, exploited her beautiful body. Susan wants to go back to Hollywood, but that's impossible. The doctors say it will take years for her to get well. The best thing she can do is find something to occupy her time, to keep her mind off Hollywood and showbusiness. Perhaps she will find a man. That will be good for her."

For many years it was believed that Susan had committed suicide, but these were rumours circulated by those who had lost touch with her in the '60s. She still lives in Austria, but has proved elusive to those sending invitations for interviews and convention appearances. Hollywood may have created Susan Denberg, but she has long since claimed her old life back. ∞

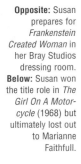

Opposite: Susan prepares for *Frankenstein Created Woman* in her Bray Studios dressing room. **Below:** Susan won the title role in *The Girl On A Motorcycle* (1968) but ultimately lost out to Marianne Faithfull.

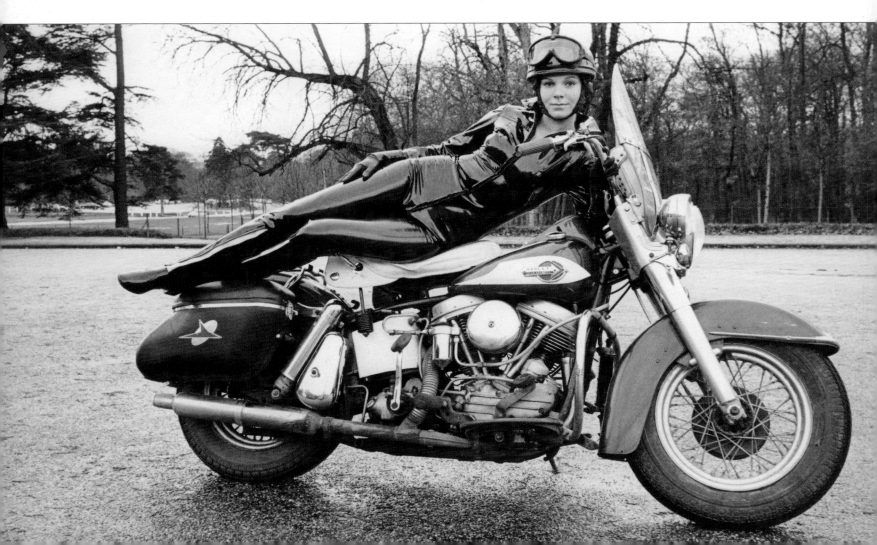

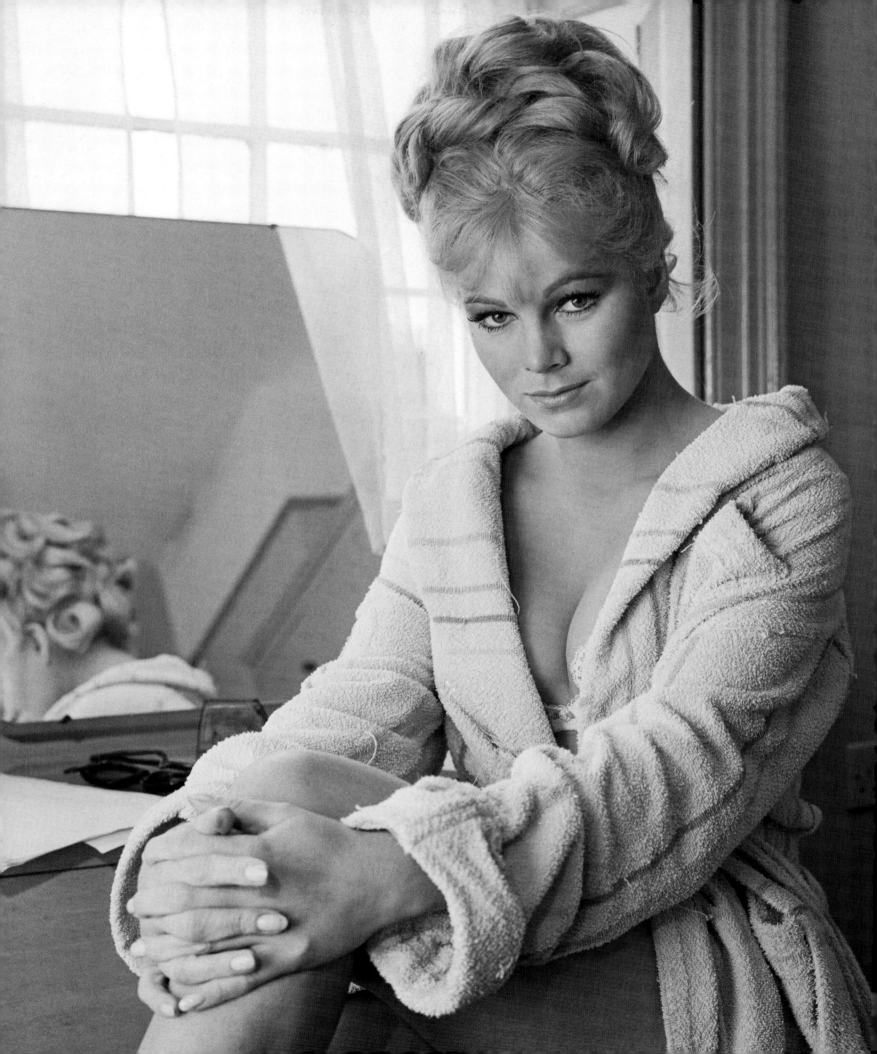

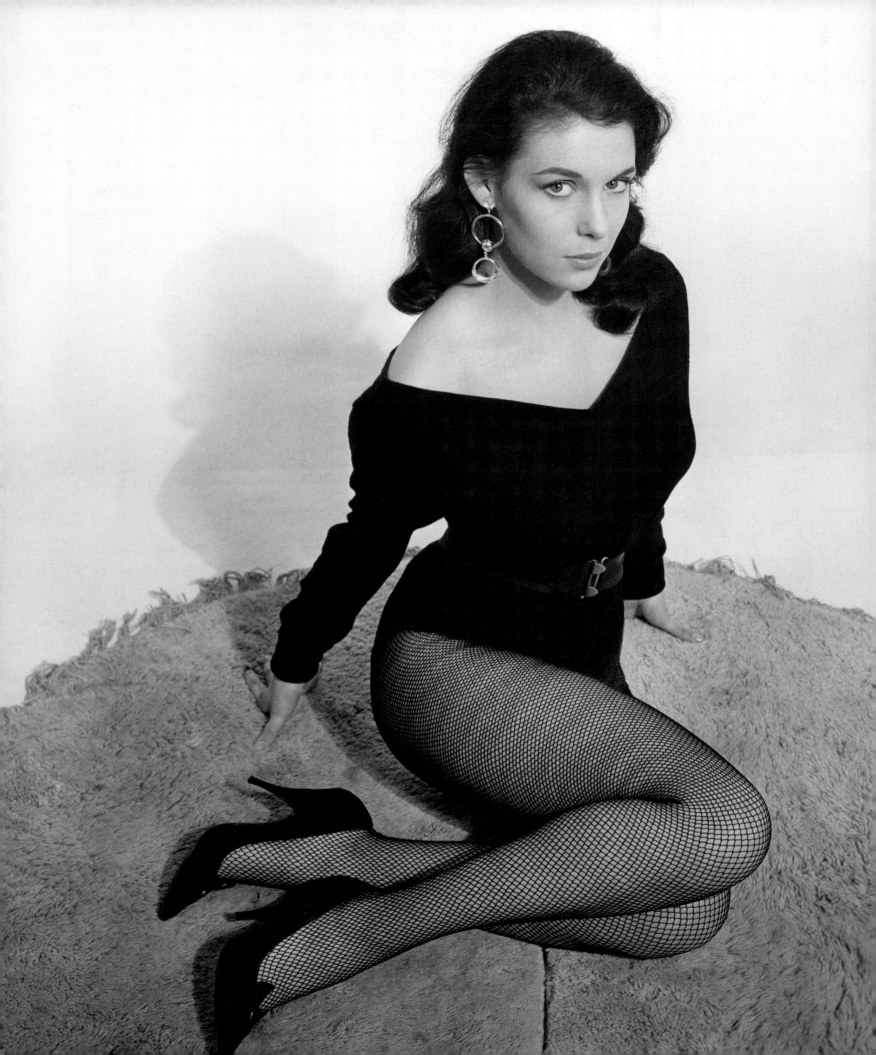

MARIE DEVEREUX

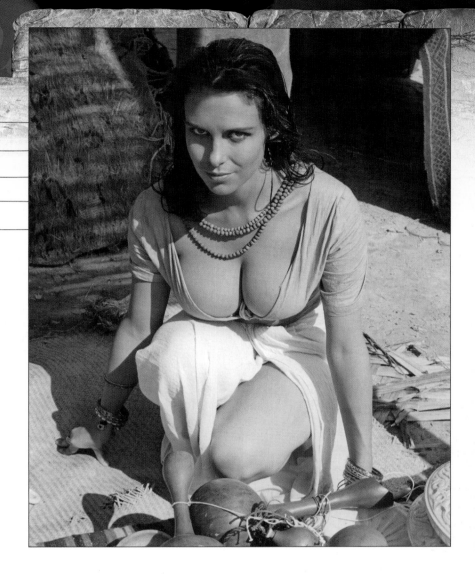

PATRICIA Sutcliffe was born in London in 1938. Her mother was Spanish and her father part Belgian, which went some way towards qualifying her as one of the Continental beauties sought by Hammer in the late 1950s.

Pat started modelling at 15, and by 16 was taking her bra off for saucy 'girl next door' magazine *Spick and Span*. With the kind of voluptuous curves that 1950s pornographers considered the epitome of glamour, it was only a matter of time before she started appearing in 'under the counter' publications.

Up-and-coming actor Michael Caine introduced Pat to legendary photographer George Harrison Marks, and she became one of his favourite nude models. Marks changed Pat's name to Marie Deveraux and cast her in countless photo sessions which earned her the nickname 'The Countess of Cleavage'.

Marie had danced at London's notorious Windmill Theatre but had loftier career ambitions. "Photographers and artists liked my looks and figure," she said in 1960, "but physical attributes are only useful if you treat them as a means to a more serious end. In my case, I wanted desperately to become an actress."

In 1958 she appeared on stage alongside Anton Rodgers in *The Tender Trap,* but she was typecast by her 38-23-36 figure and found meaningful dramatic parts difficult to come by. She certainly didn't find any at Hammer, who cast her in a succession of purely decorative roles across five films produced between 1958 and 1961.

Regularly commuting to Bray Studios from her parents' house in New Malden, Pat was credited as Marie Devereux (a slightly different spelling of her stage name) when she appeared as a harem girl in *I Only Arsked* (1958) and as the willowy Karim in *The Stranglers of Bombay* (produced in 1959).

She had most recently played Noel Coward's girlfriend in *Surprise Package* when she returned to Bray for *The Brides of Dracula* in January 1960. Hammer publicist Colin Reid could barely contain his enthusiasm for her "sizzling dark beauty, cascading raven tresses and devastating physique" but Marie was already starting to tire of the routine. It didn't help that the coffin she was made to lie in was too narrow for her hips and she had to spend three hours wedged inside, draped in garlic.

Marie suffered the final indignity when the film's closing credits spelt her surname 'Deveruex'. She appeared in two further Hammer films, *A Weekend With Lulu* (1961) and *The Pirates of Blood River* (1962). She doubled for Elizabeth Taylor in the 1963 *Cleopatra* and then, according to Harrison Marks, followed the film crew from Rome back to Hollywood in an effort to further her career. She came to the attention of *Playboy*, but secured only a few more film roles (including an appearance as a nympho in *Shock Corridor*) before dropping off the radar in 1964.

In 1960 Marie claimed she would give herself two years to find stardom as an actress. The irony underlining that ambition is that she is immortalised not in the films she made for Hammer, but in the photographs they took of her. ∽

Opposite: Marie as one of *The Brides of Dracula* in 1960. **Above:** A 1959 shot of the 'Countess of Cleavage' as Karim in *The Stranglers of Bombay*.

DIANA DORS

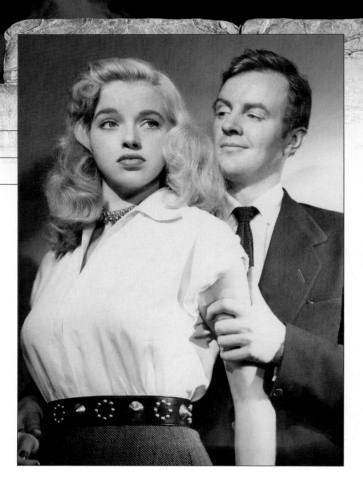

A fun-loving girl with an unhealthy addiction to fast living and lawless young men, Diana Dors was Britain's most beloved sex symbol.

She was born Diana Mary Fluck in Swindon on 23 October 1931 and made her uncredited debut in *The Shop at Sly Corner* (1947). Under contract to Rank and mired in their world of staid filmmaking, she decided to revitalise her image and her private life in 1951. She unveiled her new peroxide blonde look in time for her wedding to Dennis Hamilton on 3 July. A door-to-door salesman with a notorious anger management problem, Hamilton styled himself as Diana's Svengali but the couple often found themselves unable to afford or maintain the sumptuous lifestyle they craved.

Rank loaned Diana to Hammer for *The Last Page,* and she was desperate for the film's £450 salary. Filming started at Bray Studios, in the village where Diana would later make her home, just four days after her wedding. She was cast as Ruby Bruce, a sultry book shop assistant who is manipulated by her boyfriend Jeff Hart (Peter Reynolds) into blackmailing her boss John Harman (an improbably cast George Brent). This was the first Hammer film directed by Terence Fisher, later to become the company's most celebrated director, but Diana was the best thing about it.

Hammer's American distributor Robert Lippert released the picture under the title *Man Bait*. The poster was dominated not by the star, George Brent, but by a shot of Diana in her underwear. Lippert offered her a contract in the States on the condition she divorced Hamilton, but when the deal fell through Hamilton told the press that Diana had turned Lippert down because the roles weren't interesting enough.

Diana was still struggling when she returned to Hammer in February 1953 for a cameo in *The Saint's Return*. As a gangster's moll, she appears in a sequence where she is ordered to delay Simon Templar (Louis Hayward), even though she's dressed in nothing but a bath towel. She changes remarkably quickly and manages to briefly divert the Saint by snogging him into submission. It wasn't much of a role, and by now Diana's blonde bombshell routine had crossed the line into self-parody.

Twenty-seven years, three marriages and one bankruptcy later, she returned as a 'special guest star' in *Hammer House of Horror* (1980). This was a series that recalled numerous luminaries from Hammer's history, and none of the actors went further back than Diana. In the episode 'Children of the Full Moon' she exercised admirable restraint as the genial matriarch of a foster home for werewolves.

Such opportunities were rare in the 1980s, by which time Diana had long since relied on making a living as a television celebrity rather than an actress. She died of ovarian cancer on 4 May 1984, shortly after completing her final film, *Steaming*. It is among the handful of credits that prove hers was a neglected talent all along. ∽

Right: Ruby (Diana Dors) is menaced by her cruel boyfriend Jeff (Peter Reynolds) in *The Last Page* (1952). **Below:** Playing older than her 48 years in 'Children of the Full Moon' (1980).

SHIRLEY EATON

FURTHER UP THE CREEK

A WEEKEND WITH LULU

IN the early 1960s one critic described Shirley Eaton as the "well-scrubbed girl next door". This was a role she honed to perfection in a series of movies that include some of the greatest homegrown comedies of the era. The two films she made for Hammer during this period are unlikely to appear on anyone's list of classics, but her distinctive glamour – characterised by parted blonde hair and striking, angular features – was some compensation for the lack of laughs in *Further Up the Creek* and *A Weekend With Lulu*.

Below: Shirley preens herself before an admiring Leslie Phillips in a tongue-in-cheek publicity shot from *A Weekend With Lulu* (1961).

Shirley Jean Eaton was born in Edgware, Middlesex, on 12 January 1937, and made her stage debut aged just 12. As if pre-destined for a career in British comedies, she made an uncredited appearance as a schoolgirl in *The Belles of St Trinian's* (1954) and

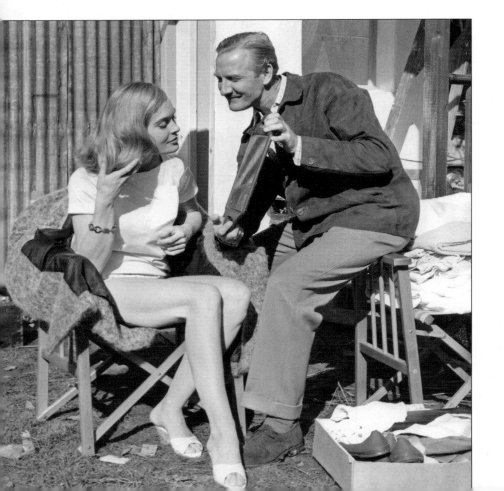

was given a speaking role in the similarly acclaimed *Doctor in the House* the same year.

By 1958 Shirley was regularly being given starring roles. The plot of *Carry On Sergeant*, the first film in the series, partly revolves around her character's efforts to infiltrate a national service depot so she can spend her wedding night with her recently conscripted husband (Bob Monkhouse). In May 1958 Shirley went straight from the Pinewood set of *Carry On Sergeant* to Bray Studios and Hammer's *Further Up the Creek*. Shirley was the most appealing passenger on the errant HMS *Aristotle*, turning heads in a pair of hot pants and a sleeveless top, but she couldn't save the film from becoming what James Carreras called "a disaster".

Shirley went on to starring roles in *Carry On Nurse* (1959) and *Carry On Constable* (1960) before returning to Hammer in October 1960 to make Continental caravan caper *A Weekend With Lulu*. The presence of Shirley and Bob Monkhouse, two of the stars of *Carry On Sergeant*, only served to highlight the fact that Hammer's effort suffered from a weak script and slack editing in comparison. When Barbara Windsor joined the cast of *Carry On Spying* (1964) it was clear that a saucier approach had usurped Shirley's more polite contributions to the Carry On team. Shirley had already set her sights on bigger things, starring alongside Mickey Spillane in *The Girl Hunters* (1963) and Sean Connery in *Goldfinger* (1964). Her spectacular demise in the latter, smothered in skin-suffocating gold paint, created one of the most enduring images in British cinema.

"It's taken the Americans in a Mickey Spillane picture, and now Bond, to realise I am much more sexy and sensuous than the British public ever realised," said Shirley in September 1964. "There's a career ahead with an entirely new image."

The exploitation pictures that actually lay ahead were surprisingly undistinguished given Shirley's now global notoriety, and she retired in 1968 to devote herself to her husband Colin Rowe and their two sons. "I loved my acting career, the fun and games," she said in 1978. "But what is a career after all? It's only a driving force that lasts so long, then you're on the heap. Having children is eternal." ∽

JULIE EGE

CREATURES THE WORLD FORGOT

THE LEGEND OF THE 7 GOLDEN VAMPIRES

MODEL, actress and sex symbol, the desperately ambitious Julie Ege was Hammer's most heavily promoted glamour girl of the '70s. "I want to be a star," she said in 1972, "and what's wrong with wanting that?"

She was born Julie Dzuli in Sandnes, a small town in Norway, on 12 November 1943. She left school aged 15 and was crowned Miss Norway two years later. Realising that she had to improve her English in order to maximise the ensuing publicity, she briefly relocated to London and worked as an au pair for a family in Golders Green.

Julie took part in the Miss Universe contest in Florida in 1962, and was working as a model back in Norway when she married her first husband. He was a farmer, but Julie got bored of the rural lifestyle and they divorced nine months later.

She returned to Oslo to resume her modelling career and promptly fell in love with her dentist, who became her second husband in 1965. Before long, however, the couple clashed over Julie's desire to become a star in international movies. Her husband reluctantly let her move to London, and agreed to finance her flat in Kensington High Street for two years on the understanding that she would return if her plans didn't work out.

Julie arrived in England in early 1967 and made a minor impact as a glamour model, becoming that May's Pet of the Month in *Penthouse* magazine. Film roles were harder to come by. Several months of Swiss location filming in 1968 amounted to a disappointingly brief appearance in the James Bond film *On Her Majesty's Secret Service*. She attracted more publicity for taking her clothes off in *Every Home Should Have One* (1970), a Marty Feldman comedy that cast her as a randy Swedish au pair.

By this time Julie's private life had become complicated. In 1969 she had given birth to a daughter, Joanna, and was now struggling to maintain the cost of her rent and a nanny. Despite only visiting her husband for holidays, she insisted to journalists that their long-distance marriage was still intact. "What can we do?" she told the *Evening Standard* in May 1970. "He can't come here because his practice is there. And he's now 40, anyway. If I get known I can live anywhere, but I can't go back to Oslo yet." Perhaps unsurprisingly,

Julie's second marriage was about to come to an end.

Her fortunes seemed to improve when she heard about a competition that Hammer had launched to find a new female star. The prize was a film contract and the mantle 'Sex Symbol of the 70s'. Julie was apparently chosen from over 1,500 applicants, and cast as cavegirl Nala in the company's latest prehistoric saga, *Creatures the World Forgot*.

Daily Mail film critic Barry Norman was wary of the hype, and visited Sir James Carreras at Hammer House to ask him why he had chosen Julie. "Why?" asked an incredulous Carreras. "Good God, man, you have eyes, haven't you?"

Julie's discovery and the subsequent publicity campaign had in fact been carefully orchestrated by Carreras in partnership with distributor Columbia and Julie's agents, London Management. In August it was estimated that Julie had so far been the subject of a staggering 1,657 column inches in British newspapers. *Creatures the World Forgot* would be her first starring role, and the first opportunity to transform the goodwill of the tabloids into something bankable.

原始人100万年

Opposite and top: Julie models her costume from *Creatures the World Forgot* (1971). **Above:** Julie as cavegirl Nala, seen here in the Japanese poster for *Creatures the World Forgot*.

The gruelling location shoot took place in South West Africa and began in July 1970. When it was finally over Julie embarked on an affair with Hammer writer and director Jimmy Sangster. "We were together for three or four months and had a great time," says Sangster. "I remember I bought her a Mini. After we split up she met Tony Bramwell, who was part of The Beatles' record company Apple. One day I told Julie I was going on holiday to Cannes with Ralph Bates and his wife, and she said 'That sounds like fun. Can I come too?' I wasn't about to refuse, so I picked her up from her house and Tony waved her off. If I was him I would have been livid."

In January 1971 Julie recorded a single for Apple, a cover of 'Love' from the previous year's *John Lennon/Plastic Ono Band* album. She later admitted her singing voice was "useless", but Lennon was polite about her efforts.

The X-rated *Creatures the World Forgot* premièred in March, but critics and audiences were baffled that it didn't feature any of the stop-motion dinosaurs that had helped to make *One Million Years B.C.* such a hit. The result was a ponderous slog that flopped at the box-office.

Julie spent the next few years exploiting her blonde bombshell image in a succession of sex comedies and other minor British films. In 1973 Hammer's Michael Carreras was casting the company's kung fu extravaganza *The Legend of the 7 Golden Vampires* when he recommended Julie to director Roy Ward Baker. A memo preserved in Hammer's filing cabinets confirms Baker's half-hearted consent to the idea, and she started filming in Hong Kong that October.

On its release in 1974 *The Legend of the 7 Golden Vampires* was slated by influential young critic Charles Shaar Murray, who famously dismissed Julie as "a pair of big tits with a Swedish accent". Carreras thought the review was hilarious, but the film's poor reception convinced him to draw a line under the traditional Hammer horrors.

Below: Underdressed for her recording of John Lennon's 'Love' in 1971. **Below right:** With boyfriend Jimmy Sangster in 1970.

Julie's relationship with Tony Bramwell came to an end in 1976, and the following year she returned to Oslo with her new boyfriend, the author and playwright Anders Bye. She occasionally acted, most notably in several stage productions of *The Rocky Horror Show*, but the birth of the couple's daughter Ella in 1978 finally prompted her to retire.

The couple separated after eight years together, and Julie declared that she was unlikely to have another long-term relationship. She raised her children, studied for a history degree and then trained to become a care worker. In 1998 she qualified as a registered nurse, and continued working at a hospital in Oslo after she was diagnosed with lung and breast cancer. She died on 29 April 2008.

"To be honest, I was never really that proud of my performance in films," she reflected in 2005, "but I gave it my best and enjoyed the work very much." ∽

BARBARA EWING

DRACULA HAS RISEN FROM THE GRAVE

'GUARDIAN OF THE ABYSS'

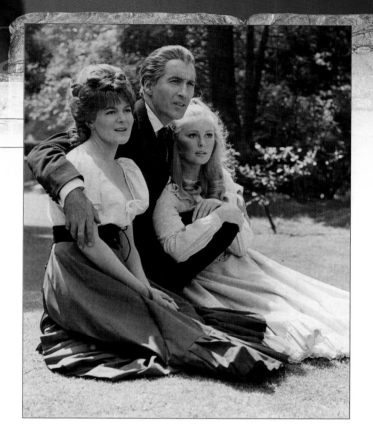

IN *Dracula Has Risen From the Grave* Barbara Ewing played Zena, a feisty waitress at the Café Johann. One night the sexually frustrated Zena trudges home through a forest but is pursued and ultimately ensnared by Count Dracula. Thereafter she is humiliated and sidelined by the vampire before meeting a pathetic end, befanged but essentially toothless in comparison to her former self.

Barbara's touching performance is all the more impressive in light of the fact that *Dracula Has Risen From the Grave* was only her second film. She was born in Wellington, New Zealand, on 14 January 1944, and originally intended to become a social worker. She won a scholarship to Wellington College and obtained a degree in English.

Barbara went on to work chiefly among the Maori people, learning to speak the language fluently and even recording an album called *Maori Songs I Love*. In 1962 she was awarded a scholarship to study at RADA in England and, in 1965, won the Gold Medal award for the most promising student. She intended to return to New Zealand after graduating from RADA, but delayed the move when agents and producers started offering her work.

Barbara had toured with several repertory companies, appeared alongside Donald Wolfit and joined the Royal Shakespeare Company by the time director Freddie Francis cast her in her first film. In the portmanteau horror *Torture Garden* (1966) she mustered a certain dignity in the thankless role of a woman murdered by a grand piano.

Francis was so impressed with Barbara that he offered her a role in his next movie, Hammer's *Dracula Has Risen From the Grave*, which began shooting in April 1968. By this time Barbara had gained experience on television, but was unprepared for the Hammer publicity machine. "I remember them saying to me, 'Bring along your starlet's kit and we'll do some photographs.' Well I didn't have any starlet's kit – this was the '60s, so all I had were mini-dresses and things like that. I remember the photographer – some very old guy who'd obviously been taking these shots for years and years – saying to me, 'Now lick your lips and blow a kiss to the camera.' And I simply burst into tears! I was just hopeless at all that."

Barbara made the best of her role as an astrology-obsessed antiques dealer in 'Guardian of the Abyss' (1980), one of the most Gothic episodes of the anthology series *Hammer House of Horror*. Three years later she achieved her greatest success on television, playing the fearsome Agnes Fairchild in the sitcom *Brass*. By this time she felt television had typecast her as a "dour, sexually repressed Northern matron" and she gleefully sent herself up in the series, boosting her cleavage with a "little bosom trick" she had learned at Hammer.

Barbara's first novel, *Strangers*, was published in 1978. She resumed writing in 1997, and *The Mesmerist*, published in 2007, is her sixth novel to date. Barbara has been delaying the decision to return to New Zealand since 1965. Her success as a writer makes it likely she'll be staying in England for a while longer. ∞

Opposite: The publicity shot that made Barbara cry. **Above and below:** At Pinewood with *Dracula Has Risen From the Grave* co-stars Christopher Lee and Veronica Carlson.

SUZAN FARMER

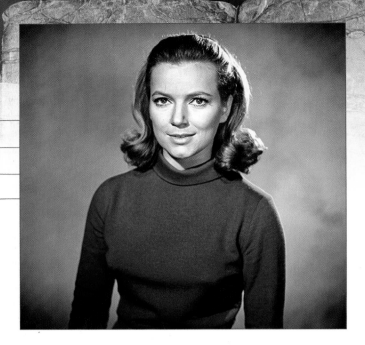

SUZAN Farmer was an attractive addition to four of Hammer's films, albeit in underwritten roles. Born in Tonbridge, Kent, on 16 June 1942, Suzan (she was christened with the 'z') left school at 15 to become an actress. She understudied Julia Lockwood as Wendy in the 1957 Scala Theatre production of *Peter Pan,* and enrolled at the Central School of Speech and Drama in 1959. By this time she was frequently being asked to play children in television serials. "Even then I could pass as a child of nine," she recalls.

In 1962 she was cast as a beauty queen in *The Wild and the Willing*, an unconvincing drama about university life. The film is chiefly notable for featuring the screen debuts of John Hurt and Ian McShane, the latter of whom Suzan would go on to marry in 1965. "He's a very good actor," she enthused shortly after their wedding. "He's absolutely genuine and he's an even better cook than I am." The couple settled in a flat in St John's Wood, London, but the marriage lasted just two years.

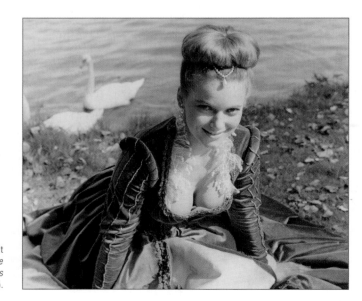

Right: Gravel-pit glamour in *The Devil-Ship Pirates* (1964).

Suzan's first Hammer film was *The Scarlet Blade*, an English Civil War drama shot at Bray Studios in March 1963. Director John Gilling had previously cast her as a kidnap victim in the second episode of *The Saint* the year before. Later in the year Suzan was asked to appear in *The Devil-Ship Pirates*, another costume adventure filmed at Bray.

Suzan had posed in a basque and fishnets to promote *The Scarlet Blade*, even though the film was a U certificate picture. For *The Devil-Ship Pirates* photographer Tom Edwards again exploited her glamorous appeal with a photo session by the decidedly unglamorous gravel-pit Hammer were using to float their prop pirate ship, the *Diablo*. The typically bra-busting pictures were endorsed by publicist Dennison Thornton, whose press release gave prominence to Suzan's vital statistics: 36-22-35.

While competently produced, neither *The Scarlet Blade* nor *The Devil-Ship Pirates* are the best examples of Hammer's matinée swashbucklers. There was rather better on offer when, in 1965, American International cast her in *Monster of Terror*. As Susan Witley, the daughter of a wheelchair-bound scientist played by Boris Karloff, Suzan claimed to be "thrilled to bits with the size and scope of the part." She received the billing 'introducing Suzan Farmer' but was quick to disparage some of her earlier roles. "I'm not just another silly heroine who gets in the way!"

Suzan returned to Bray in the summer of 1965, contracted to appear in two back-to-back productions: *Dracula Prince of Darkness* and *Rasputin the Mad Monk*. The scripts of both films would bring her dangerously close to the silly heroines she clearly resented playing. *Dracula Prince of Darkness* would at least offer her character, Diana, the occasional feisty moment; she is strangely eager to meet the owner of the abandoned Castle Dracula, and

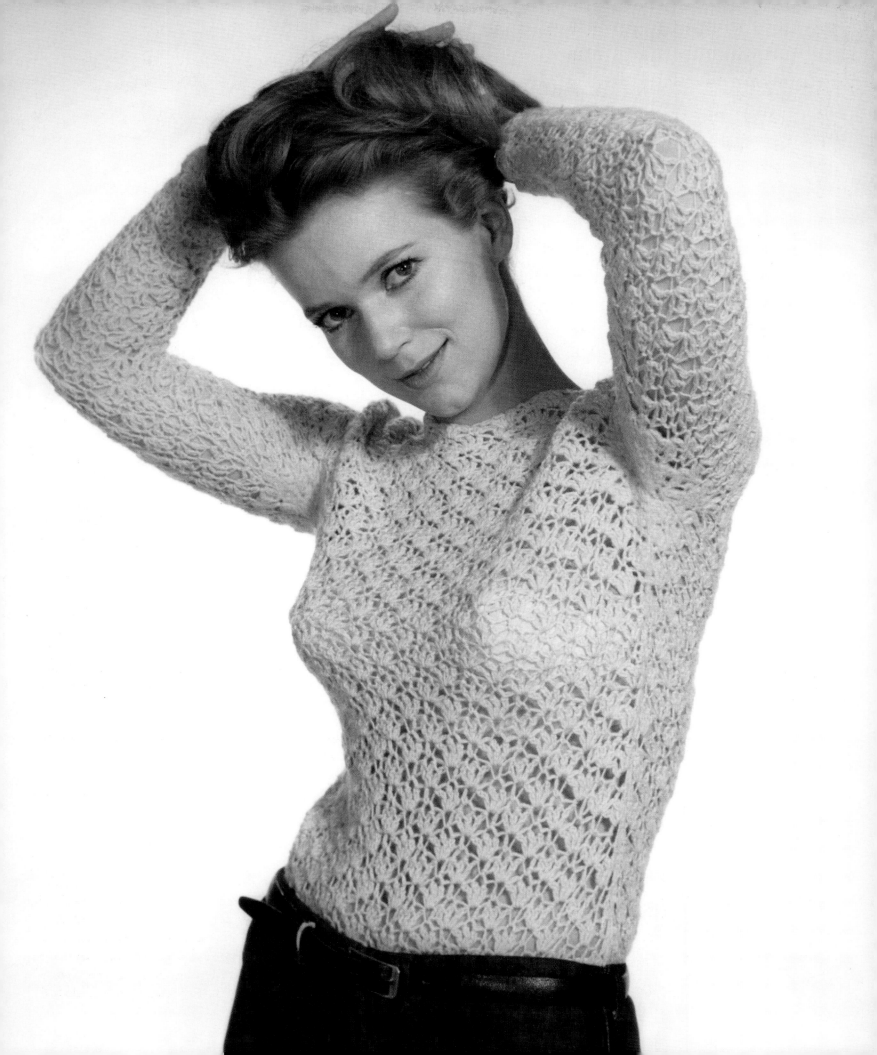

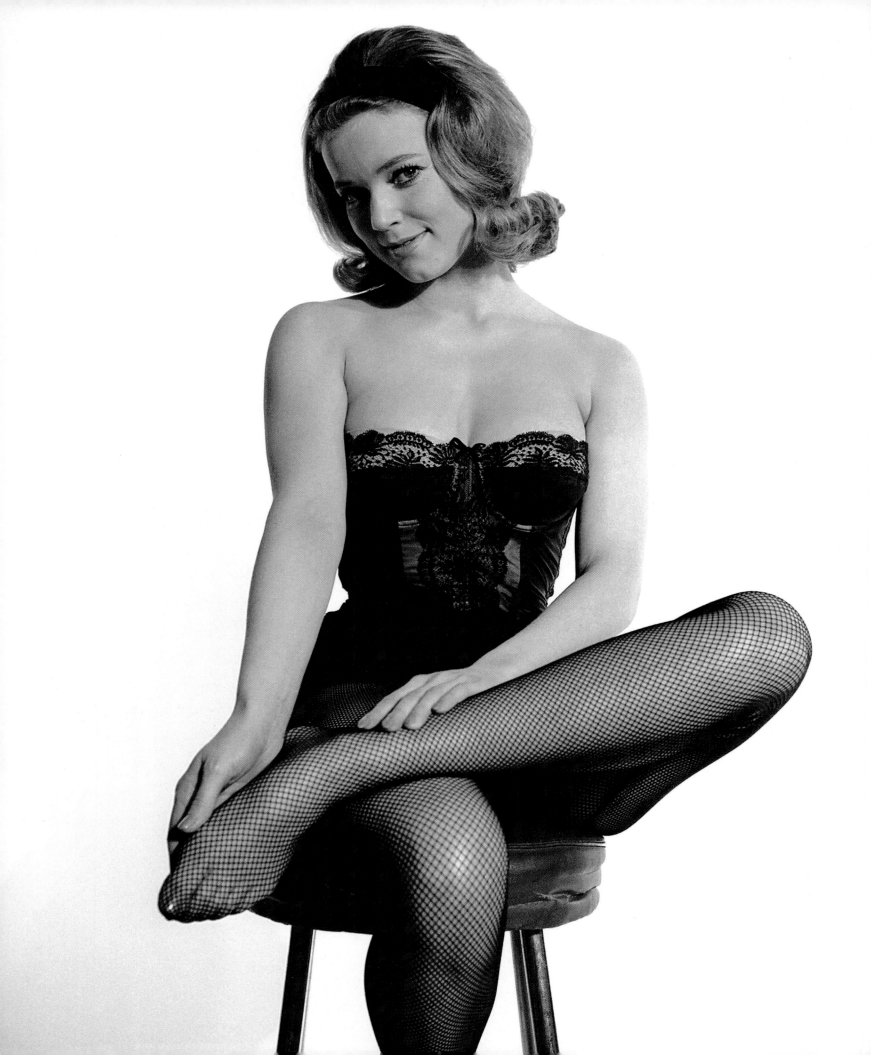

expertly fires the first shot that leads to the Count's demise.

Suzan's final Hammer film, *Rasputin the Mad Monk*, sadly gave her rather less to do. She was cast as Vanessa, lady-in-waiting to the Tsarina and the sexual bait in her brother's plot to ensnare Rasputin. Situations that offered tantalising dramatic potential were not explored by a script that rendered her character frustratingly tangential.

Television work dominated Suzan's career in the late 1960s. She made three further appearances in *The Saint*, and later guested in such 1970s favourites as *UFO*, *The Persuaders!* and *The Lotus Eaters*. Her last film was the suspense thriller *Persecution*, produced by Hammer rival Tyburn and released in 1975. The final years of Suzan's career included a short stint in *Coronation Street* and a strangely haunting performance in the 1978 *Blake's 7* episode 'Deliverance'.

Despite having made four films for Hammer, Suzan Farmer wasn't lucky enough to have been given any distinguished roles by the company. She can, however, boast of an unforgettable confrontation with Christopher Lee in *Dracula Prince of Darkness*.

Towards the end of the film Suzan's character Diana is cornered by Dracula in a scene directly inspired by Bram Stoker's novel. The vampire silently compels her to discard her crucifix and then unbuttons his shirt to reveal his bare chest. Scoring his skin with a fingernail Dracula then draws Diana towards the bleeding wound, forcing her shoulders down as she draws nearer, unable to resist. The sexual connotations of this perverse bonding ceremony are clear, and made all the more disturbing by Diana's inability to resist.

The British Board of Film Censors intervened at script stage, forbidding the inclusion of the climax where Diana would have lapped Dracula's chest wound and emerged, her face "dripping with the blood of the vampire". But even without this scene, which the BBFC described as "sadistic and quite disgusting", Christopher Lee and Suzan Farmer created an atmosphere of palpable dread and one of the most powerful moments in any Hammer horror. ∽

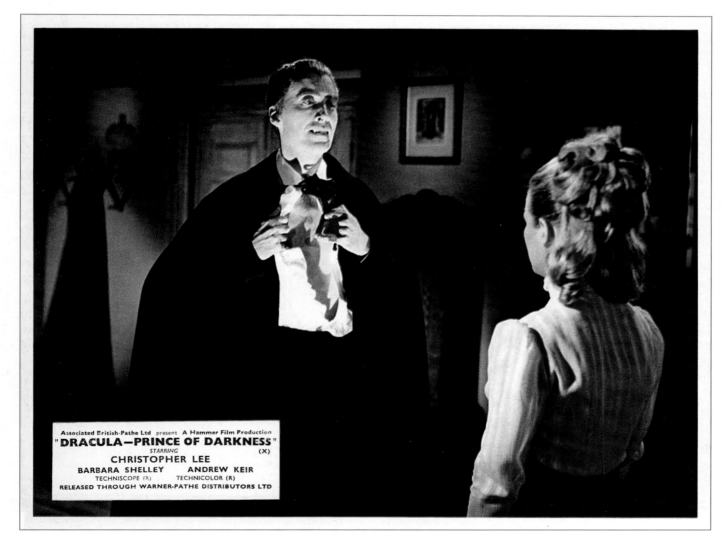

Associated British-Pathe Ltd present A Hammer Film Production
"DRACULA—PRINCE OF DARKNESS"
STARRING (X)
CHRISTOPHER LEE
BARBARA SHELLEY ANDREW KEIR
TECHNISCOPE (R) TECHNICOLOR (R)
RELEASED THROUGH WARNER-PATHE DISTRIBUTORS LTD

Opposite: A saucy publicity shot for the U certificate swashbuckler *The Scarlet Blade* (1963).
Left: X certificate blood lust with Christopher Lee in *Dracula Prince of Darkness* (1966).

SHIRLEY ANNE FIELD

THE DAMNED

SHIRLEY Broomfield was born in London's East End on 27 June 1938, but was evacuated during the Blitz and subsequently grew up in a children's home in Bolton, Lancashire.

Determined to follow her childhood ambition to become an actress, Shirley Anne first shortened her surname because "I didn't want Broomfield up in lights – my family had rejected me." She had lead roles in *Horrors of the Black Museum* and cult favourite *Beat Girl* (both 1959), but most of her films left her frustrated. "I was what you called 'the special girl' in movies, which meant you never got to do anything special," she says. "You just had to look good, and if you were lucky, you got one line."

She was on the verge of quitting when director Tony Richardson offered her a role in *The Entertainer* (1960). The film was still in production when he asked her to appear in *Saturday Night and Sunday Morning*, which he was about to produce. The role of Doreen, Brummie girlfriend of Arthur Seaton (Albert Finney), would prove to be the most important of Shirley Anne's career.

As the new darling of Britain's kitchen sink movement, Shirley was not typical of the actresses cast in Hammer films in 1961. *The Damned*, however, was not typical of Hammer films. Its nihilistic storyline challenged the rigid morality of the Gothic horrors, and Joseph Losey's uncompromising direction represented the company's final major bid for credibility.

Hammer cast Shirley Anne as Joan, the free-spirited sister of brutal Teddy Boy King (Oliver Reed). The scenes requiring Shirley to wiggle her bottom in a tight-fitting pair of Capri pants must have reminded her of her days as 'the special girl', but she is vulnerable and sympathetic when appealing to Simon Wells (Macdonald Carey) for sanctuary, and suitably forceful when confronting her psychopathic brother. A compassionate

Opposite: The Damned's Shirley Anne Field on location in Weymouth and (top) in the studio at Bray.

voice in what Bernard (Alexander Knox) calls "the age of senseless violence", Joan's growing awareness makes her one of the most tragic of all the film's characters.

In July 1967 Shirley Anne married Charles Crichton-Stuart and they had a daughter, Nicola, soon after. The couple divorced in 1975, by which time Shirley Anne's film career had seemingly petered out. "I just never seemed to be offered any parts, and I made the mistake of not creating my own," she said in 1985. "Maybe some people thought I was a rich film actress who didn't want to work; but I had a daughter to bring up, and I got on with that."

Her perseverance paid off when Stephen Frears cast her in *My Beautiful Laundrette* (1985), one of the most important British films of the decade. Her appearance in the similarly acclaimed *Hear My Song*, filmed in 1991, added another homegrown classic to her distinguished CV.

Now mainly working in television, Shirley Anne has devised the auto-biographical one-woman stage shows *Staying Aglow* and *Reflections: A Life in Pictures*. And she knows exactly the sort of movie she now wants to appear in. "I loved *Mamma Mia!* And the fact it appealed to that market over 40," she says. "That's the kind of joyful film I'd like to make." ∞

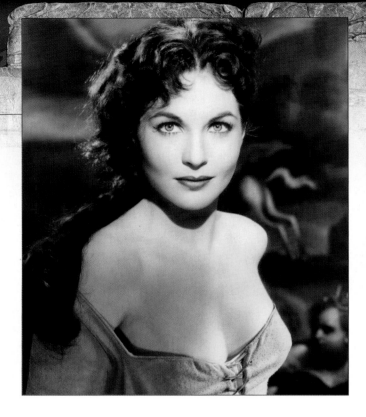

YVONNE Furneaux was born Yvonne Scarcherd in Lille, France, on 11 May 1928. Although she was approaching her 31st birthday when she started filming *The Mummy*, Hammer's press releases claimed she was actually 28. Yvonne was educated at Oxford University where she gained a degree in French. After graduating she attended RADA, winning a scholarship in her first term. Early highlights of her film career included *The Beggar's Opera* (1953), in which Laurence Olivier personally chose her to play the flamboyant Jenny, and Antonioni's *Le Amiche* (*The Girlfriends*, 1955), one of numerous films she made in Italy.

Although Yvonne was French she lived in Middle Temple, London, with her parents. Publicity for *The Mummy* claimed she was a big horror fan who read Edgar Allan Poe and had enjoyed *The Curse of Frankenstein* and *Dracula*. While this may have been true, Yvonne was initially reluctant to appear in *The Mummy*. She considered the film cheap and frivolous, and felt that the dual characters of Isobel and her ancient lookalike Princess Ananka were too passive to be interesting. Her attitude towards the project changed when filming began, and she was deeply impressed by the dedication and sincerity of the film's stars, Peter Cushing and Christopher Lee.

Cushing played Isobel's husband John Banning and greatly enjoyed Yvonne's company on set. As a good-natured tease he tore the lid off a box of tissues called 'For Men' and surreptitiously

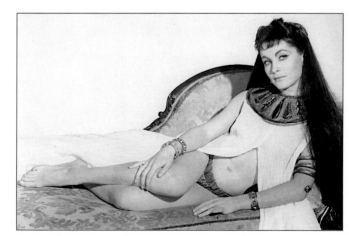

Opposite: It's for you – Yvonne answers the call for a late '50s glamour shot.
Right: Posing in Egyptian costume for *The Mummy* (1959).

attached the piece of cardboard to her back. It remained there for a whole day before she realised.

Christopher Lee's scenes with Yvonne included an arduous yomp carrying her "87 paces through a swamp at night, three times, with my arms fully extended because these lovelies were unable to wrap their arms around my neck, having fainted from the horror of being within my embrace." Lee still winces at the memory of the shoulder injury he sustained as a result.

Shortly after *The Mummy* Yvonne returned to Rome to star in the classic *La dolce vita* for Federico Fellini. He was apparently dismayed to discover she had just made a Hammer horror.

Her next brush with greatness came in 1964 when Roman Polanski cast her as the guest star in his first British feature, *Repulsion*. Her character Helen is prominent in the early part of the film until she goes on holiday with her married lover (Ian Hendry), unwisely leaving her flat in the hands of her paranoid sister Carol (Catherine Deneuve). The scene in which the disgusted Carol listens to her sister's lovemaking through the wall is a clue to the ensuing madness, and earned Yvonne a special distinction: she became the first woman in a mainstream film to be heard experiencing an orgasm.

Her film career was virtually over by the late 1960s, but Yvonne made an ill-advised comeback in the title role of the 1984 comedy *Frankenstein's Great Aunt Tillie*. The casting of Donald Pleasence as the Baron couldn't save the film, which brought her career to an ignoble end. ∽

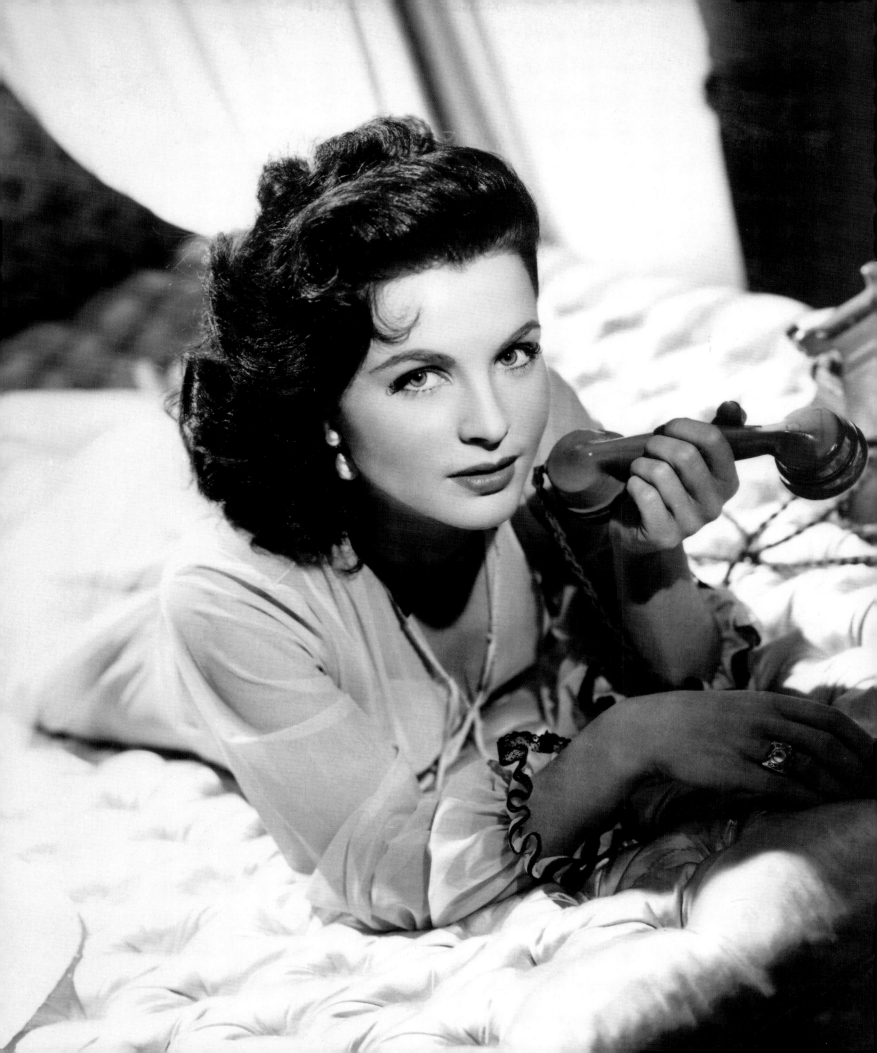

VALERIE GAUNT

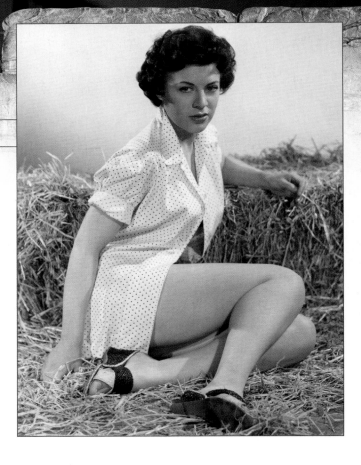

Opposite: Justine (Valerie Gaunt) nervously approaches the Baron's laboratory in *The Curse of Frankenstein* (1957). **Right:** A publicity shot from *The Curse of Frankenstein* and (below) *Dracula* (1958).

THE mysterious Valerie Gaunt was the wicked woman of Hammer's seminal Gothic dramas. Valerie's scenes in *The Curse of Frankenstein* and *Dracula* are the most erotically charged encounters in both films, and as such are representative of the way Hammer pushed the boundaries of sex, as well as horror, in the late 1950s.

In *The Curse of Frankenstein* Valerie played Justine, the maid, as a barely restrained sexpot who seizes the opportunity for an illicit clinch with Baron Frankenstein (Peter Cushing). Justine's accent makes her sound as though she's graduated from the Paris branch of the Rank Charm School, but there's nothing ladylike about the rage she unleashes when she discovers that the Baron intends to marry his cousin, Elizabeth (Hazel Court). She threatens to kill him if they go ahead, and reveals that she is pregnant. When the Baron casually spurns her she threatens to tell Elizabeth about their affair, and all about "what goes on up there in that laboratory of yours".

Later, Justine seeks out the proof she needs to blackmail her lover. She explores his laboratory but is soon cornered by the Creature. She lets out a piercing scream as he advances on her. On the other side of the laboratory's now locked door, the Baron half smiles with cruel satisfaction.

Valerie's scenes as the 'vampire woman' in *Dracula* are relatively brief, but she plays this scheming vixen to even greater effect. The vampire woman first appears looming over Jonathan Harker (John Van Eyssen) in Castle Dracula. She pleads with Harker to help her escape, but as soon as she gains his trust she bares her fangs and sinks them into his neck. Dracula (Christopher Lee) pulls her away and hurls her to the ground.

Valerie's performance in the next scene shows remarkable ferocity, as she licks the fresh blood from her lips and launches herself at Harker again like a rabid animal.

The following day, Harker finds her dormant in her coffin. As he drives a stake through her heart she ultimately reverts to an aged vampire crone.

And with this, Valerie Gaunt's film career came to an end. Very little is known about her, although it has been established that she was born in Birmingham in June 1932 and trained at RADA. She spent several years in repertory theatre and in September 1956 appeared in the *ITV Television Playhouse* drama *Chance Meeting*. The programme was seen by Anthony Hinds, who invited her to Bray to begin work on *The Curse of Frankenstein* less than two months later. This and *Dracula* seem to be the only films she ever made.

Subsequently married with four children, she is aware of the interest in her Hammer roles but prefers to remain enigmatic. Her empowered characters speak for themselves, precursors of the predatory villainesses that would help to define Hammer horror. ∞

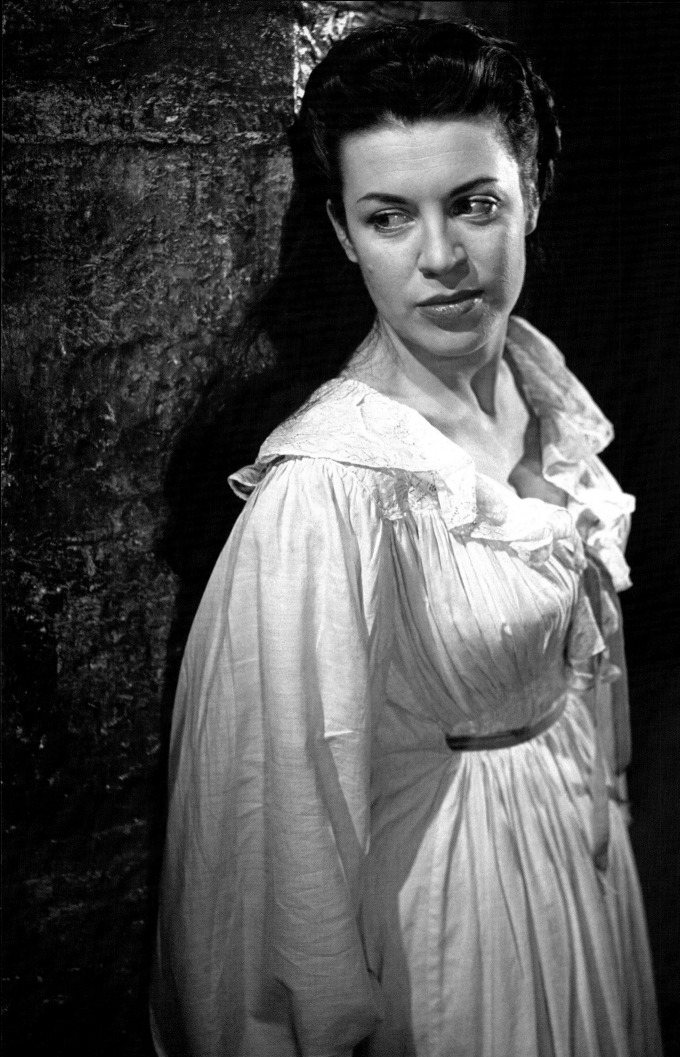

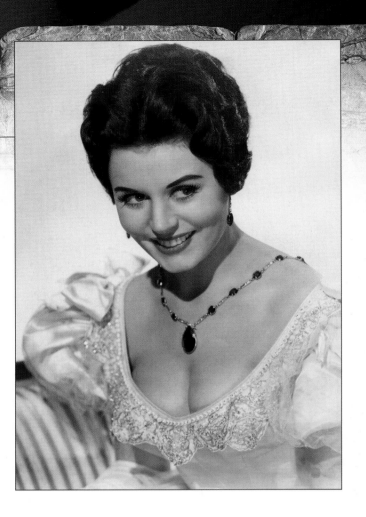

THE daughter of a lawyer, Eunice Sargaison was born in Purley, Surrey, on 17 March 1931. A showbusiness 'it' girl of the 1950s, she became something of a reality television pioneer when, in August 1953, four million Americans saw her marry scriptwriter Leigh Vance on the live programme *Bride and Groom*. The show was sponsored by a cake mix manufacturer, and the happy couple's incentives included £700 worth of gifts, including their rings.

Back in England she was under contract to the Rank Organisation, but became frustrated when years passed without them offering her any roles. In March 1956 she invited Fleet Street photographers to witness her angrily tearing up her contract. "I'd rather fire myself than wait around until I'm forgotten by the film industry," she said.

Later that year she became the hostess of ITV's variety show *Palais Party*, and at the end of 1957 she was approached by Hammer to co-star in *The Revenge of Frankenstein*. Eunice was cast as do-gooder Margaret Conrad, who arrives at the Baron's poor hospital looking like she smells of the soap she's so keen to hand out to the patients. Jimmy Sangster's script gives her very little to do except befriend and release Frankenstein's latest experiment, the pitiful Karl (Michael Gwynn).

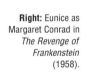

Right: Eunice as Margaret Conrad in *The Revenge of Frankenstein* (1958).

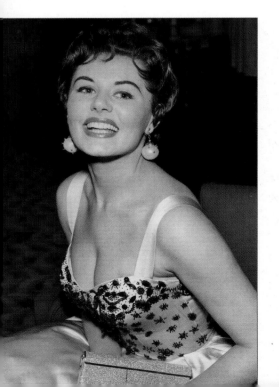

The Revenge of Frankenstein was a considerable hit, but Eunice didn't make another picture until early 1962. In her first scene in *Dr. No* she purses her lips and challenges a handsome stranger to a game of chemin de fer. He tells her his name is "Bond, James Bond" and cinema history is made.

Eunice's character, Sylvia Trench, reappears dressed in Bond's pyjama top and ushers in a new era of casual, consequence-free sex when she becomes the very first of 007's conquests. Although intended to be Bond's regular girlfriend, Sylvia was dropped after the second film in the series, *From Russia With Love*.

Hammer had kept Eunice's endearing, slightly squeaky voice, but the Bond producers dubbed her with the ubiquitous Monica van der Zyl. Audiences in London's Palace Theatre got to hear the real Eunice when she joined the original West End cast of *The Sound of Music* in 1961. She played the haughty Baroness for five years.

In 1969 Eunice married actor and photographer Brian Jackson and gave birth to a daughter, Kate, the following year. When Jackson left her shortly afterwards she struggled with the cost of raising her daughter alone. In October 1974 she was arrested for shoplifting 13 bottles of shoe colouring from the Farnham branch of Woolworth's. She told the police it was "a cry for help", and admitted she had had just four weeks' work in the last three years.

Eunice picked herself up, and happily came out of retirement in 1990 when she was cast as Little Red Riding Hood's grandmother in the Phoenix Theatre's production of *Into the Woods*. In recent years she has performed a one-woman show, *Fried Ants in the Kasbah*.

She now divides her time between England and Spain, occasionally making appearances at James Bond fan events. "I don't feel any frustration," she says, "and I don't long for the past." ∽

JUDY GEESON

JUDY Geeson swept to fame in a handful of roles that briefly defined her as a figurehead for the permissive society. For many years her private life and career were subjected to intense scrutiny by a tabloid press that confused this accomplished actress with some of the roles she played.

Judith Amanda Geeson was born in Arundel, Sussex, on 10 September 1948. She came to prominence in 1967 as the schoolgirl with a crush on Sidney Poitier in *To Sir, With Love* and then appeared in *Here We Go Round the Mulberry Bush*, meeting her co-star and future boyfriend Barry Evans during the filming of the scene in which they share a bath.

Television and film roles followed in quick succession, and in 1969 Peter Hall cast her as a wanton marriage-breaker in the controversial *Three Into Two Won't Go*. Her character's immorality, and her nude scene in particular, brought Judy a lasting notoriety.

In 1971 she appeared opposite Richard Attenborough in the harrowing *10 Rillington Place*, and at the end of the year was top-billed in *Fear in the Night*. In the film's press book Judy described the influence of Buddhism in her life, and her devotion to a macrobiotic diet that would have bewildered many actresses of the previous generation. "You feel so well and lively on just the brown rice and organically grown vegetables and fruit, that the thought of eating meat at all is pretty sickening," she said. "I couldn't be a Hammer vampire with my present views on food."

While her sister, Sally, starred as Sid James's daughter in the popular sitcom *Bless This House*, Judy continued to balance theatre, film and television work. She was never as 'hot' as she had been in the late 1960s, but she was content in her relationship with set designer Sean Kenny, whom she met in 1971. Tragically, Kenny died of a stroke in 1973 and Judy admitted it took years to recover from the loss.

In 1984 she moved to the United States and the following year married American actor-director Kristoffer Tabori after a whirlwind romance. They were together for just 18 months and their subsequent divorce involved a lengthy and expensive legal wrangle over the house they had shared. Journalists depicted the decline of Judy's marriage and career as a sudden reversal of fortune, with one early '90s report revealing that she had been "reduced to" working as a nanny and a shop assistant.

Judy still lives in Los Angeles, where she runs the Beverly Hills antique shop Blanche and Co and continues to act on stage and in television. She has ambitions to develop a new career as a writer. "I am a fatalist. I believe that everything that happens to us happens for a reason," she said in 1992, sounding exactly like the 23-year-old that espoused the virtues of New Age living during the making of *Fear in the Night*. "After years in the spotlight it's difficult to explain what it's like to suddenly have freedom and to realise there are other things in life than just acting." ∞

Above: Judy pictured during the filming of *Fear in the Night* with her pets Tara the dog and Benjamin the cockatoo.

JENNY HANLEY

SCARS of Dracula was released in October 1970 and must have been a sobering experience for anyone who remembered the lovingly crafted films from Hammer's heyday. There are, however, compensations for the flat-pack sets and phoney painted backdrops. Christopher Lee's Count lends a melancholy dignity to the proceedings and Jenny Hanley's Sarah is a winsome victim who unwittingly helps to introduce a more explicit era in the company's films.

Jenny was born in Gerrards Cross, Buckinghamshire, on 15 August 1947. She was the daughter of actress Dinah Sheridan and actor Jimmy Hanley, the latter a veteran of Hammer films *Room to Let* (1950) and *The Lost Continent* (1968). As a child, Jenny remembers being "fat, with specs, braces and moles on my face". When her mother overheard someone say it was a pity such a beautiful woman had such a plain daughter she enrolled Jenny on a course at a modelling school.

Jenny's brother Jeremy had ambitions to became an actor (he instead became chairman of the Conservative Party) while Jenny trained to be a nanny. Her modelling, however, led to a contract from the James Bond producer Harry Saltzman and she was cast as one of Blofeld's Angels of Death in *On Her Majesty's Secret Service* (1969).

Opposite: Sarah (Jenny Hanley) witnesses the fiery demise of the Count in *Scars of Dracula* (1970).

In the months that followed Saltzman couldn't find any further roles for her and Jenny was released from her contract in order to appear in *Scars of Dracula*. She spent three weeks of the film's schedule at Elstree, where the wardrobe and make-up departments accentuated her character's vulnerability by teasing her hair into ringlets and applying huge false lashes to her wide, fluttering eyes.

Towards the end of the film Dracula confronts Sarah on the roof of his castle but she remains protected by the crucifix hanging from a chain around her neck. The Count's pet bat swoops down to tear the crucifix away, and it leaves her chest smeared with blood. The subsequent lingering close-up of Sarah's crimson-splattered cleavage is one of the most depressing shots in any of Hammer's early '70s films, a cynical combination of sex and horror that probably would never have been passed by the BBFC before July 1970, when the age restriction for X certificate films was raised from 16 to 18.

After *Scars of Dracula* Jenny was given a lead role in *The Flesh and Blood Show* (1972) and in 1974 became one of the presenters of the twice-weekly children's series *Magpie*. She stayed with the programme until 1980, when it was finally seen off by its strait-laced rival *Blue Peter*.

Jenny started a family in the 1980s but returned to television in the '90s as a regular guest in the 'Dictionary Corner' of game show *Countdown*. She has subsequently become a prolific voiceover artist (ironically, given that Hammer replaced her voice in *Scars*) and a regular presenter for the Saga and BBC Berkshire radio stations. Despite her frustration at having been dubbed, she looks back on her brief time at Hammer with fondness.

"People in the profession used to say that you hadn't finished acting school until you had done your Hammer horror," she says. "I did, and I loved it." ∞

LINDA HAYDEN

TASTE THE BLOOD OF DRACULA

'BLACK CARRION'

HAMMER'S most celebrated ingénue, Linda Hayden starred in some of the best, and some of the very worst, exploitation films of the 1960s and '70s.

Linda Mary Higginson was born in Stanmore, Middlesex, on 19 January 1953. Her wealthy parents sent her to elocution lessons before she joined the Aida Foster Stage School at the age of 13. She made her film debut just two years later, playing a Lolita-style nymphet in the controversial *Baby Love* (1968).

In an interview to publicise the movie in *Photoplay* magazine, Linda explained that "young kids like myself have something going for us that the Rank starlets did not have in their day – at least in their films. We have sex and permissiveness in films now, and we can act in a way that they were never allowed to do. But for me, the sex and permissiveness stops with the acting. I am not like the girl in the film in real life."

Linda continued her studies at the Aida Foster school, declining numerous offers of parts in smutty films. In autumn 1969 she accepted a role in Hammer's *Taste the Blood of Dracula,* partly because it didn't involve having to take her clothes off.

Like *Baby Love, Taste the Blood* is a product of a morally confused era. This time, however, Hammer cast Linda in the role of the heroic innocent. Her character, Alice, escapes the drunken lechery of her violent father (Geoffrey Keen), only to find sanctuary in the embrace of Dracula (Christopher Lee). Alice gleefully murders her father with a spade, exacting her new master's revenge and symbolically triumphing over corrupt old fogeys everywhere.

When *Taste the Blood of Dracula* opened in May 1970 Linda was already working on another minor classic imbued with the increasingly cynical zeitgeist. Her entrancing performance in *Blood On Satan's Claw* is considered by many to be the highlight of her career, and she treasures the *New York Times* review that described her as "the sort of girl who, fully clothed, could have easily unhinged Salem."

As the British film industry declined, Linda was dragged along with it in a couple of the *Confessions* sex comedies, the similarly fruity *Let's Get Laid* (1977) and the staggering *Queen Kong* (1976). All co-starred her then boyfriend Robin Askwith. But in Linda's own estimate, her most regrettable credit is *Exposé* (1976), a sex shocker briefly branded a 'video nasty' in the early 1980s.

In 1984 Linda was once again the subject of controversy when details of her relationship with theatre producer Paul Elliott became public. The couple married in 1987 and Linda decreased her stage and television work to start a family.

Notable among her later roles is a brief and largely overlooked return to Hammer. In the mid-1980s she appeared in the 'Black Carrion' episode of anthology series *Hammer House of Mystery and Suspense*, inexplicably cast in a minor role confined to flashback sequences. As was so often the case, she deserved better. ∞

Below: Alice Hargood (Linda Hayden) is threatened by her lecherous father (Geoffrey Keen) in *Taste the Blood of Dracula* (1970).

TO THE DEVIL A DAUGHTER

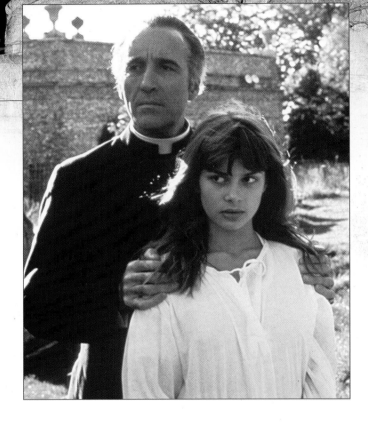

NASTASSJA Aglaia Naksyński was born in Berlin, Germany, on 24 January 1959. Her father was the notorious actor Klaus Kinski, one of the most reviled hedonists in German film history. As a child Nastassja had ambitions to be a doctor, but her father left home when she was eight, and by the time she was 12 she was providing care and financial support for her now fragile mother Ruth.

Nastassja was discovered by the wife of director Wim Wenders, who cast her as a deaf mute in *The Wrong Move* (1975). Shortly after the film's release Peter Sykes, the director of Hammer's *To the Devil a Daughter*, went to Germany to find an actress who would be acceptable to the ailing company's co-production partners Terra Filmkunst.

Sykes was impressed with *The Wrong Move*. He met Nastassja, and then raised what must have been the uncomfortable prospect of her estranged father also starring in *To the Devil a Daughter*. Fortunately for Nastassja this wasn't to be. "I met Klaus Kinski in a hotel and asked him if it was going to be secure in working with him from the point of view of insurance and drugs," recalled Sykes. "He was very honest and said, 'If it's more than ten days I can't guarantee you anything.'"

Leading man Richard Widmark remained aloof and critical

Top: Nastassja and Christopher Lee in a 1975 publicity shot from *To the Devil a Daughter*.
Right: A German lobby card from the film.

during the filming of *To the Devil a Daughter* in England, hoping to antagonise Nastassja into a more heartfelt rejection of his character's efforts to rescue her from Satanists. "He was hard, but never unfair," said Nastassja in November 1975. "Sometimes he shouted at me, but I never took it personally. He taught me a lot."

Most controversially, the film's muted climax included a dream sequence in which Nastassja's character Catherine was seen entirely naked. This was just one of the early films in Nastassja's career where she feels regrettable decisions were taken on her behalf. "If I had had somebody to protect me or if I had felt more secure about myself, I would not have accepted certain things. Nudity things," she told Louise Farr in 1997. "Inside it was just tearing me apart."

In 1976, the year *To the Devil a Daughter* was released, Nastassja was sentenced to three months in a juvenile prison for shoplifting, stealing trinkets that she hoped would make her mother happy again. Soon afterwards she began a relationship with director Roman Polanski, for whom she would give the outstanding performance of her career in *Tess* (1979). Other notable films included the erotically charged *Cat People* (1982) and *Paris, Texas* (1984), the film that reunited her with Wim Wenders.

From 1984 to 1992 she was married to Egyptian filmmaker Ibrahim Moussa, and she subsequently lived with producer and composer Quincy Jones. Following the birth of her two children, Aljosha and Sonja, in the mid-1980s she stepped back from her career to concentrate on their upbringing. ∞

MARLA LANDI

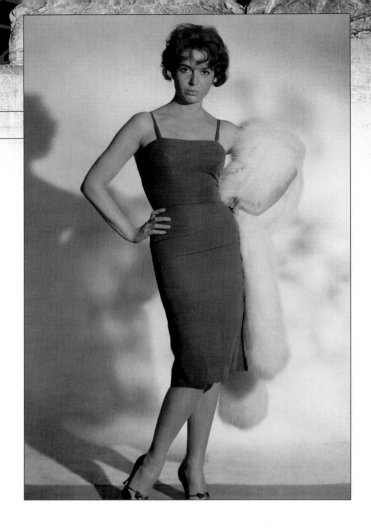

Opposite and top: Publicity shots from *The Hound of the Baskervilles* (1959). **Below:** Filming *The Pirates of Blood River* in 1961 with co-star Glenn Corbett and producer Anthony Nelson Keys.

MARLA Scarafia was born in Turin, Italy, in 1933. She attended university in Turin, but her studies were interrupted by frequent offers of modelling work. A Continental beauty with the poise and elegance favoured by 1950s couture houses, Marla appeared in *Vogue*, *Tatler* and numerous other European magazines, soon earning a reputation as Princess Margaret's favourite model. Small roles in films and television inevitably followed in the mid-1950s, and she changed her name to differentiate her new career from her modelling. "I decided on the name Landi because that name was not my own," she told the *Daily Express*. "I want to be a genuine success as an actress, not just a girl who got into films because her picture was often in the newspapers."

Marla's acting career received an unexpected boost in February 1957, when Rod Steiger recommended her for a part in the Graham Greene adaptation *Across the Bridge*. She replaced the troubled leading lady Barbara Bates and the film was released to considerable acclaim six months later.

In September 1958 Hammer began production of *The Hound of the Baskervilles* without having cast the key role of Cecile, the firebrand daughter of the villainous Stapleton. Peter Cushing and his wife Helen were watching *Across the Bridge* when Peter realised that Marla was ideal. He telephoned producer Anthony Hinds, who invited Marla to Bray Studios for an interview.

Marla makes a striking debut in *The Hound of the Baskervilles*, observing Watson while sitting casually astride a rock. She then hoists her skirts and skips away, leading him into the mire. Marla clearly understands the almost feral nature of the embittered Cecile, relishing the erotic encounters with Sir Henry (Christopher Lee) and taking a

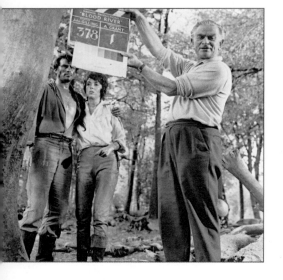

sadistic satisfaction from the hound's retribution. Hammer's Cecile is half-Spanish, but Marla's occasionally impenetrable Italian accent is something of a hindrance to the revelatory scenes at the end of the film.

Hammer didn't call on Marla again until summer 1961, when she was cast as Bess Standing in the successful swashbuckler *The Pirates of Blood River*. As in *The Hound of the Baskervilles* Marla spent a lot of time looking sullen, but this time her voice was dubbed. In the years following *The Pirates of Blood River* Marla secured several roles in British television, often cast as Spaniards or Italians. In 1964 she appeared in the BBC programme *Parliamo Italiano*, teaching viewers how to ask for directions in Italian. In 1968 her television career came to a close with an appearance in BBC 2's children's programme *Play School*.

Primarily a model and fashion journalist, more than an actress, Marla now regards her films with fondness. "I used to look at my own movies and then close my eyes because I would be absolutely horrified," she says. "Now I think, maybe I wasn't all that bad."

The widow of Sir Francis Dashwood, Marla lives on the family's West Wycombe estate. ∽

SUZANNA LEIGH

A part of the Swinging Sixties lives on in Suzanna Leigh, a vivacious blonde whose turbulent life story is more dramatic and absorbing than any of the parts Hammer gave her.

Suzanna Smith was born in Reading on 26 July 1946. The family moved to London's Belgravia but Suzanna's father, a professional gambler, died when she was six. Suzanna endured a fractious relationship with her mother, a millionaire property developer, and an unhappy schooling complicated by her dyslexia. Her father had told her she was Vivien Leigh's goddaughter, so at the age of 11 she visited Leigh to ask for advice on how to become an actress. Leigh had no memory of attending Suzanna's christening but said she didn't mind if she adopted her surname.

Suzanna grew restless at the Webber Douglas drama school, completing just two terms before embarking on a television career in London and Paris. She was given leading roles in the British films *Bomb in the High Street* (1961) and *The Pleasure Girls* (1965) before American producer Hall Wallis offered her a seven-year contract. Moving to Hollywood, she co-starred with Tony Curtis and Jerry Lewis in *Boeing Boeing* (1966) and with Elvis Presley in *Paradise, Hawaiian Style* (1966) before a ruling by the Screen Actors' Guild restricted her ability to work in the US.

Suzanna returned to London, where her recent successes in Hollywood helped her gain diverse roles in the BBC's *Wednesday Play* and the Bulldog Drummond thriller *Deadlier Than the Male* (1967). Her choices in horror films were all unfortunate, beginning with Freddie Francis' ridiculous *The Deadly Bees* (1967). She fared little better when Hammer offered her a role in *The Lost Continent*, a would-be epic based on a book that prolific author Dennis Wheatley confessed he couldn't even remember writing. Suzanna was cast as the over-sexed Unity Webster, one of the passengers of the doomed SS *Corta*. The ship is dragged across the Sargasso Sea to an inhospitable island, where the crew and passengers must contend with giant mutated creatures and the feuding descendants of scuppered galleons. In

Top: Sitting pretty – Suzanna in glamour shots for *The Lost Continent* (1968) and *Lust for a Vampire* (1971, opposite).

amongst the chaos Suzanna was enjoying herself in an extravaganza she now charitably describes as being like "an early *Jurassic Park*."

For her next Hammer assignment Suzanna swapped Borehamwood for a sun-drenched location shoot in Malta. 'One on an Island', an episode of Hammer's little-seen anthology series *Journey to the Unknown*, was essentially a two-hander between Suzanna and Brandon de Wilde (previously the child star of *Shane*). The scene where the dazed Vicki (Suzanna) walks out of the sea wearing a sequined evening dress is surely one of the most glamorous moments in any Hammer production.

During the 1960s Suzanna kept in close contact with James Carreras through their extensive charity work for the Variety Club. She called on Carreras in 1970 when a family dispute left her facing a crisis. "I found myself with no home and no money," she says, "so I phoned up Jimmy because I heard he was making a movie. He said, 'I don't think this is your sort of movie.' So I

Right and opposite:
More from Ronnie
Pilgrim's publicity
session for *The
Lost Continent*.
Below: On location
with *Lust for a
Vampire* in 1970.

said, 'Sure it is. I'll make it my sort of movie. What is it?' He told me it was called *To Love a Vampire*, and added that everything was cast. I told him this was an emergency, so he rearranged some of the casting and gave me the role of the gym mistress."

Suzanna didn't understand why Carreras had tried to dissuade her until she arrived at Elstree Studios. "During rehearsal I walked in to the dormitory set and all the girls had their clothes on, but when we went for a take I walked through the same door and suddenly everyone had taken their clothes off! I said to the director, Jimmy Sangster, 'I can't do this!' and he took me to one side and said, 'It's okay Suzanna. What we're doing here is the Swedish version. Unless you're intending to move to Sweden you'll never see it. No-one you know will ever see this version.' At the time there were a lot of Swedish-type films around so I went for it. Of course it was absolute nonsense, but it kept me on the set."

The press book for *Lust for a Vampire*, as the film was ultimately titled, described Suzanna as "rich and beautiful", with an extensive wardrobe that "includes five minks and a chinchilla". Reminders of such decadence now prompt laughter. "Nowadays I'd be lynched!" she says.

In 1972 Suzanna met stockbroker Tim Hue-Williams, who was to become her partner for the next ten years. In 1975 she wrote off a Rolls-Royce, briefly dying through loss of blood in the subsequent operation to save her life. There was further drama when Hue-Williams left her for a wealthy heiress. Suzanna was four months pregnant at the time. She spent much of the '80s and '90s fighting a legal battle with Hue-Williams over maintenance payments for their daughter Natalia. With her acting career over, Suzanna tried to launch an interior design business, re-mortgaging her Belgravia flat to turn it into a showpiece. She couldn't work her way out of debt, however, and was forced to sell the flat before filing for bankruptcy in 1987.

She took on a variety of jobs to provide for her daughter, including teaching etiquette at a library in Mayfair and selling the *Encyclopaedia Britannica* at Heathrow Airport. When times were hardest she relied on benefits to make ends meet.

In 2000 she published her autobiography *Paradise, Suzanna Style*, and three years later she and Natalia settled in Memphis. Together they run The Suzanna Leigh Experience, organising acting classes and events for the numerous Elvis fans that make the pilgrimage to Graceland.

Life's adversities have seemingly done little to dent Suzanna's optimism, and her only regret about her career is that she spent more time in Borehamwood than Hollywood. Despite this, she remains proud of her work with Hammer. "Some people used to ask me why I was making Hammer films, but I was happy to do them," she says, cheerfully. "I loved the intensity and the drama, and they were a force to be reckoned with." ∞

VALERIE LEON

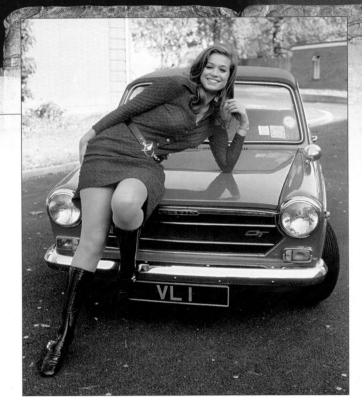

VALERIE Leon enjoys cult status three times over. She starred in a Hammer horror, appeared in seven Carry Ons and worked with both Roger Moore and Sean Connery in two James Bond movies. Among the prized possessions in her home is a framed poster from *Never Say Never Again*. It features a dedication from Connery that reads: "To Valerie, till the next time we get back into bed."

From 1969 to 1975, however, Valerie was probably best known for starring in a series of television commercials for Hai Karate, the aftershave that the voice-overs promised could "turn a usually docile woman into a ravenous creature". She later spoofed her maneater image by playing a whip-cracking dominatrix in *Revenge of the Pink Panther* (1978), earning the condemnation of Peter Sellers' Inspector Clouseau. "You two should be ashamed of yourselves," he says, addressing her barely restrained cleavage.

Valerie was born in London on 12 November 1945 and worked as an au pair in Paris before joining the staff of Harrods as a trainee fashion buyer. She played truant in summer 1965 to attend an audition for the touring musical *The Belle of New York*. "I guess I got the job because I looked pretty and I was head and shoulders

Right: Valerie shows off her car's personalised number plates in 1971.
Opposite: An assertive pose for glamour photographer Ben Jones.

taller than all the other chorus girls. So I left my respectable job to become an actress."

The following year she appeared in the West End production of *Funny Girl*, starring Barbra Streisand, and started combining stage work with a busy schedule of small roles in *The Saint*, *The Avengers* and other filmed television series. She made her mark in 1968's *Carry On Camping* as the shop assistant who famously shows Charles Hawtrey "how to stick the pole up". The following year she submitted to Hawtrey once again when she played the Amazonian Leda in *Carry On Up The Jungle*.

In late 1970 she auditioned for the dual role of Margaret/Tera in Hammer's *Blood From the Mummy's Tomb*. She had previously worked with the film's director Seth Holt when she doubled for Julie Newmar in the ill-fated *Monsieur Lecoq*. "Unfortunately it was never completed," says Valerie. "But it was on that film I met an actor called Peter Madden, and he told me to accentuate my best assets. I was so bloody naïve I didn't even know what he was talking about at first, but from then on I started wearing tight sweaters and displaying a cleavage."

This wasn't enough to convince Holt and Howard Brandy, the producer of *Blood From the Mummy's Tomb*, and they instead cast Shakespearian actress Amy Grant. They were soon over-ruled by Sir James Carreras, who had been impressed with Valerie after meeting her at several Variety Club events. Carreras was unconcerned about Valerie's relative inexperience and insisted she should be the film's star.

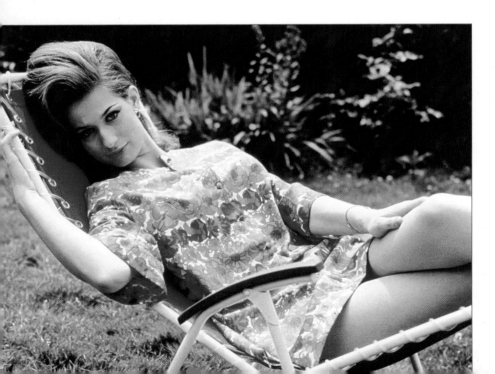

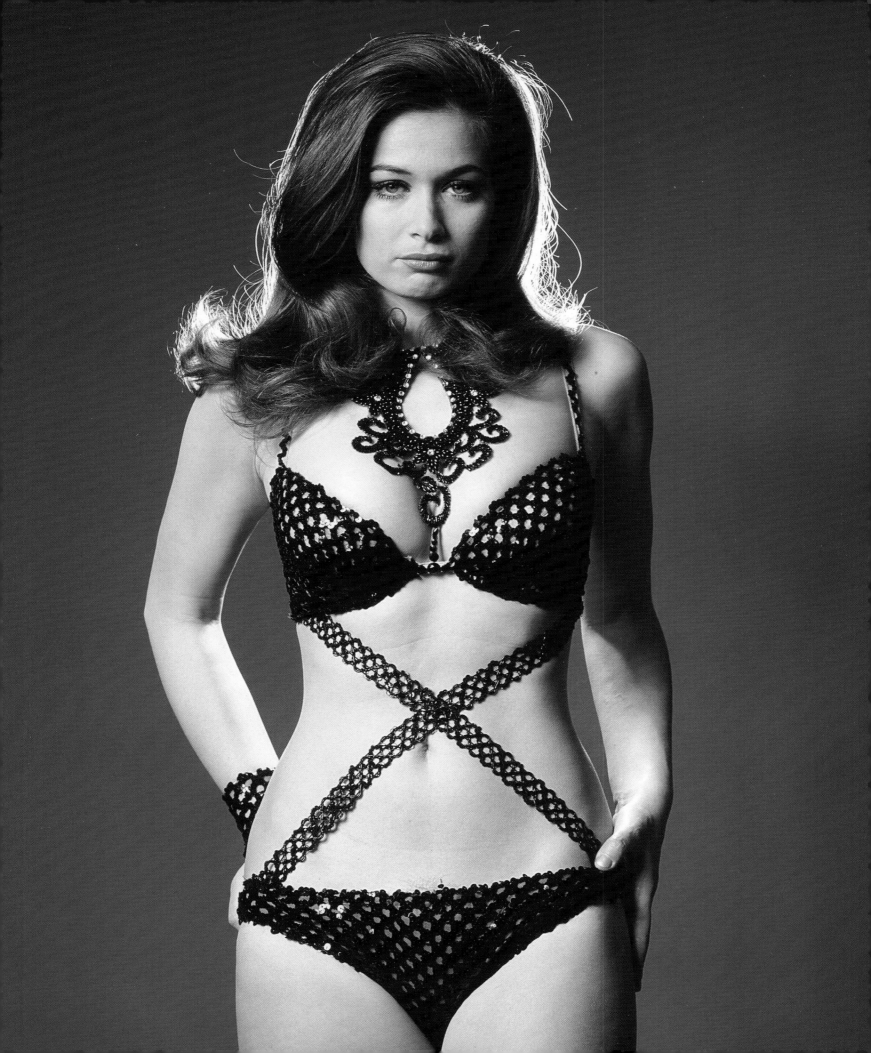

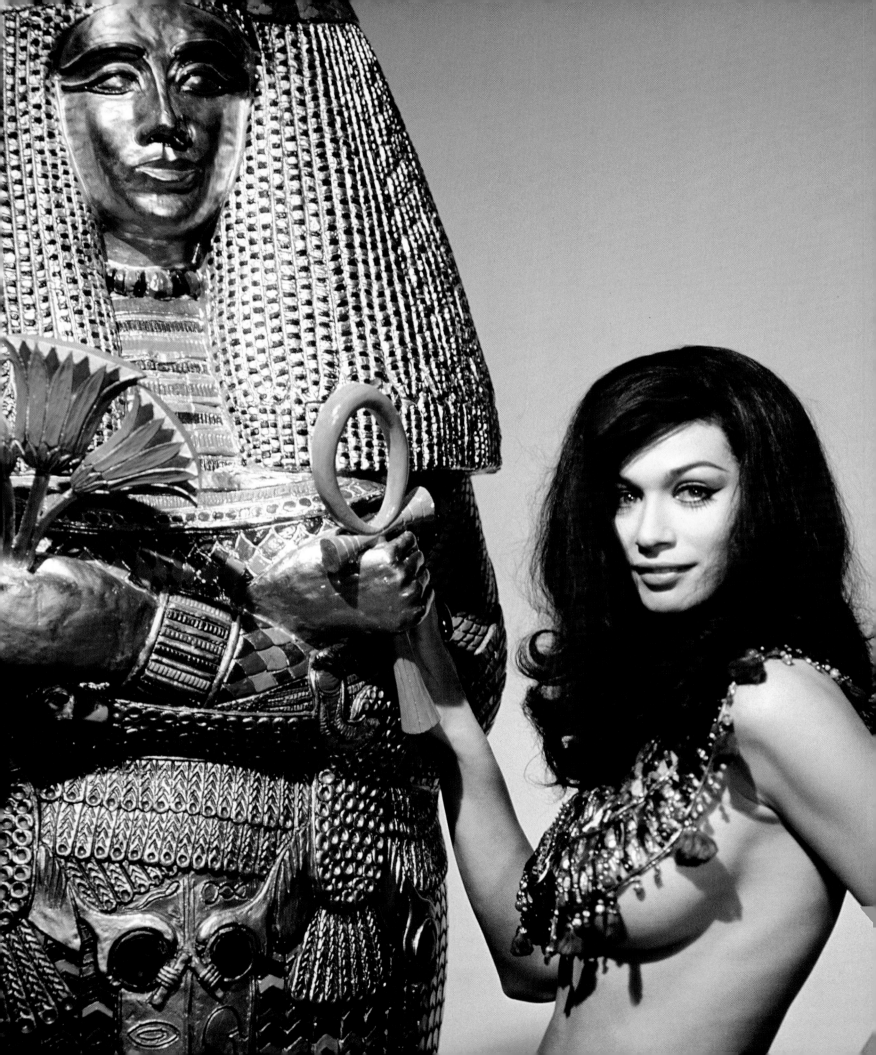

Blood From the Mummy's Tomb started filming on 11 January 1971 and was beset by tragedy almost immediately when Peter Cushing pulled out to care for his dying wife. He was hurriedly recast with Andrew Keir and filming resumed.

Although she was unaware she had been Holt and Brandy's second choice, Valerie was already desperately insecure. "I guess people might have thought I was a bit stuck up, but really I was just terribly shy. I didn't socialise or even go to the bar. At lunchtime I brought sandwiches and shut myself in my dressing room while I studied my lines. I went through life in a bit of a bubble at that time and I regret it so much now."

She sighs in frustration at herself. "I can't even use the excuse that I was young, because I wasn't that young when I made the film. The only thing I can put it down to is that I had quite a repressed, middle-class upbringing."

She was assertive enough, however, to resist any pressure to take her clothes off. "I had two doubles in the film," she remembers. "You can see one of them at the end when Margaret is fighting Tera, and I had another double for what I call 'the bottom shot' where I get out of bed. Someone did a little book about me once called *Everything But The Nipple*, and the title came from the fact that I always showed a lot of cleavage but nothing else. I believe that suggestion is far more titillating.

"And anyway," she adds, laughing at herself, "I was far too prudish."

Valerie's anxieties intensified when, at the end of the fifth week of shooting, Holt suffered a terminal heart attack. Attempting to make sense of the incomplete footage, Michael Carreras picked up from where Holt had left off and finished the film.

"I was not allowed to go to the funeral," says Valerie, "and I was absolutely devastated about that. As far as I remember on the day of the funeral they filmed a scene with me and George Coulouris, and I was crying so much they had to redo my make-up before we could continue."

Blood From the Mummy's Tomb made its debut at the National Film Theatre in October 1971, by which time Valerie had returned to her more usual fare of saucy light entertainment. In 1970 she had met Michael Mills, the BBC's head of comedy, while filming an episode of *Up Pompeii*. They married in 1974 and later had a son and daughter. He died in 1988.

Valerie admits that the heyday of her career was the 1970s, but feels she has much more to give now. "The trouble is, when you get to my age you don't get offered so much."

In recent years she has made several short films and returned to television with roles in sitcoms *Last of the Summer Wine* and *The Green Green Grass*. She has also written a one-woman show, *Valerie Leon's Carry On!*, which she first performed to critical acclaim in 2009.

"I used to get fan mail in the 1970s, but it was nothing compared to what I get these days," she says. "*Blood From the Mummy's Tomb* has become something of a cult. I even got a letter from someone on Death Row, asking for a picture of me from the film. He said he thought it would help him into the next world!" ∞

Top: Valerie and the *Blood From the Mummy's Tomb* cat, Sunbronze Danny Boy, meet the press in 1971. **Opposite and below:** Publicity pictures from the film by Hammer photographer Ronnie Pilgrim.

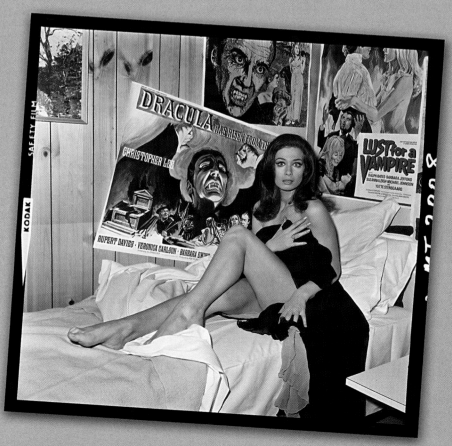

JENNIE LINDEN

IN *Nightmare*, the fourth of the Hammer suspense thrillers written by Jimmy Sangster in the early 1960s, a neurotic schoolgirl called Janet is haunted by memories of her mother murdering her father. She fears that she will inherit the same insanity and will also be sentenced to an asylum. Of course nothing is what it seems, and Janet turns out to be the target of a typically convoluted scheme.

Promoting *Nightmare* in March 1963, Hammer publicist Brian Doyle claimed that "Jennie Linden was the very first actress producer Jimmy Sangster and director Freddie Francis interviewed." Forty years later, Sangster revealed that Hammer had in fact asked someone else to play Janet first. Her name was Julie Christie. Filming was due to start on 17 December 1962, but with less than a month to go, the schedule was thrown into jeopardy by Christie's agent. "We'd already cast her and she'd signed the contract when we got a call from her agent," says Sangster. "Please would we release her – she's got the offer of a better job. Naturally we said no. Then Julie herself called. Please! Please! Okay. Julie was practically in tears so Freddie and I told her we'd release her. She went off to do *Billy Liar*."

Right: Jennie on location for an episode of *The Persuaders!* in 1971.
Below: With co-star and friend Peter Cushing in a publicity shot from *Dr. Who and the Daleks* (1965).
Opposite: At home in Marylebone in 1965.

One afternoon in late November 1962 Sangster and Francis braved thick smog to drive to the Connaught Theatre in Worthing, where they saw Jennie Linden as a dizzy American teenager in the play *Under the Yum-Yum Tree*. They invited Jennie to screen test at Bray Studios the following day – it was her first ever visit to a film studio. She started filming just two weeks later.

Jennie Linden was born Jennifer Caroline Fletcher in Worthing on 8 December 1939. She won a scholarship to the Central School of Speech and Drama, but also spent three years studying for a teaching diploma at her father's insistence. "I was determined never to use my teacher's degree," she later said. "I felt that once I did I would never become an actress."

Freddie Francis was deeply impressed with Jennie's performance in *Nightmare* and predicted great things for her. A year after making *Nightmare* she returned to Bray to visit Francis and Peter Cushing on the set of *The Evil of Frankenstein*. In spring 1965 she was cast alongside Cushing in her next film, *Dr. Who and the Daleks*, and in the summer they were reunited in a stage production of *Thark* that originated in Guildford and went on to the West End.

Jenny's career continued along unpredictable lines. After considerable television work she was cast in *Women in Love* and BAFTA nominated as Most Promising Newcomer of 1969. She reportedly turned down the chance to play Amy in *Straw Dogs* (the part went to Susan George) but remained busy in television. In the early 1990s her fruity voice-overs could be heard during Channel 4's raucous 'yoof' programme *The Word*.

Nightmare may not be the greatest of Hammer's suspense thrillers, but the film's dream-like opening titles are among the most disturbing things ever shot at Bray. In this sequence, lured through the corridors of a dank asylum by the voice of her insane mother, Jennie Linden is one of the most tragic and vulnerable of all Jimmy Sangster's victims. ∽

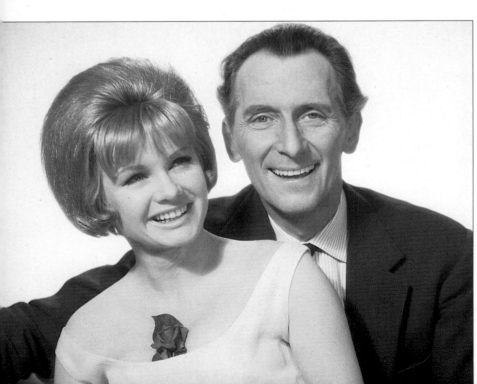

JOANNA LUMLEY

"NICE to see you again Jessica," says Inspector Murray (Michael Coles) in *The Satanic Rites of Dracula*, neglecting to mention that Lorrimer Van Helsing's granddaughter looks nothing like the girl he met on his previous investigation into the occult.

Jessica had been played by Stephanie Beacham in *Dracula A.D. 1972*, but for the sequel the role went to the lissom Joanna Lumley, an actress who had been on the brink of stardom since the previous decade.

The daughter of a major in the Gurkha Rifles, Joanna Lamond Lumley was born in Kashmir, India, on 1 May 1946. In England she was turned down by RADA, but a collaboration with designer Jean Muir helped her to become one of the most successful models of the 1960s. In 1967 she gave birth to her only child, Jamie, and the following year resumed her efforts to launch her acting career. She was cast as one of Blofeld's Angels of Death in the James Bond film *On Her Majesty's Secret Service* and received her first starring role in the little-seen satire *The Breaking of Bumbo* (1970). Her marriage to actor and writer Jeremy Lloyd began and ended in 1970, the same year *The Breaking of Bumbo* sank without a trace.

Things hadn't improved much for Joanna when Hammer cast her in *The Satanic Rites of Dracula*. Don Houghton's script gives Jessica Van Helsing rather less to do than in *Dracula A.D. 1972*, but she retains her plucky spirit and investigates the vampire-infested cellar of Pelham House. Unfortunately she then needs to be rescued by the police officers who had previously been so patronising towards her, but her ordeal provides the film with one of its most memorable sequences. An unconscious Jessica is later the centrepiece in Count Dracula's final ceremony before she is rescued once again.

The mid-1970s saw a slide in Hammer's fortunes and *The Satanic Rites of Dracula* only received a limited release. In 1973 Joanna joined the cast of *Coronation Street*, and would later make several appearances in Jeremy Lloyd's *Are You Being Served?*

In early 1976 the former Hammer writer and director Brian Clemens cast Joanna as the dynamic Purdey in *The New Avengers*, the show that finally brought her stardom. She went on to play the lead in the cult supernatural series *Sapphire and Steel* (1979-1982) and made a triumphant comeback as the grotesque Patsy in *Absolutely Fabulous* (1992-2005).

In 1986 Joanna married conductor Stephen Barlow and in 1995 was awarded an OBE. A tireless campaigner for animal rights and an outspoken figurehead for the Gurkhas, she remains the most prominent and consistently successful of all Hammer's English leading ladies.

Of course, Hammer played virtually no part in this success, but the friendship Joanna forged with her *Satanic Rites* co-star Peter Cushing proved enduring. In January 1995 she attended Cushing's memorial service in London. Avoiding the press gathered outside St Paul's Church, she maintained a solitary and low key presence, pausing only to describe her on-screen grandfather as "the most gentle man I have ever met." ∞

Top: Joanna is joined by co-stars Michael Coles and Peter Cushing in this French front-of-house still from *The Satanic Rites of Dracula* (1974).

YVONNE MONLAUR

THE BRIDES OF DRACULA

THE TERROR OF THE TONGS

OF all the actresses Hammer promoted in the immediate wake of *And God Created Woman*, Yvonne Monlaur was the one who looked, and sounded, most like Brigitte Bardot. Strikingly beautiful in her own right, Yvonne coped admirably with a difficult role in one of the company's greatest horror films, but could do little to enhance one of its worst.

Yvonne Bèdat de Monlaur was born in Indochina on 15 December 1939. Her work as a model, notably in *Elle* magazine, led to her first acting roles. By the late 1950s she was making so many films in Italy that she and her mother shared a flat in Rome's Via Archimede, while Yvonne also maintained a rented apartment in Paris.

Avventura a Capri (1959) brought her to the attention of Hammer, but an accident during filming threatened to end her career. She was aboard a motor launch with a friend and a press photographer when the speedboat motor blew up. Everyone aboard survived, but Yvonne had to swim almost a mile to reach the shore, by which time it was discovered she had badly burned her hands, feet and part of her face.

She had recovered in time to visit Britain later in 1959. She was accompanied by her mother, who also acted as her manager and chaperone. Yvonne's first British film was Sidney Hayers'
Circus of Horrors, which she started shooting in November. Shortly afterwards James and Michael Carreras invited her to Hammer House and she was given a lead role in *The Brides of Dracula* without even having to audition.

The script was barely ready to shoot when *The Brides of Dracula* entered production in January 1960. Yvonne's character, French schoolteacher Marianne Danielle, was a clumsy amalgamation of two characters from a previous draft. Yvonne also had to contend with the language barrier, but found a helpful and patient co-star in Peter Cushing.

Right: A 1959 portrait of Yvonne from her first British film, the lurid *Circus of Horrors*.

These difficulties were just two of the things that conspired against *The Brides of Dracula*, but the film's opulent beauty more than compensated for its shortcomings. Yvonne's swooning, wide-eyed performance prompted Hammer publicist Colin Reid to describe her as "magnetically feminine... she has it all – beauty, sex and acting talent."

In April 1960 Hammer took Yvonne out of this Gothic wonderland and imposed her on the dubious revenge thriller *The Terror of the Tongs*. The script makes a cursory reference to her character's mixed race origins but her accent and appearance remain incongruous throughout the film.

Yvonne's time in England saw the beginning and end of her career in horror films. Frustrated by the roles she was being offered she took what was intended to be a temporary break from acting in 1970. She briefly returned to Chateau Meinster, the setting for *The Brides of Dracula*, in 2004 when she joined the voice cast of an internet drama to promote Image Comics' graphic novel *The Black Forest*.

The girl Hammer's trailers described as "France's latest sex kitten" is now a glamorous pensioner, whose grasp of English is a little shakier than it once was. Her reputation is undimmed, however, and she remains one of Hammer's iconic leading ladies. ∞

ROSENDA Monteros was born in Veracruz on 31 August 1935. This diminutive Mexican actress had only a handful of roles in English language movies, but they included an important contribution to Hammer's most romantic melodrama, *She*.

After extensive work in theatre, Rosenda made her first film in 1954. Her earliest roles were all in Mexico and included *The White Orchid* directed by Reginald Le Borg, who had made *The Flanagan Boy* for Hammer two years before. At around the same time Rosenda made three films for writer and director Julio Bracho, whom she married in 1955.

By 1957 their relationship was over, but Rosenda's career continued to thrive. In 1959 she appeared in Luis Buñuel's *Nazarin*, and the following year received her biggest break yet when John Sturges directed *The Magnificent Seven* at Mexico City's Churubusco Studios. Rosenda was cast as the spirited village girl Petra, who falls in love with novice gunslinger Chico (Horst Buchholz).

The Magnificent Seven's slow-burning success brought her to the attention of British distributors and in 1962 she appeared alongside James Mason and John Mills in the exotic comedy *Tiara Tahiti*. Now flitting between England, France and Mexico for films and television series, in August 1964 she went even further afield when she became one of the few cast members to visit southern Israel for the location filming on *She*.

Rosenda was fourth-billed as Ustane, the mysterious handmaiden used to lure Leo Vincey (John Richardson) to the lost city of Kuma. Ayesha (Ursula Andress) entices Leo further, believing him to be the reincarnation of her dead lover, Killikrates. Fortunately Leo doesn't seem to mind who he kisses after a night out with the boys, and he gets it on with Ayesha straight after scoring with Ustane.

Realising that Leo has been bewitched by Ayesha, the broken-hearted Ustane later resolves to leave Kuma. Her fate is sealed when Ayesha witnesses their goodbye kiss. A terrified Ustane is last seen clutching the bars of a gilded cage suspended over a pit of fire.

At Elstree, Rosenda's plaintive character was thankfully spared the violent excesses outlined in the film's original script. Writer John Temple-Smith had promised "Ustane, half-naked, flogged by the guards", but in David T Chantler's final draft screenplay even

her execution would occur off-screen. Temple-Smith would instead subject the half-naked Carita to a public flogging in his next Hammer film, *The Viking Queen*.

Rosenda was the subject of several glamour shoots during her stay in Israel, most of the pictures imbued with her carefree spirit and all produced to the same high quality as those featuring Ursula Andress. Back in England Hammer's publicists described Rosenda as a "stormy scrap of flamenco fire blazing a trail through London… If her personality, birth and talent have anything to do with it, sparks of all kinds should be flying at Elstree Studios."

While her supporting role was overshadowed by Ursula Andress – both in terms of the script and the ensuing publicity – Rosenda's sensitive portrayal of the tragic Ustane is the performance that gives *She* its heart. ∞

Right: Rosenda at her London hotel in August 1964, prior to beginning work on *She*. **Opposite:** Cooling off in southern Israel, several weeks later.

CAROLINE MUNRO

DRACULA A.D. 1972

CAPTAIN KRONOS VAMPIRE HUNTER

TRANQUIL, self-deprecating, and still very beautiful, Caroline Munro is crystallised in the memory as a coltish brunette provocatively posing in an unzipped wetsuit.

As the face, and body, of Lamb's Navy Rum Caroline starred in arguably the most famous poster campaign of the 1970s. One of the few models to make a successful transition to acting, her subsequent achievements included two of the most intriguing Hammer horrors and the biggest Bond film of the decade.

She was born in Windsor on 16 February 1949 and attended art school in Brighton. In 1965 one of her fellow students asked to photograph her, and then entered the pictures in a modelling competition sponsored by the *Evening News*. The judges, who included photographer David Bailey, chose Caroline's picture out of more than 700 that were submitted and she was bestowed the title 'The Face of 1966'.

That year Caroline was given small roles in Bailey's film *G.G. Passion* and the James Bond spoof *Casino Royale*. A 1968 screen test for director Peter Collinson led to a contract with Paramount, and a part alongside Richard Widmark and Cesar Romero in *A Talent for Loving*. The American actor and musician Judd Hamilton, whom Caroline would marry in 1970, was also in the cast. She admits the whole experience was a little daunting. "I didn't get into acting via the formal route of drama school and training, so everything was a learning curve. In *A Talent for Loving* I basically played myself."

Caroline began her 12-year stint with Lamb's Navy Rum in 1969, and in early 1971 the

Right and below: Publicity pictures of Caroline taken at Elstree during the making of *Dracula A.D. 1972*. **Opposite:** Hammer used pictures from this 1972 session to promote Caroline's appearance in *Captain Kronos Vampire Hunter*.

advertisements made an impression on Sir James Carreras. "He used to get the train up and down to Brighton and he saw these great big billboards which appeared outside Victoria Station and places like that," she remembers. "He asked me to come and see him and I read for a couple of things they thought I might be right for. I did a screen test too."

In May that year Hammer placed Caroline under contract, initially to appear in the unrealised disaster movie *The Day the Earth Cracked Open* but also to be promoted as 'The Hammer Find of 1971'. "They wanted a Raquel Welch lookelikey, and I'm not sure if I fit the bill for that," she says. "But I thought Sir James was wonderful, very amusing, and it was an exciting time."

Caroline's first Hammer assignment came in September that year when she was cast as Laura, one of Johnny Alucard's gang

Right: Another of George Whitear's glamour shots from *Dracula A.D. 1972*. **Below:** On location for *Captain Kronos Vampire Hunter* in 1972.

of thrill-seeking teenagers in *Dracula A.D. 1972*. She made the most of the small role, mustering a disturbing bout of hysteria before being claimed as the Count's first victim.

"Prior to *Dracula A.D. 1972* I thought of myself as more of a model than an actress and I didn't really take filming seriously," she says. "I felt as though I was just going through the motions, but the *Dracula* film felt right. When I was working with Christopher Lee I especially remember thinking, I really do like this – it's something I *can* do."

In early 1972 Caroline was offered a role in Brian Clemens' iconoclastic Hammer horror *Captain Kronos Vampire Hunter*. The script was tailored towards Caroline's casting as Carla, the gypsy recruited by Kronos (Horst

Janson) to be his companion and lover. "I *took* her," says Caroline, clenching her fists, "and I really enjoyed it. I *was* her for the time we were filming. I think it's a lovely film and I'm quite proud of it."

Although little-seen on its original release, *Kronos* now enjoys something of a cult following, due in no small part to Caroline's serene and sensual performance.

Hammer producer Roy Skeggs wanted Caroline to next star in *Frankenstein and the Monster From Hell*, but in August 1972 the idea was scotched by Michael Carreras, who pointed out that the *Frankenstein* film would be double-billed with *Captain Kronos* in America. The role went to Madeline Smith instead. In 1975 Caroline joined a long list of actresses considered to play the title role in Hammer's *Vampirella*, but her steadfast refusal to perform nude scenes would have caused problems if the project had gone ahead.

In 1973 Brian Clemens helped to secure Caroline a leading

role in *The Golden Voyage of Sinbad*, which he scripted. *At the Earth's Core*, released in 1976, reunited her with Peter Cushing from *Dracula A.D. 1972*. In the following year's blockbuster *The Spy Who Loved Me* she played the helicopter assassin Naomi. Her lewd wink to 007 (Roger Moore) before she attempts to kill him secured her reputation as one of the best-remembered Bond girls of the '70s.

In the 1980s roles became less frequent and she made such dubious choices as *Maniac* (1980) and *The Last Horror Film* (1982). Her marriage to Hamilton ended in 1982, and the year afterwards she turned down a role in the American soap *The Bold and the Beautiful* to instead become a hostess on ITV game show *3-2-1*.

Is this a decision she now regrets? "Professionally, possibly," she says, "but emotionally I don't regret it at all because I had my parents in England and I'd met my husband-to-be. I would have had to have signed a five-year contract, which would have

been a long old time to tie up. They told me I could have flown back to England at the weekends, but I couldn't really."

Caroline married writer and director George Dugdale in 1990 and the couple have two daughters, Georgina and Iona. She still appears in independent films and, along with her good friend Martine Beswicke, is a popular guest at James Bond and Hammer fan events.

"I've never particularly sought fame and notoriety," she says. "I've gone along with what's been thrown at me and I've only sought to do the job as well as I can. Maybe I haven't always made the right choices, but you can't go back. My career meant a lot to me, but I never put work before my family life."

Her only regrets are to do with money, and not having been more sensible with the large amounts she earned when she was younger. Now that one of her children is considering following in her footsteps, Caroline has some sage advice.

"I've told her to get a proper job first!" ∞

KATE O'MARA

KATE O'Mara had the opportunity to become one of Hammer's biggest stars of the 1970s. Fearing that she would become typecast, she turned down a contract with the company and instead gained a formidable reputation in theatre and television.

Born Kate Carroll in Leicester on 10 August 1939, Kate's feline features and assertive demeanour brought her to the attention of casting directors in the mid-1960s, when she made guest appearances in the ITC series *Danger Man*, *The Saint*, *The Champions* and *Department S*. "I looked rather extraordinary then," she says. "Almost foreign. And directors thought foreign meant flamboyant, and foreign meant sexy."

Kate was given regular roles in the television series *Weaver's Green* and *The Main Chance*, and in 1968 appeared alongside Peter O'Toole in *Great Catherine*. Despite this early success she relished the prospect of a supporting role in *The Vampire Lovers*. She won the part in 1969 and Hammer were so impressed with her audition that they offered her a six-film, three-year contract

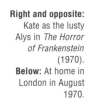

Right and opposite: Kate as the lusty Alys in *The Horror of Frankenstein* (1970). **Below:** At home in London in August 1970.

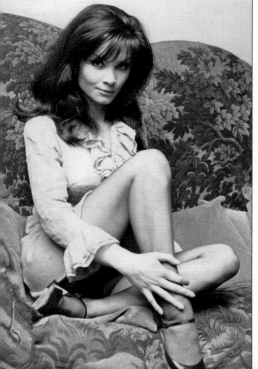

before shooting even began. In February 1970, the *Evening Standard* interviewed her at Elstree Studios. "I play a governess and I'm seduced by Ingrid Pitt," she said, perching on the wash basin in her dressing room. "Well, it will be nice to have a lady for a change. She drains me of all my blood. We have a great scene, all panting and fangs."

Against her better judgement Kate turned down Hammer's offer of a contract but asked if she could be considered for another supporting character. She was duly second-billed as the Baron's bedwarmer Alys in *The Horror of Frankenstein*, which started shooting at Elstree less than two weeks after *The Vampire Lovers* wrapped.

This misconceived comedy was less successful than *The Vampire Lovers*, but Hammer remained convinced that Kate had star potential and continued to court her. In 1971 she was shortlisted for *Dr Jekyll & Sister Hyde* but lost out to Martine Beswicke, who was considered to have a stronger facial resemblance to leading man Ralph Bates. To her frustration Kate was also overlooked for *Twins of Evil*, even though she insisted she could have played both sisters. In 1980 she was asked to guest star in 'Witching Time', the opening episode of *Hammer House of Horror*, but a theatre commitment took precedence and she had to turn it down.

By this time Kate had become a television star, having helped to revitalise drama series *The Brothers* with a vampish turn as a ruthless businesswoman. She lent some much-needed glamour to the dour soap opera *Triangle*, and in the 1980s joined the cast of *Dynasty* for a lucrative stint playing the scheming sister of Alexis (Joan Collins).

Kate has long since reconciled herself to a screen persona which, she says, is nothing like the real her. Still busy in theatre and television, she is keen to maintain her glamorous reputation. "I'd willingly pose for *Playboy*, if it paid me enough," she says. "I'm still a size eight, and the legs have held up pretty well." ∞

BARBARA PAYTON

BARBARA Payton was one of the most notorious actresses to work for Hammer. For once, her extraordinary and ultimately tragic life story left little room for publicists' exaggeration.

Born Barbara Lee Redfield in Cloquet, Minnesota, on 16 November 1927, Barbara was a beautiful and promiscuous teenager. She claimed to have lost her virginity aged 15, seduced by a schoolfriend's 45 year-old father at his birthday party. She married her high school boyfriend at 16, only to divorce him months after. At 17 she married Air Force captain John Payton, but their tempestuous relationship struggled to withstand her attempts to break into Hollywood. She ultimately succeeded, signing a contract with Universal, but her husband fell by the wayside as she embarked on a series of affairs that reportedly included flings with Howard Hughes and Bob Hope.

By 1950 Barbara was raking in $10,000 a week at Warner Bros. She divorced John Payton and by 1951 was the subject of a violent struggle for her affections when jealous boyfriends Franchot Tone and Tom Neal fought over her. Neal won the fight, but Barbara married Tone once he recovered. Seven weeks later she left him for Neal and a violent relationship that lasted for the next four years. During this time her Hollywood career petered out and the girl who had once starred opposite James Cagney and Gregory Peck was reduced to B movie schlock like *Bride of the Gorilla* (1951). Over in England Hammer were keen to exploit her bad girl image and she was grateful for the work.

James Carreras hosted a reception in Barbara's honour when she arrived in July 1952, and filming on *Four Sided Triangle* began soon after. She was cast as Lena, a woman subjected to a primitive cloning process in a duplicating machine developed by scientists who are rivals for her love. The film is considered important by those who regard it as a step towards *The Curse of Frankenstein*, but *Four Sided Triangle* is more tepid romance than proto horror.

A few weeks after filming ended Barbara went straight into her second Hammer film. *The Flanagan Boy* was filmed at Bray from September to October 1952. Barbara's portrayal of the Machiavellian Lorna helped to lend *The Flanagan Boy* an authenticity lacking in Hammer's other noir-style thrillers. In America the film was retitled *Bad Blonde*, and accompanied by a trailer that warned "Bad is the word for Barbara!"

Back in America she was unable to revive her career and repeatedly fell foul of the law as she descended into alcoholism, prostitution and homelessness. In 1962 she was stabbed by a drunk, and in the following years was arrested for shoplifting and possession of heroin.

Barbara's final act of defiance was the 1963 publication of *I Am Not Ashamed*; she was reportedly paid just $1,000 for the ghost-written memoir. Her looks ravaged by years of alcohol abuse, she later returned to her parents in a desperate bid to recover from her addictions. On 8 May 1967 she was found dead on their bathroom floor, a victim of heart and liver failure. She was 39. ∾

Top: Barbara submits to the 'reproducer' in *Four Sided Triangle* (1953).
Below: Hammer producer Anthony Hinds helps Barbara to celebrate her 25th birthday following production of *The Flanagan Boy* in 1952.
Opposite: A John Jay portrait of Barbara from *The Flanagan Boy* (1953).

JACQUELINE PEARCE

THE PLAGUE OF THE ZOMBIES

THE REPTILE

THE star of numerous cult films and television series, Jacqueline Pearce is an extraordinarily intense actress who now enjoys a cult following of her own. Before developing the screen persona that endeared her to generations of *Blake's 7* fans, she played some of the most distinctive female characters in any of the Hammer horrors.

Jacqueline was born in Byfleet, Surrey, on 20 December 1943. "The first time I opened my mouth I said I wanted to act," she says, but she found little encouragement at her strict convent school. "The woman who ran it was a dipsomaniac and I spent all my time getting her bottles of gin. But there was a lay teacher, a brilliant teacher and actress who couldn't act herself because she had very bad vision and couldn't see across the stage. She suggested I should be an actor. I had to persuade my father that 'actor' was not a euphemism for 'prostitute' and to let me audition for RADA."

Jacqueline graduated in 1963 and married the actor Drewe Henley the following year. She had only played a handful of minor roles when she visited Bray Studios in spring 1965 to audition for Hammer producer Anthony Nelson Keys. "He told me I had a

Right: Jacqueline endures the lengthy make-up process for *The Reptile* (1966).
Below: Dead funny – Jacqueline awaits her cue to rise from the grave in *The Plague of the Zombies* (1966).
Opposite: Wearing a sari created by Rosemary Burrows for *The Reptile*.

wonderful face for film," she says, smiling broadly at the memory of her first big break. Keys was preparing *The Plague of the Zombies* and *The Reptile*, two low-budget horrors that would be filmed back-to-back that summer. He was so impressed with Jacqueline that he gave her leading roles in both.

Jacqueline's performance in *The Plague of the Zombies* is perfectly in tune with the film's alarming shift from eerie murder mystery to disorienting monster rampage. As Alice, the voodoo victim wife of an ineffectual GP (Brook Williams), Jacqueline begins the film as a remote and bewildered figure, before crawling out of her own grave and getting decapitated with a spade.

The Reptile began filming at Bray in September 1965, just three days after *The Plague of the Zombies* wrapped. Jacqueline was cast as Anna Franklyn, another secretive and disturbed young woman. Her ordeal in this film is even more remarkable, as a curse periodically transforms her into a grotesque and murderous snake woman. Unfortunately, the filming proved an ordeal for Jacqueline as well.

"It was hell," she says emphatically, staring at a picture of her face obscured by green scales and a pair of bulging eyes. "I spent a couple of hours in make-up every morning. I could only shoot every other day because taking it off would leave my skin so raw. I wasn't comfortable in that at all."

In the hands of a lesser director than John Gilling, *The Plague of the Zombies* and *The Reptile* could have collapsed under the

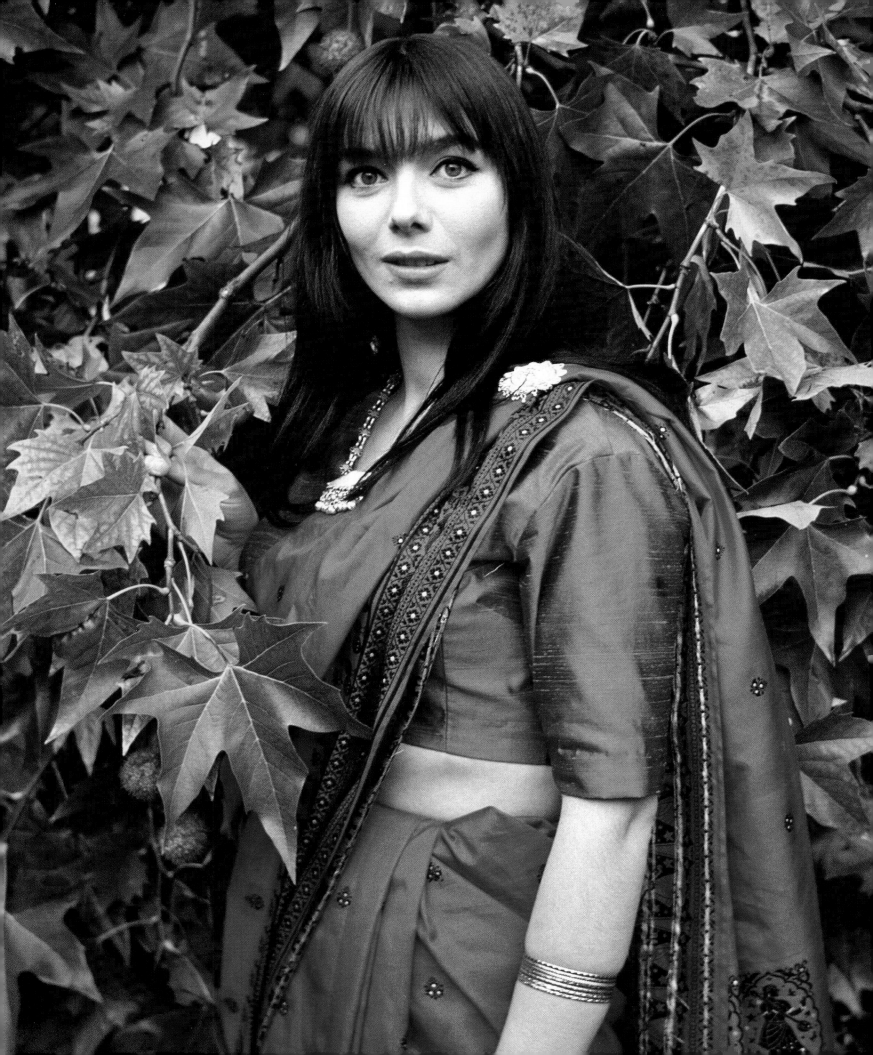

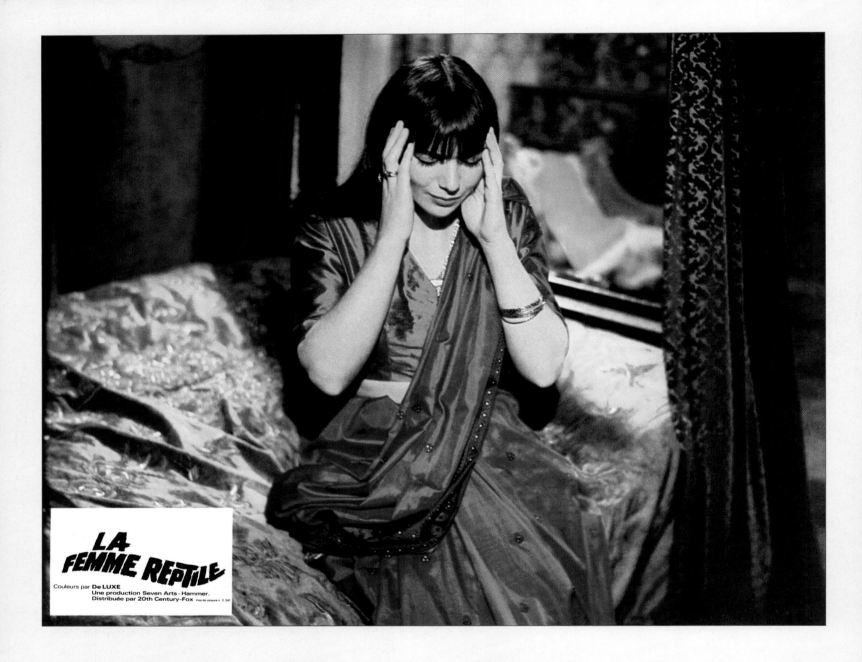

LA FEMME REPTILE

Couleurs par **De LUXE**
Une production Seven Arts - Hammer.
Distribuée par 20th Century-Fox Visa de censure n 2.241

Above: As the tormented Anna Franklyn in this French front-of-house still from *The Reptile*.
Opposite centre: With Hammer make-up artist Roy Ashton on *The Plague of the Zombies.*
Opposite: Outside Bray Studios in summer 1965.

weight of their own absurdity. Although both were made as B movies, the seminal *Zombies* in particular is now considered one of Hammer's greatest films.

Gilling's success came at a price, however, and he was disliked by many actors who considered him foul-mouthed and abrasive. "He did have something of a reputation," confirms Jacqueline, "but I never had any trouble with him. This was probably because I was so young and inexperienced. I think he felt kind of protective towards me. I never saw or heard the monster that he supposedly was."

Despite her discomfort on *The Reptile*, Jacqueline is nostalgic about her time at Hammer and gazes fondly at a picture of her posing outside the house that was the heart of the studio. "I loved Bray and it was a great time for me," she says. "It was like a family

there. It had the best restaurant I've ever been in. I must have put on a stone while I was making those films."

A photograph of her wearing the red sari from *The Reptile* reminds her of Hammer's wardrobe mistress. "Rosie Burrows put all the costumes together for me and I think she did very well. I've got such happy memories of all the crew, including her and Bert Batt, the assistant director. It was very sad when Hammer left Bray. I think we lost something special."

Jacqueline's reputation grew over the following years. In 1967 she spent three months in John Mortimer's play *The Judge*, and got to marry Jerry Lewis in his Swinging London comedy *Don't Raise the Bridge, Lower the River.*

Jacqueline's real-life marriage to Drewe Henley broke down and he married the actress Felicity Kendal in 1968. *Don't Raise the Bridge,*

Lower the River failed to lead to a career in America, but Jacqueline achieved a special notoriety when, in 1977, the BBC offered her the role of the villainous Servalan in their space opera *Blake's 7*.

The part was originally written for a man and intended to last for just one episode, but Jacqueline's remarkable performance as the cruel Federation commander made her intrinsic to all four seasons. Servalan's camp severity earned her a devoted following, and small reminders of the character in the occasional gesture and facial expression can make a conversation with Jacqueline mildly disconcerting.

"I'm mainly remembered for *Blake's 7*, which is absolutely fine," she says. "Servalan was a wonderful character who's become an icon. I'm very grateful to her."

In 1989 Jacqueline moved to Cornwall and spent seven years as an artist's model. Her life changed again in the subsequent decade when she was diagnosed with breast cancer. "When I finished the treatment I thought, I've been through a life-changing experience but my life hasn't changed. I wanted it to, and I wanted to do something completely different. I was interested in working with animals, particularly primates, so I found a sanctuary in South

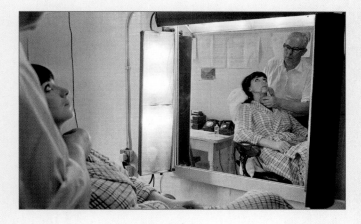

Africa that cared for orphaned and injured vervet monkeys. I worked there for two months in 2006 and then they invited me to live there. It's the best thing I've ever done."

Jacqueline now considers her home to be the African bush, and she only occasionally returns to England. "I do enjoy acting but it's no longer my primary objective," she says. "If someone asks me to come back and do a play or something then of course I'll consider it, but I'm not hanging round waiting for agents to call."

In the 45 years since Jacqueline Pearce arrived at Bray Studios her career has seen highs and lows. She has survived a life-threatening illness and has discovered a new sense of purpose on another continent. What advice would she offer her younger self?

There is a long pause before she replies.

"I'd say, Hang in there kid." ∽

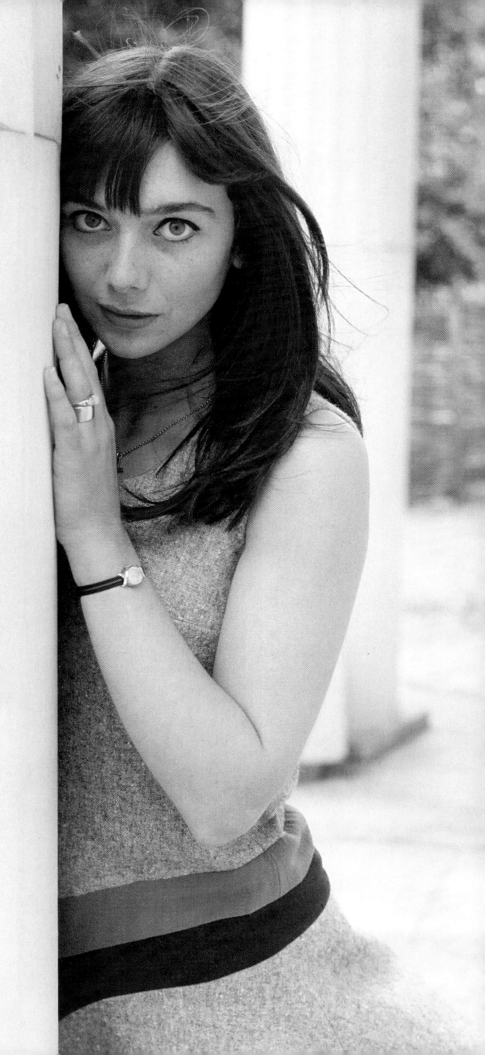

INGRID PITT

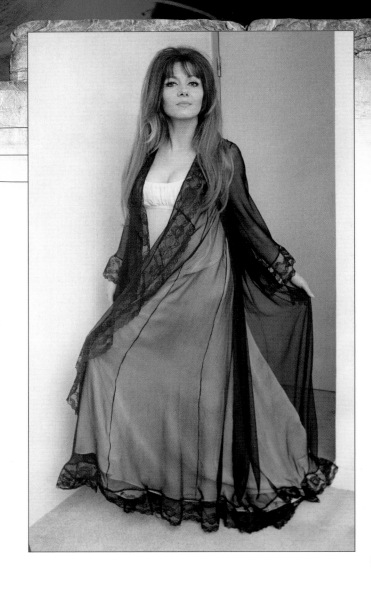

DAZZLING Polish beauty Ingrid Pitt is the most emblematic of all the leading ladies associated with Hammer. Her performance in *The Vampire Lovers* (1970) heralded the final, most explicit, phase of Hammer glamour and when the company was revitalised in 2007 it was Ingrid they chose to represent the old guard in their first production, *Beyond the Rave*.

Ingrid was born Kasha Kotuzova on 21 November 1937, on a train carrying her mother to a Nazi concentration camp. "They did horrific things to us," she remembers. "My mother told me, 'Never be a victim' and I've never again been a victim in my life."

The Red Cross eventually brought Ingrid (the name came from her mother) to East Berlin, where she spent her teenage years and later joined the Bertold Brecht Berliner Ensemble. In 1962 she escaped to West Berlin by swimming the River Spree and married the American soldier who had helped her. She adopted his surname, Pitt, and moved to the United States. Their daughter, Steffanie, was born in Colorado, where Ingrid lived on a reservation with Native Americans.

Her marriage came to an end, and in 1964 she took her daughter to Spain, where she had a handful of roles in low-budget

films before being cast in the wartime blockbuster *Where Eagles Dare* (1968). Ingrid savoured her role as double agent Heidi, and enjoyed the company of co-stars Clint Eastwood and Richard Burton. When filming was complete she discovered that they had bet with each other over who would get her in the sack first. "Who won?" she asked them innocently.

In 1969 she met James Carreras at the after-premiere party for *Alfred the Great*, and the following morning he gave her the script of *The Vampire Lovers*. Ingrid fell hungrily on the lead role of insidious vampire Carmilla, even after Carreras warned her that the part would involve taking her clothes off.

Filming began at Elstree in January 1970 and producers Harry Fine and Michael Style were barred from the closed set during the filming of the nude scenes. Feeling sorry for them, Ingrid undid her dressing gown to give them a quick flash of what they were missing.

Things weren't always so convivial, and a minor dispute over Ingrid's costume got out of hand until Carreras defended Ingrid

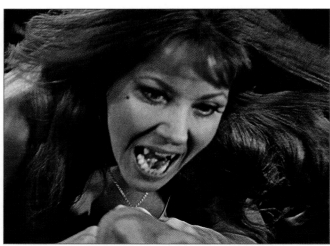

Top: Ingrid in her Elstree dressing room during the making of *The Vampire Lovers* in 1970.
Right: 'Beautiful temptress... or bloodthirsty monster?' asked the poster for *The Vampire Lovers*.
Opposite: This portrait from *The Vampire Lovers* became one of the most popular Hammer glamour shots ever taken.

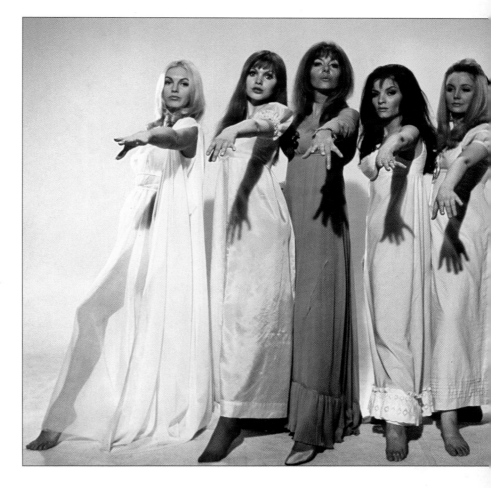

from the producers. When Fine and Style made follow-up *Lust for a Vampire* they recast the role of Carmilla with Yutte Stensgaard.

"Style and Fine didn't really want to know about me, I think because they were jealous of my close relationship with Jimmy," says Ingrid. "I just loved him and he loved me too. I'm the only one I know who had this kind of relationship with him, but please don't suggest that it was anything more than a friendship because it wasn't like that at all. I was like his daughter."

Ingrid's association with the possessive George Pinches, the head of exhibition at distributor Rank, led to more frayed tempers. Pinches was alarmed by some of the publicity stills that were circulated prior to *The Vampire Lovers'* release, and in April 1970 wrote a letter of complaint to Hammer company director Brian Lawrence: "There is a clause in her contract which does allow her to express a view regarding the use of pictures involving nudity or near nudity but it does seem that no one extended this courtesy to her... I suspect this is something which, knowing you as I do, you will be sympathetic to in the interest of an artiste who does not wish to be regarded as a piece of cheesecake with pictures in girly magazines, but a serious actress."

Ingrid falls silent on the mention of Pinches' name. "He was an idiot," she says. "I don't want to talk about him."

In summer 1970 Hammer cast Ingrid as the star of the Rank-sponsored *Countess Dracula*, a film that purported to tell the story of Countess Elizabeth Báthory, the serial killer convicted for the torture and murder of 80 young women in 17th century Hungary. Memorable scenes include a naked Ingrid drenched in the virgins' blood that her character bathes in to maintain her preternatural youth.

The film failed to make the same impact as *The Vampire Lovers*, but Ingrid's greatest regret is that director Peter Sasdy replaced her voice in post-production. "I went absolutely berserk when I found out," she says. She later encountered Sasdy at a film festival in Spain and took her revenge. "I knew he couldn't swim so I pushed him into the sea!" Fortunately Sasdy survived the ordeal, but

presumably checked the guest list at future events with more care.

Ingrid's career continued with notable roles in *The House That Dripped Blood* (1971), *The Wicker Man* (1973) and *Who Dares Wins* (1982). On television she appeared opposite Alec Guinness in *Smiley's People* (1982) and made several guest appearances in *Doctor Who*.

When acting roles became scarce she successfully pursued her other talent as a witty magazine columnist. Her numerous books include the novel *Cuckoo Run* (1980) and her autobiography *Life's a Scream* (1999).

In 1974 Ingrid met Formula 1 team manager Tony Rudlin, and the couple are still married today. She continues to maintain her writing and acting careers in parallel and in 2007 played the mother of an Iraq War soldier in Hammer's *Beyond the Rave*. Her cameo amounted to just a day's work, but in many other respects it was business as usual. "I tell him to stay safe, but of course the fool goes into a forest full of vampires!"

Ingrid has embraced her popular association with Hammer, and is used to defending *The Vampire Lovers* from those who disapprove of its lesbian scenes. "It might have been shocking, but it wasn't *dirty*," she says. "I thought the things I did in that film were wonderful. I loved it when I had nothing on." ∞

Opposite: Part of a 1970 session by Ben Jones to promote *Countess Dracula*.
Top: Happier times with director Peter Sasdy on the Pinewood set of *Countess Dracula*.
Above: Girl power – Kirsten Betts, Madeline Smith, Ingrid Pitt, Kate O'Mara and Pippa Steele in a publicity shot from *The Vampire Lovers*.

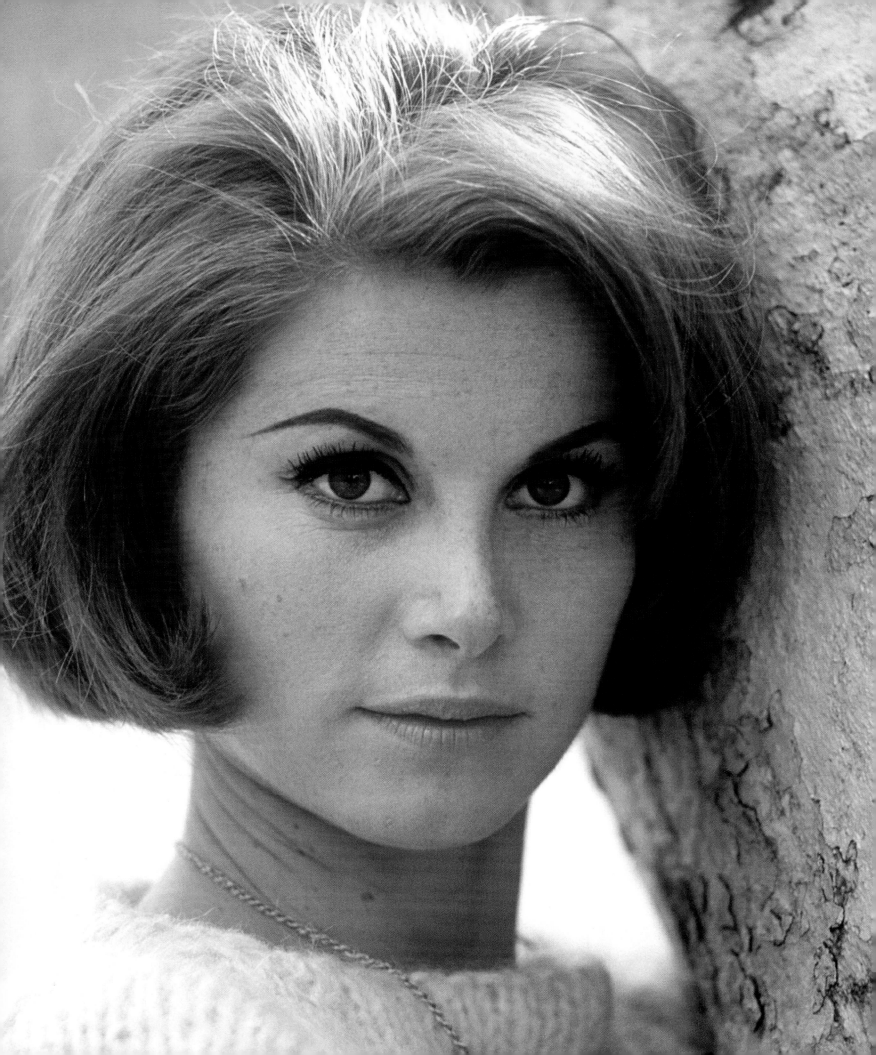

STEFANIE POWERS

FANATIC

'JANE BROWN'S BODY'

CRESCENDO

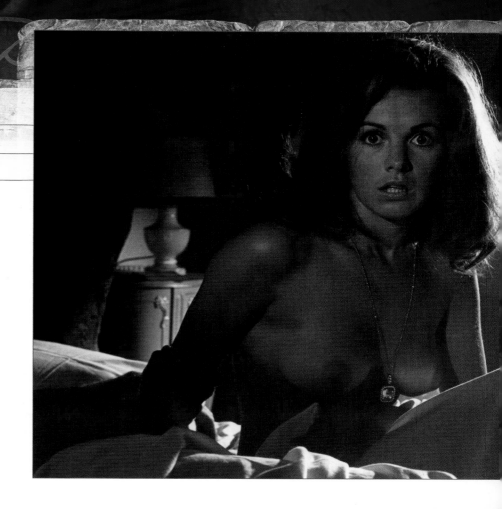

ALTHOUGH barely remembered for her association with Hammer, Stefanie Powers was given three leading roles by the company in the 1960s. The films may not have been memorable, but Stefanie was a consummate film star who added some genuine Hollywood glamour to a decade otherwise dominated by English and European actresses.

Born to Polish American parents in Hollywood on 2 November 1942, Stefania Zofia Federkiewicz seemed destined for a career in showbusiness. She attended Hollywood High with Nancy Sinatra and adopted the name Powers when she auditioned for her first theatrical job, a role in *West Side Story*, while still a teenager. A non-exclusive contract with Columbia gave her the opportunity to learn her craft at the tail end of the Hollywood star system.

Columbia cast her in Blake Edwards' *Experiment in Terror* (1962) and in autumn 1964 sent her to London for the Hammer suspense thriller *Fanatic*, her biggest role to date. Stefanie played Pat Carroll, whose sense of duty compels her to visit the mother of her dead fiancé. Unfortunately Pat's host, Mrs Trefoile (Tallulah Bankhead), turns out to be a Bible-bashing psychopath who takes her prisoner.

Hammer's publicity department interviewed Stefanie during the making of *Fanatic* and struggled to list her various accomplishments, which included painting, dancing, swimming and surfing. It was also noted that Stefanie was fluent in numerous foreign languages and had just made her first record. Given this wealth of talent it is bizarre that the ensuing press release chose to highlight Stefanie's more mundane hobbies, which included "folk music, reading books on philosophy and mowing the lawn."

From 1966 to '67 Stefanie played April Dancer in the television series *The Girl from UNCLE*, and in 1968 she returned to England to guest star in an episode of Hammer's *Journey to the Unknown*. The *Frankenstein*-style plot of 'Jane Brown's Body' gave Stefanie the most bizarre of all her Hammer roles, but she rose to the challenge of playing a girl who has to make sense of a bewildering new life after she is literally raised from the dead. The episode featured some picturesque location filming in Cambridge and was

directed by Canadian newcomer Alan Gibson.

In 1969 Stefanie was chosen by Gibson for her third and final Hammer project. The suspense thriller *Crescendo* found her revisiting *Fanatic* territory when her character, music scholar Susan Roberts, was terrorised by another bonkers matriarch (played by Margaretta Scott). Gibson would go on to great things in British television, but his lifeless film debut is distinguished only by some beautiful location photography in the Camargue and the taboo-breaking nude scenes performed by Stefanie and Jane Lapotaire.

Hammer's favourite American starlet came to global prominence in the late 1970s when she co-starred with Robert Wagner in the television series *Hart to Hart*. She was at the height of her fame in 1981 when her partner, the actor William Holden, died following a fall in his Santa Monica apartment. Stefanie helped to establish the William Holden Wildlife Foundation in his memory, and is still the organisation's president. ∽

Top: Susan (Stefanie Powers) has a rude awakening in *Crescendo* (1970). **Above:** With Maurice Kaufmann in *Fanatic* (1965).

YVONNE ROMAIN

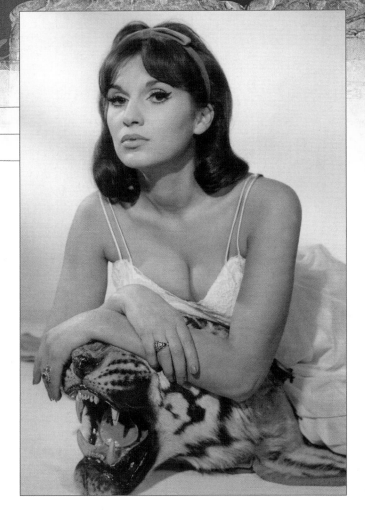

YVONNE Romain had the exotic looks considered de rigueur by Hammer in the early '60s, without any of the language problems often presented by foreign actresses. It is therefore surprising that out of her three Hammer films, Yvonne was given no lines in one and was blacked up to play a Ghilzai tribeswoman in another.

Yvonne Warren was born to an English father and Maltese mother in London on 17 February 1938. Her mother encouraged her ambition to become an actress and enrolled her at the Italia Conti stage school. Yvonne was appearing in some of the BBC's earliest children's television programmes from the age of 12, and made her film debut when she was 15, playing an Italian girl in *The Baby and the Battleship*.

In 1958 she married Leslie Bricusse, the songwriter and lyricist who would later contribute to several James Bond films and win Oscars for *Doctor Dolittle* (1967) and *Victor Victoria* (1982).

Below: Yvonne as the ill-fated servant girl in *The Curse of the Werewolf* (1961).

That summer Yvonne appeared alongside Boris Karloff in *Corridors of Blood*, the first of the numerous horror films she is now best remembered for. In 1959 she changed her surname to Romain and came a cropper in the surprisingly sadistic *Circus of Horrors*. Things would get even more unpleasant for her when she made Hammer's *The Curse of the Werewolf* the following year. Cast in the small but significant role of a mute servant girl, her character is raped in a dungeon by a raddled beggar (Richard Wordsworth). She later dies giving birth to a child that will grow up to be a werewolf. The girl's adult son was played by Oliver Reed, and although Yvonne didn't share any scenes with Reed they posed for some dramatic publicity stills that marked the first of their three Hammer collaborations.

A year later, in September 1961, Yvonne was back at Bray Studios, playing opposite Reed in the ghoulish swashbuckler *Captain Clegg*. This was her most captivating Hammer role, and the film is widely regarded as one of the finest productions from Hammer's golden age.

She returned to Hammer in 1964 for *The Brigand of Kandahar*, a cut-price epic directed by John Gilling, who had cast her in an episode of *The Saint* the year before. Having played Oliver Reed's mother in her first Hammer film, and his fiancée in the second, this time they were brother and sister in the same Afghan tribe. Reed later described it as his worst film, and neither he nor Yvonne worked for Hammer again.

Yvonne was similarly unlucky when she starred alongside Elvis Presley in the tacky *Double Trouble* (1967), but it was concern over her family life, rather than the quality of her roles, that prompted her to retire. "I had a child, and my husband's work brought us to Hollywood," she says. "I was getting work in Rome and London and we were being torn in two different directions. It was difficult, because I loved working, but I now look back and realise I made the right decision. I have no regrets whatsoever." ∽

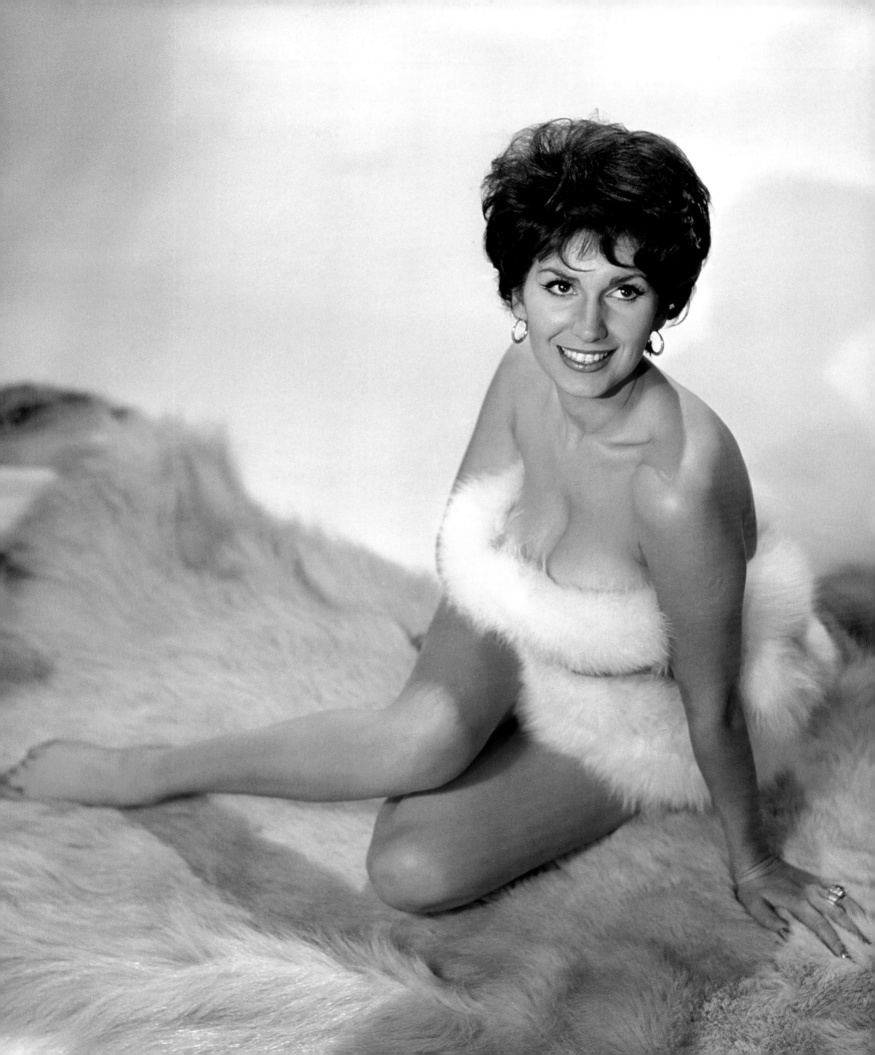

EDINA RONAY

SLAVE GIRLS

MICHAEL Carreras kept numerous photographs as mementoes of his time at Hammer. The 1966 filming of *Slave Girls* – the bizarre prehistoric fantasy he wrote, produced and directed – is well represented with a stack of oversized stills showing bevies of blondes and brunettes dressed in what look like Raquel Welch's cast-offs. Carreras' distinctive block capitals adorn the backs of the pictures, identifying leading members of the crew alongside long-forgotten starlets. One of the photographs features a proud observation relating to a diminutive blonde wearing a bikini covered in shells. The caption reads: 'Edina Ronay – now a top designer.'

Edina Ronay was born in Budapest, Hungary, in 1943. Her father, Egon Ronay, moved to England two years later and his family eventually followed. Egon became a restaurateur and renowned critic, publishing the first edition of *The Egon Ronay Guide to British Eateries* in 1957. As Egon's fearsome reputation grew, Edina pursued her ambition to become an actress.

Edina's role in the 1963 *Avengers* episode 'The Nutshell' attracted publicity because of her famous father, but her performance as an escapologist who breaks into a nuclear shelter deserved greater recognition in its own right. In 1964 she appeared in the breathless pre-credits sequence of *The Black Torment*, an Italian-style Gothic horror filmed at Shepperton Studios. Her face stared out from newspaper advertisements and posters when the movie opened that October.

Her next major film role was for producer Peter Rogers and director Gerald Thomas, the team behind the Carry On films, in their 1965 comedy *The Big Job*. Rogers was especially impressed, describing Edina as "the next Brigitte Bardot" and casting her in *Carry On Cowboy* later that year.

When she began work on Hammer's *Slave Girls* in January 1966 she was considered up-and-

Right and opposite: Publicity portraits from *Slave Girls* by Ronnie Pilgrim. **Below:** Colonel Hammond (Robert Raglan) and his daughter Sarah (Edina Ronay) in the baffling climax of *Slave Girls*, released in 1968.

coming enough to warrant second billing behind the film's star, Martine Beswick. The two became good friends during the filming, both part of a set Martine nostalgically describes as "the beautiful people".

In *Slave Girls* Edina was cast as the rebellious blonde Saria, who initially bites and then falls in love with bewildered hunter David Marchant (Michael Latimer) on his arrival in a strange jungle kingdom. Their passionate relationship incites a jealous response from the ruthless Kari (Martine Beswick) but, in a frankly incomprehensible final twist, seems to transcend David's return to the outside world.

Slave Girls made next to no impact on its belated release but Edina continued acting, notably guest starring in ITC filmed series *The Champions*, *Department S*, *Randall and Hopkirk (Deceased)* and *Jason King*. Her final film, the strangely compelling *Zapper's Blade of Vengeance* (aka *The Swordsman*, 1974), saw her character suffer an indescribable fate at the hands of a villainous Alan Lake. Perhaps unsurprisingly, she retired soon after.

As Michael Carreras correctly noted, since the mid-1970s Edina Ronay has established a successful new career as a fashion designer. After selling hand-knitted jumpers at London markets she started her own label in 1984 and forged an international reputation that consigned slave girl Saria, and all her other acting roles, to history. ∞

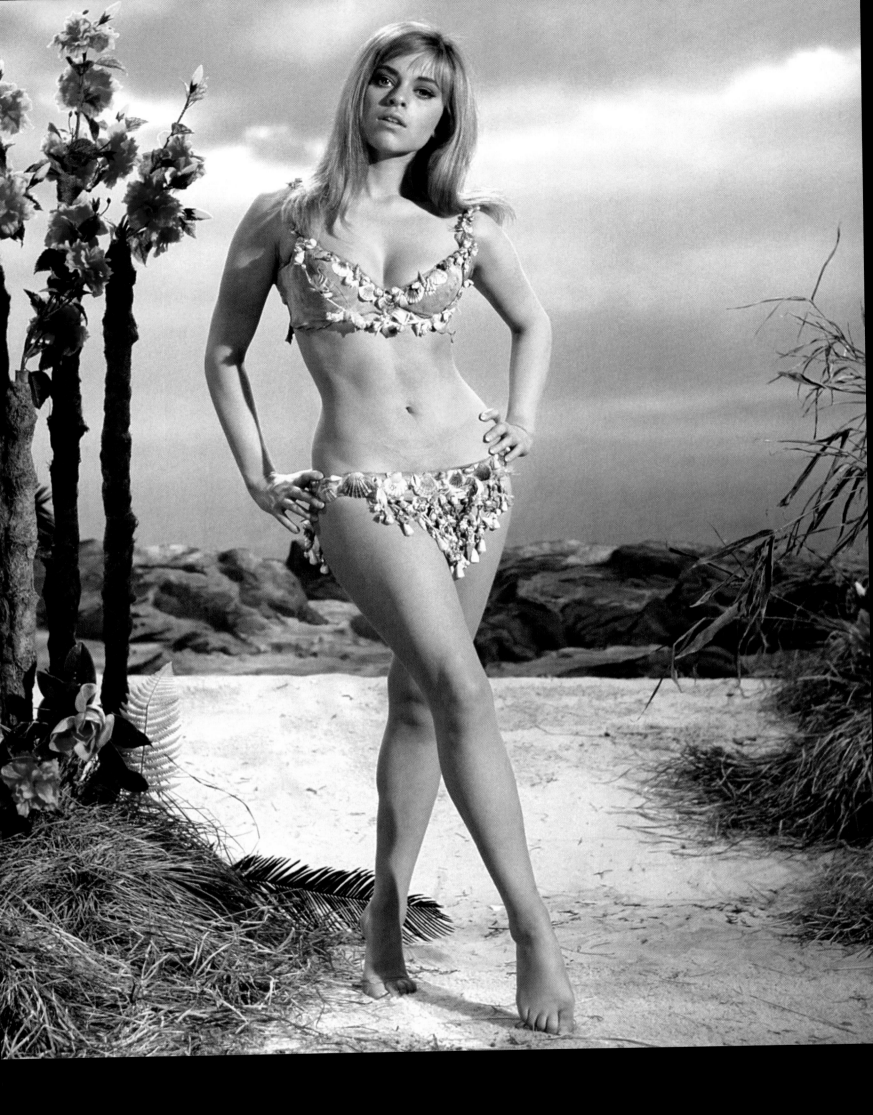

CATHERINA VON SCHELL

HAMMER'S critical judgement was seriously on the blink when it commissioned *Moon Zero Two*, but the company fortunately hadn't lost its knack for discovering talented and beautiful actresses. Catherina Von Schell is one of the saving graces of Hammer's disastrous space western.

She was born Katherina Freiin Schell von Bauschlott in Budapest, Hungary, on 17 July 1944. Her father was a diplomat and her mother a countess, but her family lost their estates and wealth to the Nazis. In 1950 they fled Hungary before Stalin's communists arrived, settling in New York. "I was brought up in America, and that is where I learned to disregard aristocracy," she says. "In American schools the only thing that would have made any difference to me would have been money. And we didn't have any, so there was no difference."

Catherina attended the Otto Falckenburg Academy of Performing Arts in Munich, and donned a tattered bikini for her film debut in *Lana: Queen of the Amazons* in 1964. In 1968 she met her first husband, the actor William Marlowe, when they both appeared in *The Amsterdam Affair*. She moved to London and received an important break when she was cast as the exotic Nancy in *On Her Majesty's Secret Service*. (George Lazenby's James Bond describes her as "an inspiration" during a night of serial shagging.)

Right and below: Two diverse portraits of Catherina from *Moon Zero Two* (1969) by photographer Arthur Lee.

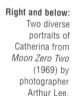

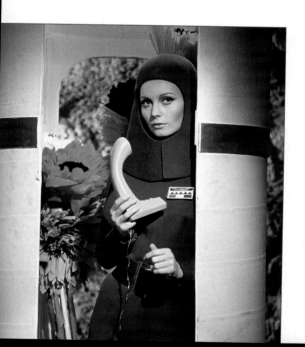

Hammer's *Moon Zero Two* began filming in March 1969, and the Bond gig elevated Catherina to star status. We first encounter her on the moon in the year 2021, although she removes her memorable mushroom-shaped balaclava to reveal the relaxed, natural beauty that made her such a popular face in the years following the Summer of Love.

It's difficult to adequately summarise the ensuing events on, and off, the lunar surface,

but Catherina stripping down to her space-age undies is a rare diversion in this plodding film.

The failure of *Moon Zero Two*, and the relatively disappointing reaction to *On Her Majesty's Secret Service*, didn't seem to hinder Catherina's career. After shortening her name to Catherine Schell she enjoyed more than 20 years of high profile work, becoming something of a celebrity amongst cult television fans in particular. Highlights from the 1970s include 'The Morning After', an episode of *The Persuaders!* in which she apparently marries Roger Moore during a night of drunken revelry. She co-starred in *The Return of the Pink Panther* (1975) and the following year joined the cast of lavish television series *Space: 1999* as a shape-changing alien. She ended the decade with a guest-starring role in 'City of Death', widely regarded as one of the most successful *Doctor Who* stories.

Catherine and William Marlowe separated in 1974. By the time of their divorce in 1977 she was living in a flat in Fulham, downstairs from Marlowe's first wife Linda.

In 1992 Catherine married theatre and television director Bill Hays. In 1995 they decided to retire from their respective careers to establish Maison Valentin, a secluded bed-and-breakfast in the Auvergne, France. Catherine has no regrets about leaving acting behind. "I got fed up with waiting around," she says. "You have to be so aggressive to get work in London now." ∞

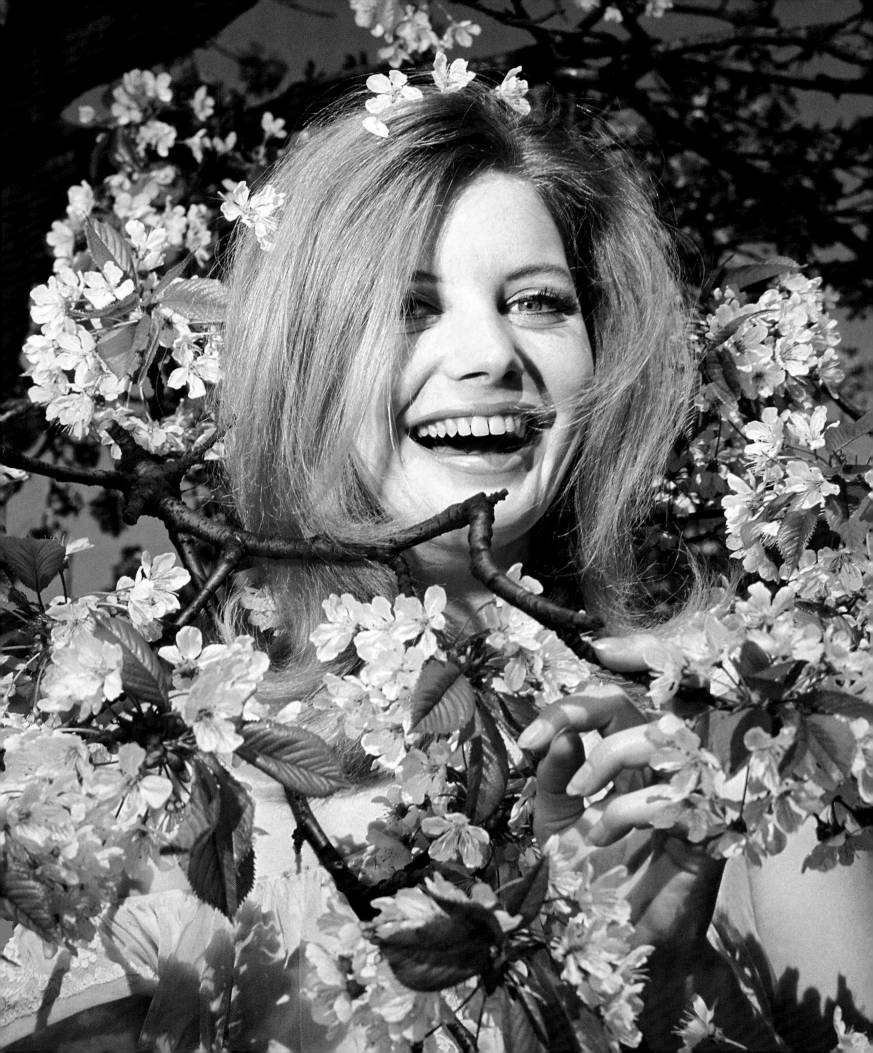

JANETTE SCOTT

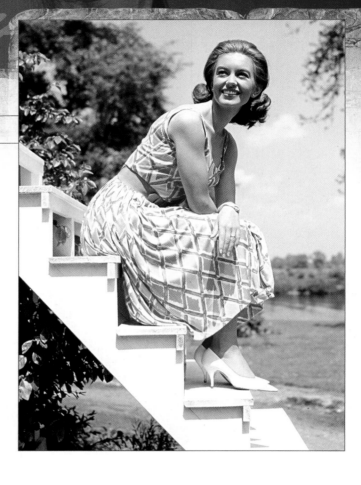

Right and opposite: Hammer's staff photographer Tom Edwards took these images to promote Janette's appearance in *The Old Dark House* in 1962.

THE daughter of actress Thora Hird and the ex-wife of American actor and musician Mel Tormé, Janette is one of the roll call of B movie icons mentioned in 'Science Fiction, Double Feature', the opening song in *The Rocky Horror Picture Show*.

Thora Janette Scott was born in Morecambe on 13 December 1938. She was a child actor who made an uncredited appearance alongside her mother in the Ealing classic *Went the Day Well?* (1942) and went on to write her autobiography, *Act One*, aged just 14. She worked steadily in British films and television throughout the 1950s, and in 1960 was the "ravishing creature" who caught Terry-Thomas' eye in the classic *School for Scoundrels*.

Janette's first Hammer film was the ill-conceived William Castle collaboration *The Old Dark House*. The film was neither frightening nor particularly funny, and failed to find an audience interested in horror or comedy. Janette was cast to type as the incongruously sweet Cecily Femm, and her wild-eyed transformation in the final act is the highlight of the film. Janette delighted in the character's red herring status, and the hysterical climax in which she threatened to behead Fenella Fielding with a meat cleaver.

Janette was much better served by the labyrinthine script for *Paranoiac*, which gave her one of the best roles of her career as the anguished and apparently incestuous Eleanor Ashby. Shooting began at Bray just weeks after *The Old Dark House* ended in summer 1962. Some of the film's gruesome surprises can still shock modern audiences, and Eleanor's hysteria when she kisses the man she believes to be her brother is especially disturbing.

Janette was top billed among a fine cast that included Hammer rep company miscreant Oliver Reed. As filming progressed Oliver developed something of a crush on Janette and would visit her home at weekends. When production ended, things started to get out of hand. On Janette's next film, *The Day of the Triffids*, Reed started to become a pest. "He would arrive in strange states of who knows what and force his way onto the set, saying I had asked for him," she recalls. "At first he was nice, then people had to be more strict and they got angry with him. I remember him forcing my car off the road a couple of times when I was driving at night, so it did get slightly out of hand. Of course, now it seems rather funny."

Aside from *School for Scoundrels*, *The Day of the Triffids* (1962) is the only other film on Janette's CV that can lay claim to lasting cult appeal. She later admitted that her star billing (appearing in the lighthouse sequences directed by an uncredited Freddie Francis) was partly a compensation for receiving such a low fee.

Janette married Mel Tormé in 1966 and retired to Beverly Hills soon after, deciding "to produce babies instead of films". For many years the risible *Bikini Paradise* (1967) was the last movie on her CV, but in 2008 she made a welcome comeback when she played Simon Pegg's mother in the successful comedy *How To Lose Friends and Alienate People*. A new career following in Dame Thora's footsteps surely beckons. ∞

BARBARA SHELLEY

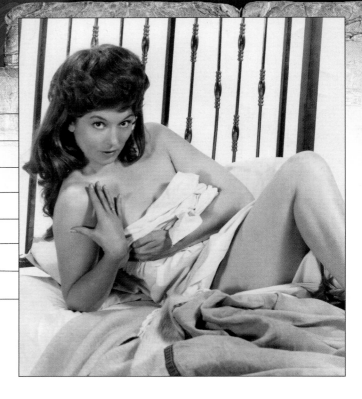

"I didn't do pictures like that!" says Barbara Shelley playfully, peering at photographs of her barely covering herself with a bed sheet. What at first glance appear to be cheesecake shots actually prove to be a series of pictures evoking her seduction scene from *Rasputin the Mad Monk*. "I was in character when I was posing for those," she says, expressing mock relief. "That sort of thing was all part of the job."

As a former model and Hammer's most prolific female star, Barbara Shelley was no stranger to photo shoots. More importantly, she was a thoughtful and accomplished actress who demonstrated her versatility in such landmark films as *The Camp On Blood Island*, *Dracula Prince of Darkness* and *Quatermass and the Pit*. The director of the latter, Roy Ward Baker, is in no doubt about her talents. "She was a beautiful girl," he says, "and she was very good at what she did."

Hammer's first lady was born Barbara Kowin in London on 15 August 1933. She shocked the nuns at her convent school by declaring she wanted to be an actress, but her initial success would be as a fashion model. It was in this capacity that she made her film debut in 1952 with a small role in the Hammer thriller *Mantrap*. She wasn't given another opportunity to act until she was recruited to a comedy revue while on a modelling assignment in Italy. From 1953 to 1957 she appeared in numerous Italian films, initially memorising her lines parrot fashion but eventually learning the language.

Top: Barbara in character as the vulnerable Sonia in *Rasputin the Mad Monk* (1966).

"I didn't really become what I'd call an actress until I came back to England," she says. "That's when I started doing radio,

television and theatre as well as films." In 1957 she played the title role in Alfred Shaughnessy's *Cat Girl*, a supernatural thriller that pointed the way to her future successes. Twenty years later, Shaughnessy noted in his autobiography, "By using her, I fear we condemned a very beautiful and talented actress to a long career in horror films."

Much of her film work would indeed be for producers of so-called exploitation films which, combined with her reputation as a model, meant she had to work hard to be taken seriously. She smiles as she recalls her efforts to preserve her modesty on the set of *Cat Girl*. "There was a scene where I was sitting up in bed. I got the hairdresser to write 'stop' across the top of my chest, so when I sat up and dropped the sheet I knew it couldn't be seen to go too far."

It was perhaps inevitable that she would come to the attention of Hammer, and in July 1957 she started work on the company's notorious prisoner-of-war drama *The Camp On Blood Island*. Her first Gothic horror, however, would be made for rival producers later that year. In *The Blood of the Vampire* she was subjected to the kind of treatment that was giving the genre a bad name. "There was a rape scene and afterwards the producers, Monty Berman and Bob Baker, and the director Henry Cass wanted me to walk around with everything hanging out. I refused because it wasn't in my contract. I said to them, 'I'm not going to do it, so you can sue me. And if you use a body double I'll sue *you*.' I was saved by a wonderful wardrobe lady who walked up to the director with a plate in each hand. She broke the tension by saying, 'Here you are

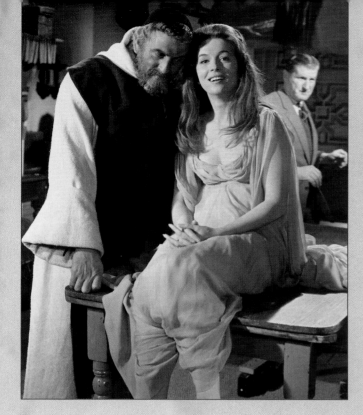

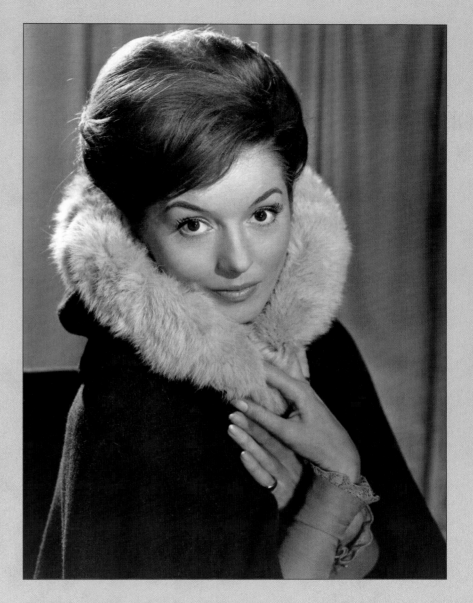

Mr Cass. Do you want them out on a couple of dinner plates?'"

In 1959 Barbara starred in the classic *Village of the Damned*, but she was soon back at Bray Studios and didn't stray far from Hammer for the next seven years. In 1960 director John Gilling cast her in *Shadow of the Cat*, and in 1963 Terence Fisher chose her to play opposite Peter Cushing and Christopher Lee in *The Gorgon*. *The Secret of Blood Island* was filmed in 1964, and was a colour prequel that confusingly cast Barbara as a different character from the one she had played in the original film. Her next two parts for Hammer, in *Dracula Prince of Darkness* and *Rasputin the Mad Monk* (both filmed in 1965), were rather more satisfying.

"To my mind the best role that Hammer gave me was in *Dracula Prince of Darkness*, because I went from an uptight Victorian lady to a no holds barred vampire," she says. "Hammer knew that it wasn't what you saw that was important, it was what you *didn't* see. There is nothing more frightening than your own hidden fears. There's an example of this in *Dracula Prince of Darkness* when I discover what has happened to my husband [Charles Tingwell]. You hear the dripping blood, and you see the silhouette of the corpse against the green light, but the horror of the situation comes from my reaction to seeing his body hanging in front of me with its throat cut."

Her final Hammer role came in *Quatermass and the Pit* (1967), in which her character Barbara Judd memorably establishes a psychic link to the insectoid aliens. In a sequence crucial to our understanding of the Martians' ancient influence, Barbara's hysteria proves much more convincing than the ropey special effects.

By the 1970s Barbara felt "trapped" by misconceptions of the horror genre and concentrated on other work, ultimately realising a long-held ambition to spend a season with the Royal Shakespeare Company. In 1988 she retired from acting to run an interior design business.

Barbara never married, and was so discreet about her boyfriends that she had to put up with irritating rumours that she was a lesbian. Such hostility from fellow actors was rare, however, and she now prefers to remember the companionship and fulfilment of her happiest productions. "I was busy all the time," she says. "I realise now I was very lucky, and I'm so grateful to Hammer and the other producers that gave me work."

She reflects on her career with a faint air of detachment, almost creating the impression that everything she describes actually happened to someone else. "I've learned that to live in the present is the most important thing. There's a lovely saying – We're given memories so we can have roses in winter. When I look back over my various rose gardens I'm only sorry I didn't enjoy them more at the time." ∞

Opposite: This Tom Edwards shot from *Quatermass and the Pit* (1967) is one of Barbara's favourite Hammer photographs.
Top left: With Andrew Keir on the Bray set of *Dracula Prince of Darkness* (1966).
Above: An elegant Tom Edwards portrait from *The Gorgon* (1964).

137

MADELINE SMITH

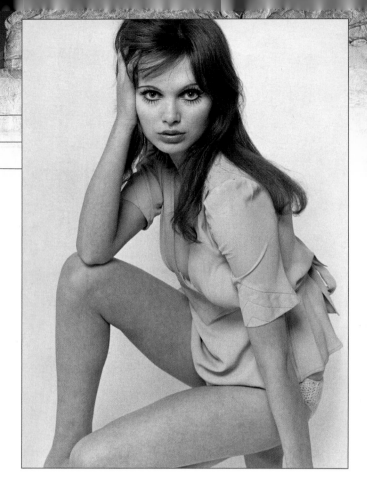

TYPECAST as comedy crumpet throughout the 1970s, the curvaceous Madeline Smith wiggled and pouted through *Up Pompeii*, *Doctor at Large*, *The Two Ronnies* and numerous other light entertainment favourites. A decorative and talented comic actress, she is less well known for the three Hammer horrors she graced at the beginning of her career.

Madeline was born in Hartfield, East Sussex, on 2 August 1949. She grew up in Kew and, aged 11, won a scholarship to a convent school in Ealing. She had early ambitions to become a doctor, but at 15 decided to study after hours at the renowned Questors Theatre near her school. She passed an audition to appear in a production there but she was prevented from taking part by one of the nuns at her school.

"I never again had the guts to try for drama school," she says, her voice deepening with resentment. "I wasn't brave enough. That woman took the stuffing out of me, and I've still got very mixed emotions about her."

In the summer of 1967 Madeline got a job at the Kensington boutique Biba, where the designer Barbara Hulanicki launched her brief career as a model. A talent scout approached Madeline in the street and offered her a role in the Italian film *Escalation* and she followed this up with a part in *The Mini-Affair*. Both films were released in 1968, by which time Madeline had decided to attend classes at London's City Lit in order to improve her acting skills.

Madeline was at the epicentre of Swinging London, but claims that the so-called permissive society passed her by. "I was gormless when it came to things like that," she says matter-of-factly. "The closest I got to anything dangerous was going out with a young man who subsequently became a monk."

In 1969 Hammer cast Madeline in the small role of Dolly, a prostitute in a brothel scene dominated by an extraordinary snake-charming sequence. Dolly is provided as entertainment for the thrill-seeking Hargood, Paxton and Secker, but is swept away by the even more decadent Lord Courtley (Ralph Bates).

"I watched *Taste the Blood of Dracula* the other night and I was reminded of why I was so happy in that scene," she says. "Those chaps – Geoffrey Keen, Peter Sallis and John Carson – were all top notch actors. It's a wonderful little scene, although I must admit I wasn't sure about that snake..."

Less than three months later Hammer invited Madeline back to Elstree to appear as Emma Morton in *The Vampire Lovers*, their most sexually explicit film to date.

"My nightie had to be pulled down to my waist and I had to run around with no top," she says, recalling the sequence she and Ingrid Pitt shared when they were both half-naked. "I wasn't exactly ecstatic about this, but when we were filming it one of the producers, Michael Style, told us that those scenes were for the Japanese version and that they wouldn't be seen over here. Of course I later realised that there was no Japanese version, and that this was something he told us so he could get his way. I was a virgin when I made the film. I didn't know what a lesbian was and I had no idea what was supposed to be happening on that bed."

The early '70s were busy years for Madeline, and in 1972 she received the most prominent role of her career when Roger

Opposite: "I remember that frock," says Madeline. "It was too rude to wear in public. I think that was its only airing."

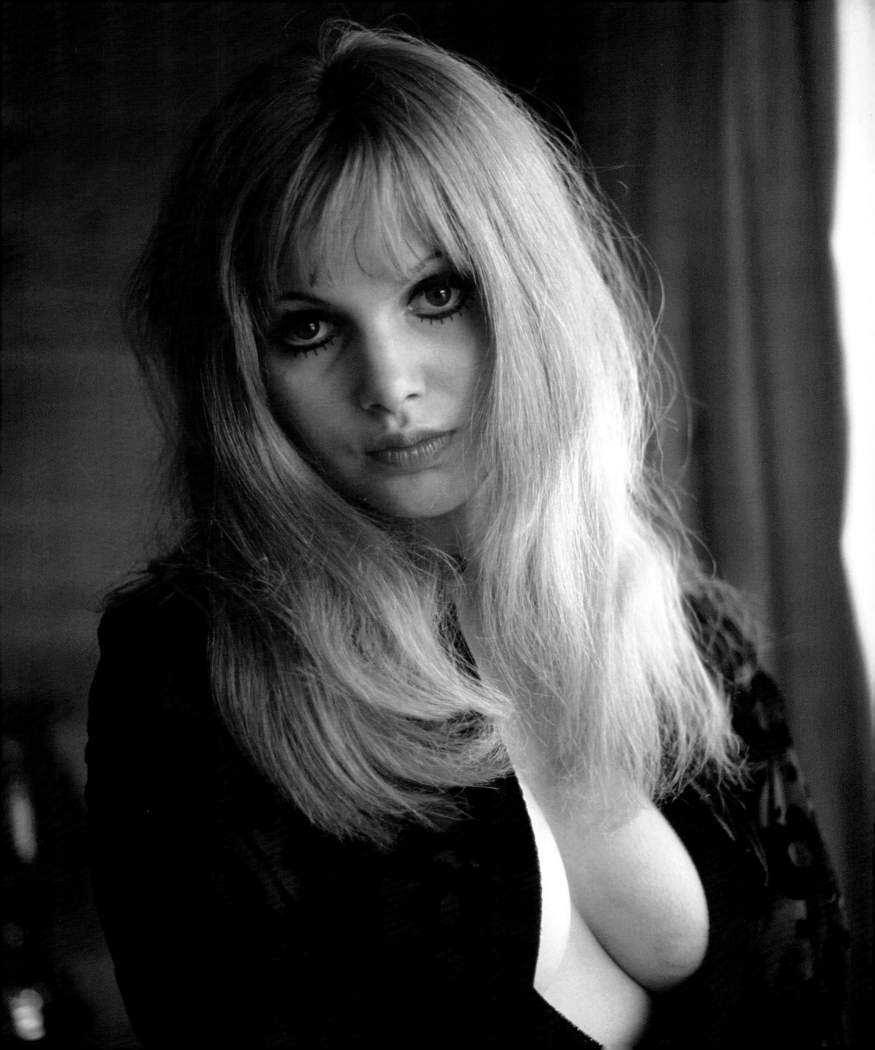

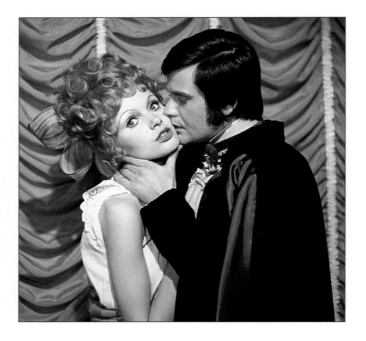

Right: Dolly is seduced by Lord Courtley (Ralph Bates) in *Taste the Blood of Dracula* (1970). **Below:** Madeline and her *Vampire Lovers* co-stars Pippa Steele and Janet Key at Elstree Studios in 1970. *Mr Forbush and the Penguins* was shooting on a neighbouring soundstage. **Opposite:** With Ingrid Pitt in *The Vampire Lovers*.

Moore recommended her to play Italian agent Miss Caruso in his debut James Bond film, *Live and Let Die*. Before this, however, there was a sombre farewell to Hammer in *Frankenstein and the Monster From Hell*. Madeline's sensitive performance as Sarah, the mute 'Angel' to the inmates of a lunatic asylum, was the most important she gave for the company.

"This was a film that didn't show my body at all," she remembers. "It was entirely about my face. This was the direction I would have liked to continue in, but I wasn't given the opportunity after that. The Frankenstein film was a fluke, in that respect."

On the set of the film Madeline gave an interview to Hammer publicist Jean Garioch in which she claimed that working in showbusiness was beginning to pall and that she was considering becoming a nurse. "I was beginning to find my life very superficial," she says, recalling how she felt. "I was profoundly unhappy because I was untrained, and I suspected that the plateau I'd reached was as good as it was going to get. I felt as though I was never going to be able to prove myself as anything other than a pair of breasts. But don't pay too much attention to what the Maddy of 1972 said in that interview. I now realise what a lucky person I actually was, and that working for Hammer was a very good thing. Hammer got the very best performances out of me and those three little films were wonderful."

In 1974 Madeline met the former Hammer star David Buck when they were both cast in an episode of the ITV drama *Crown Court*. They were together until he died of a brain tumour in 1989. "We got married six months before he died, in the beautiful chapel at Charing Cross Hospital. I'm not really the marrying kind, but by then we had a daughter, Emily, and we both agreed that we had to get married for her sake."

Having to cope as a single mother effectively brought Madeline's career as a stage and television actress to an end. "And once I stopped I couldn't jump start it again. Now I'm much older, I'm not sufficiently trained or experienced, and there's too much air between me and my last performance so I don't know in what way I'd come back. In 1979 I did an English degree, so now I'd like to use that to become a writer."

The years have done little to diminish the effervescence that made Madeline so popular in the 1970s, and it would be a loss to the profession if she has indeed acted for the last time. She is resolutely cheerful, however, and proud that Emily has recently graduated from drama school.

"Having had a kid, a long-term relationship and having done a degree, the long view of my life and career is now one of intense joy and happiness," she says. "I look back at myself in photographs and think, You lucky little bunny. I loved it. All of it." ∞

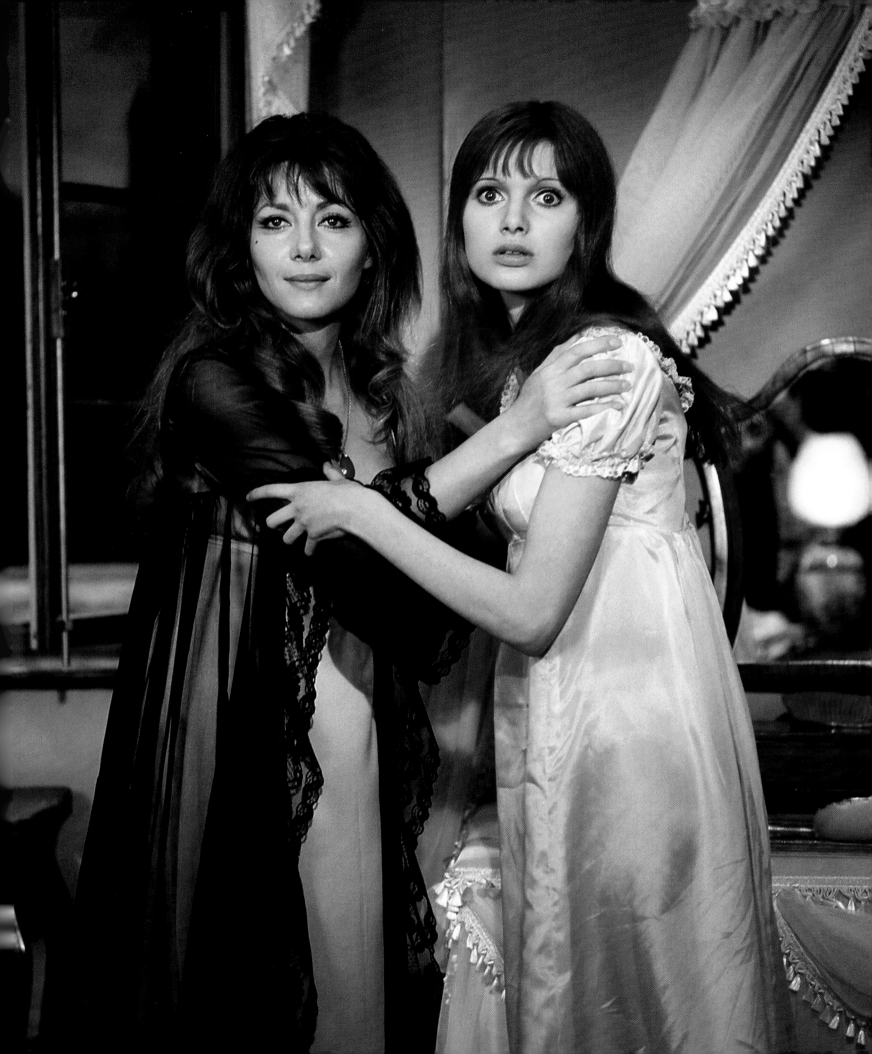

YUTTE STENSGAARD

THE rise and fall of Yutte Stensgaard is the cautionary tale of an aspiring actress who put years of effort into a career that was over as soon as it finally began. A beautiful and sincere Danish girl who was thrown to the sharks of London's film business, Yutte's handful of movies sadly include some of the most vulgar films of the era.

Jytte Stensgaard was born in Thisted, in Denmark's Jutland peninsula, on 14 May 1946. In 1963 she moved to England, initially living with a family in Cambridge and working as their au pair. There were modelling assignments in London, but Jytte was more interested in becoming an actress so joined Ronald Curtis' Studio Film Craft Drama School. She spent three years at the school, and in 1967 married Ronald's son, the art director Tony Curtis. Ronald became her manager, and used his contacts as a casting director to suggest her for roles.

"All the British films being made now have nude scenes, no matter if it's a discussion play, a spy movie or a war film" she told Danish newspaper *Aalborg Stiftstidende* in 1968. "If not, people won't bother to see them, according to the producers. So sooner or later I'll probably have to jump on the bandwagon."

Below: An early modelling assignment for Yutte in 1966.

She changed her stage name to the more easily pronounced Yutte and made her film debut in Monica Vitti's *La ragazza con la pistola* (*Girl with a Pistol*, 1968). *Scream and Scream Again*, filmed in 1969, was the finest movie she ever appeared in, but she was less fortunate with the same year's *This, That and the Other!* and *Zeta One*. Both films traded purely on her looks, and she particularly came to regret her participation in the latter's interminable strip poker sequence.

The prospect of appearing in a Hammer horror must have been more appealing, but Yutte can't have been aware that the company was struggling with something of an identity crisis as the new decade began. Producers Michael Style and Harry Fine's latest production, ultimately titled *Lust for a Vampire*, would be even racier than its predecessor *The Vampire Lovers*. Fine and Style cast Yutte as the reincarnation of Carmilla Karnstein, the character previously played by Ingrid Pitt. It would be Yutte's first, and last, starring role.

The pre-production of *Lust for a Vampire* was beset by problems. Principal cast-members Ralph Bates and Suzanna Leigh were late replacements for other actors, and director Jimmy Sangster similarly substituted for original choice Terence Fisher at the last minute. When shooting began in July 1970 Sangster's temper was frayed by Style and Fine, and he took some of his frustration out on Yutte when she naively asked the director about her character's motivation for getting out of a carriage.

"It was one of the first shots in the picture," says Sangster, "and I wouldn't have minded so much but the camera was about 100 yards away from her. She could have got out of that carriage cross-eyed and no-one would have noticed. I think she wanted to set out her parameters, but it was a difficult film and I was more interested in the actors remembering their lines and not tripping over the furniture."

Hammer's traditional elegance was stifled by an uncomfortably exploitative scenario, gratuitous nudity and an intrusive vocal number by 'Tracy' called 'Strange Love'. As Yutte's character Mircalla works her way through the pupils and staff at a ladies' finishing school it becomes depressingly clear how far Hammer's standards had fallen.

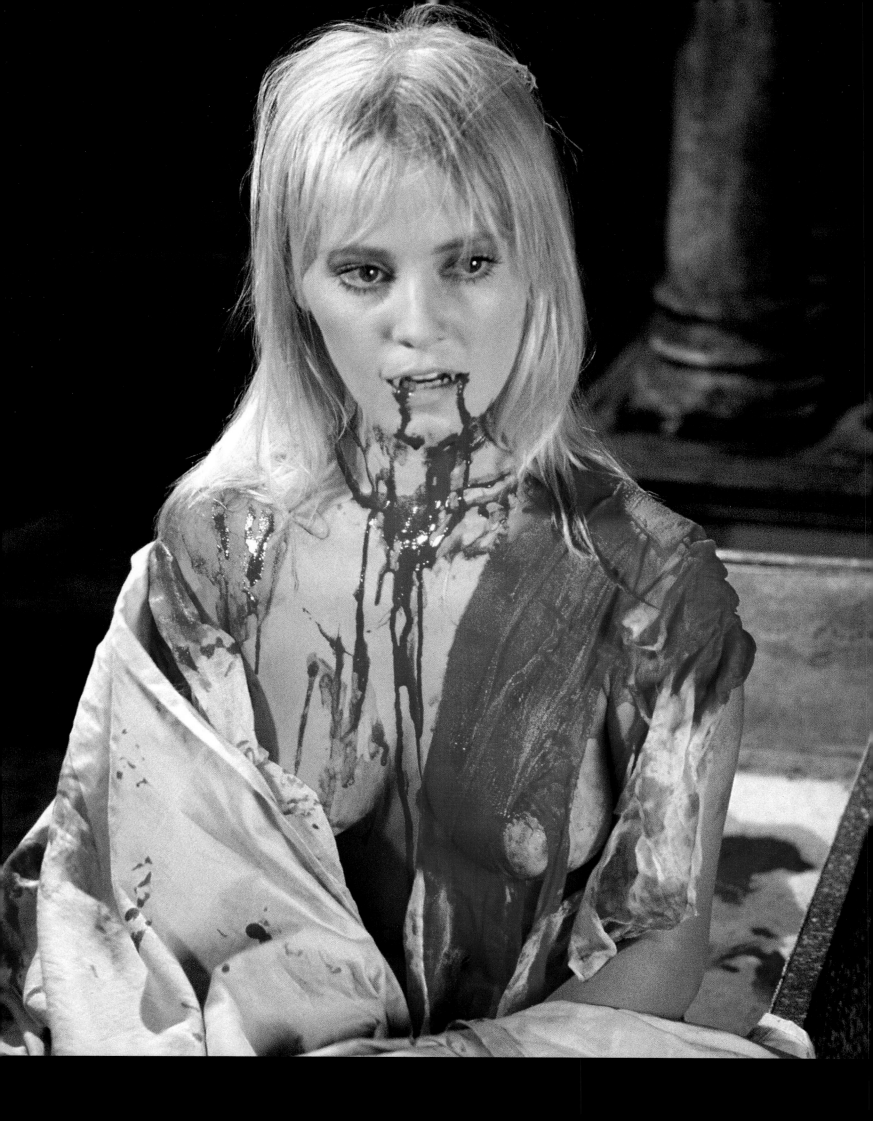

Yutte was alarmed to discover her voice had been replaced in the finished film, but this couldn't disguise the fact that she was no match for Ingrid Pitt. The *Lust for a Vampire* pressbook did her few favours by claiming that her ambition was to be, "not just a successful screen personality, but a good and competent actress."

Against her better judgement, Yutte accepted an offer to become the hostess of ATV's popular game show *The Golden Shot*. She spent much of the first half of 1971 on the programme and was hurt when the British press, who had previously been supportive of her efforts, falsely claimed she had been fired because of her Danish accent.

At the end of 1971 Yutte and Tony Curtis separated, and without the guidance of her former father-in-law her career entered a steep decline. At the beginning of 1972 she was working part-time at a Bond Street clothes shop. "I want to get enough experience to open a boutique of my own, as a second string to my acting career," she bravely told a visiting reporter.

That summer she met John Kerwin, a foreign correspondent for American television network NBC, when they were both watching the tennis at Wimbledon. They fell in love and Yutte followed him to New York, hoping to start a new career as a singer.

In America, however, things proved even harder for her. In July 1974 she told *Aalborg Stiftstidende*: "I'm tired of the whole film business, tired of living in hope... I'm not disappointed that more

didn't come out of it, but it bothers me that I didn't see earlier how difficult it is. I could have used my time on something better. I want a husband, a home and eventually kids, but I also want time to be a career woman."

She married John the following month and they had a son, Sten, who became the subject of a custody battle when the couple divorced in 1979.

Yutte settled on the West Coast but never remarried. In the late 1980s she became a born again Christian and subsequently worked for a magazine and radio station run by the priest whose philosophies had transformed her life. Once deeply reluctant to be reminded of the films she made in England, she has since reconciled herself to her past and has even attended fan conventions in America.

Yutte is now a national account director for one of America's biggest radio networks. Forty years on from her short-lived film career she is happy to have finally found her true vocation. ∞

Above: At work in a West End boutique in February 1972.

VICTORIA VETRI

Right: Filming the nude sequence that would only be seen in the British version of the film. **Below:** Sunbathing on location in the Canary Islands.

THE promotional film *Beauties and Beasts* purports to reveal the inner workings of Hammer's publicity machine, but is little more than propaganda itself. Inside Hammer House the film eavesdrops as James Carreras confers with company director Brian Lawrence and producer Aida Young. They discuss the virtues of Ursula Andress and Raquel Welch before turning their attention to their latest discovery.

"Isn't it exciting to find somebody new and launch them each time?" asks Young.

"If we can find somebody that looks like this, I agree," says Carreras, holding up a photograph.

"What's her name?" asks Lawrence.

"Victoria Vetri," replies Carreras.

Victoria Cecilia Vetry was born to Italian parents in San Francisco on 26 September 1944. In the 1960s she was married and divorced twice, and gave birth to a son. During this period she had used the pseudonym Angela Dorian for her various endeavours as a folk singer, model and actress. It was Angela whom *Playboy* crowned Playmate of the Year 1968, and it was Angela who had appeared in *The Man from UNCLE*, *Batman*, *Star Trek* and *Rosemary's Baby*.

Her first movie role under her real name (albeit with a slightly different spelling) was Hammer's *When Dinosaurs Ruled the Earth*. American distributor Warner Bros reportedly hired Francis Ford Coppola to shoot her screen test before sending her to London amid a barrage of publicity.

Director Val Guest supervised a five-week location shoot in the Canary Islands which began in October 1968. The cast and crew enjoyed a party atmosphere and Victoria was entirely relaxed about taking her clothes off for a naked swim that would only be seen in the X rated British print of the movie.

In December journalist Tony Crawley visited the studio filming at Shepperton, only to witness a mishap in the water tank that knocked her goatskin bra off. "That's not even embarrassing anymore," she said afterwards. "Happens every other shot. At least losing a bra doesn't hurt. Everything else does. My worst bruises come from that damned tank. That's where I banged my knee – here, see. That's where I trod on a loose nail – down there. That's where I fell off the bloody raft thing and banged this shoulder – see that bruise, under the make-up. God, what I didn't do..."

Victoria had great ambitions for the future, and especially hoped to win the long-coveted role of Maria in a production of *West Side Story*. *When Dinosaurs Ruled the Earth* was, however, her last major film, and her television career would fizzle out in the mid-1970s.

While she was being battered at Shepperton, James Carreras was singing her praises to *Films and Filming* magazine. At the same time he made it clear that she was simply part of the Hammer glamour turnover. "I think Victoria Vetri has the quality of Raquel Welch and will certainly go on, but we haven't any future projects lined up for her. We launch people, but we're looking for new faces all the time. With these spectaculars you don't really need stars..." ∞

RAQUEL WELCH

HAMMER'S remake of Hal Roach's 1940 dinosaur epic *One Million B.C.* was originally intended to reunite Ursula Andress and John Richardson from *She*, but Ursula had appeared in that film under duress and refused to return.

Pre-production on *One Million Years B.C.*, as the remake would be entitled, got underway before *She* was even released. In summer 1965 Tom Chantrell was commissioned to illustrate a giant brochure promoting the film, and chose to foreground an illustration of a girl in what looked like an animal-skin swimsuit. She wore a necklace made of animal teeth and brandished a sharpened rock like a dagger, all of which was more in keeping with the violence associated with Hammer's X certificate films.

American distributor Twentieth Century-Fox had other ideas. Richard Zanuck, the company's vice-president in charge of production, nominated the relatively unknown Raquel Welch as the film's lead cavegirl. The actress had just completed her first starring role, in the science fiction film *Fantastic Voyage*, and had already proved that she was no pushover. When Zanuck asked her to cut her hair for the role she refused, so he told her to be a team-player. "Where's the team?" she replied.

Raquel was awaiting the release of *Fantastic Voyage* when she received a phone call from Zanuck, asking her to appear in *One Million Years B.C.* When Raquel learned that the film was a dinosaur movie she immediately protested. At which point Zanuck reminded her that she was under contract to Twentieth Century-Fox and that she had no choice but to do as she was told.

London's reputation as a 'swinging' city was starting to reach Los Angeles, and Raquel consoled herself with the thought that she could at least sample some of the capital's burgeoning counter-culture while she was there. "I thought I'll go to London, I'll do this turkey, and then everybody will forget about it and I'll have myself a great time." She couldn't have been more mistaken.

Raquel Welch was born Jo Raquel Tejada in Chicago on 5 September 1940, the daughter of an Irish-American woman who met her Bolivian husband at a Spanish class. At school in San Diego, Raquel won the first in a string of beauty contest

Right and opposite: Images of Raquel taken by Pierre Luigi during the location shoot in Lanzarote.

titles and went to work as a weather girl at her local TV station. She married fisherman James Welch in 1959 and the couple had two children, but in 1961 Raquel packed her bags and took her children for a new life in Dallas. After a spell waitressing and modelling she relocated to Los Angeles and started getting small roles, including a bit part as a college girl in the Elvis Presley film *Roustabout* (1964).

Encouraged by producer Patrick Curtis, who would become her second husband, Raquel attended numerous auditions and was eventually offered a contract by Fox. They launched her career with *Fantastic Voyage*, in which she joined a team that was shrunk to microscopic size and injected inside the body of an assassination victim in order to remove a blood clot from his brain.

One Million Years B.C. was similarly far-fetched, casting Raquel as Loana, a feisty but compassionate member of the blonde Shell tribe. Loana encounters the rugged Tumak (John Richardson), an outcast from the Rock tribe, and the ensuing plot contrives to place them in frequent peril from stop-motion animated dinosaurs, man-eating gorillas and even a giant turtle.

The quality of Ray Harryhausen's special effects, and the

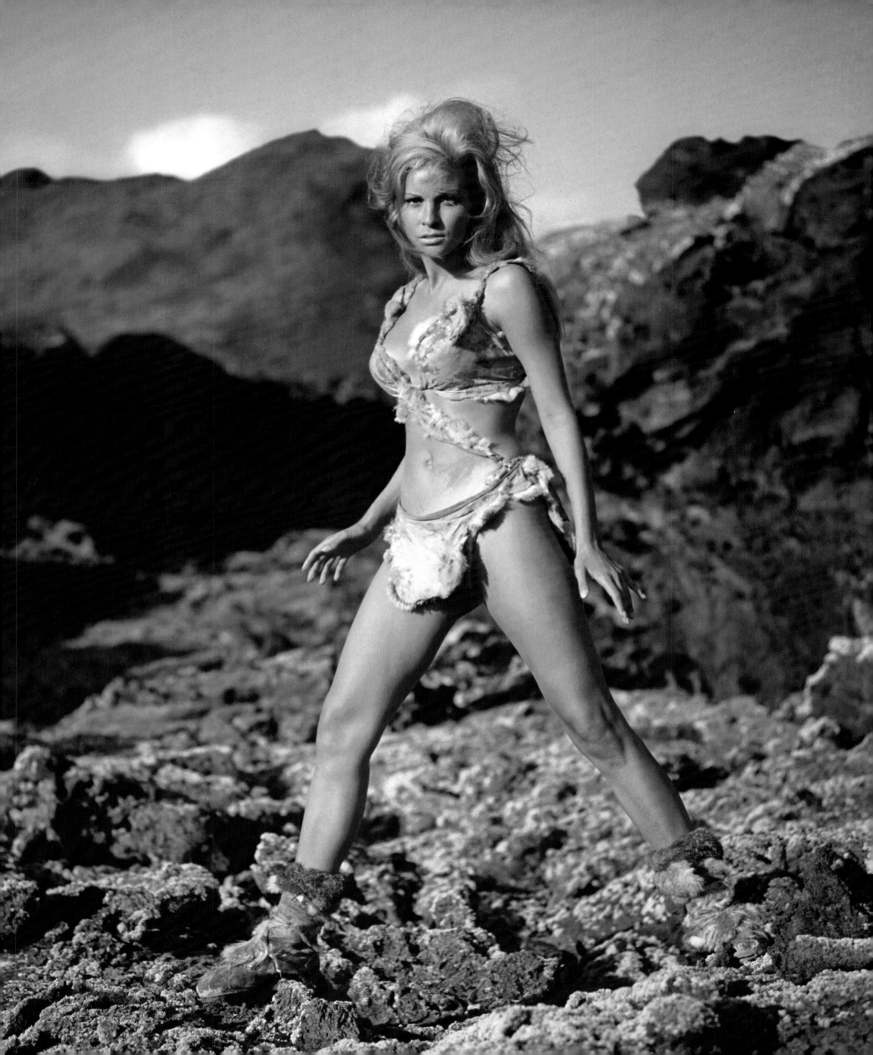

stunning location photography in the Canary Islands, would probably have ensured that the film was a hit anyway. The presence of Raquel, looking stunning in a skilfully engineered bikini, made *One Million Years B.C.* irresistible.

In 1971 costume designer Carl Toms told *Today's Cinema* about Raquel's legendary outfit. "She has such a perfect body that I took a very soft doeskin, we stretched it on her and tied it together with thongs – prehistoric people knew nothing of bust darts and seams. We then took tiny pieces of fur and glued them at the edges of the bikini to make it appear as though Raquel was wearing two strips of fur inside out."

The film's director, Don Chaffey, made the location look swelteringly hot, but Raquel remembers that at one point it actually started snowing. "It was freezing, and I got the worst case of tonsillitis. I almost died from it, I was frozen solid. I was out there with hardly anything on and I was trying to embellish

Below and opposite: Ronnie Pilgrim took these studio portraits when *One Million Years B.C.* continued filming at Elstree.

my part with little subtleties. It never turned out that way and it was probably for the best, because I was pretty green and I'm not sure my ideas would have worked anyway. The director would say, 'Please darling, I don't want to hear any ideas. You see Rock A over there? You start at Rock A, you run to Rock B, and in the middle imagine you see a giant turtle coming over the hill.'"

Unit photographer Pierre Luigi's most famous still of Raquel, taken on location in Lanzarote, was reproduced in an estimated 200 newspapers and magazines all over the world. It made Raquel a star, and one of the greatest sex symbols of the decade. "Part of me loved it," she says, "but part of me thought, Oh gosh, I'm not sure I like this – no one was supposed to see me in this movie!"

Raquel was even more alluring in the original *Bedazzled* (1967), and went on to appear in *Hannie Caulder* (1971) and *The Three Musketeers* (1973). In 1980 a dispute with MGM over her alleged behaviour on the set of *Cannery Row* ended in a lawsuit, which

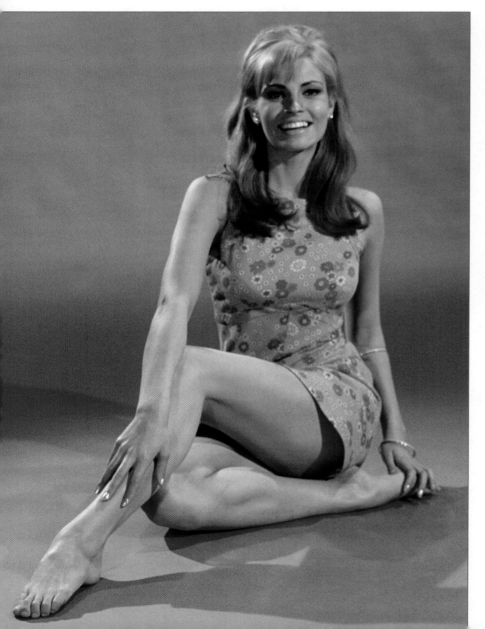

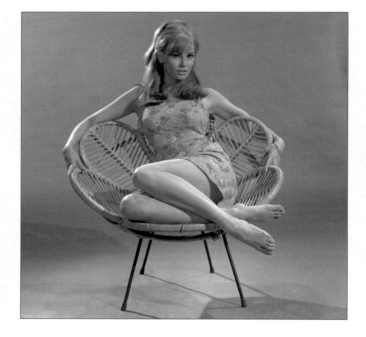

Raquel won. She was awarded a multi-million dollar payout, but later admitted that the incident had made her an "outcast" to the Hollywood power-brokers who once employed her. Despite this fear she has continued to act in films and television and now also markets her own beauty and fitness products.

"That chick who was only allowed to come out of her trailer to say the line 'Me Loana, you Tumak,' is dead," she said in 1995, still trying to live down *One Million Years B.C.*

In more recent years she seems to have reconciled herself to the film, admitting, "It was a big hit and God knows it put me on the map, so I'm very grateful I did that silly dinosaur movie all those years ago." ∽

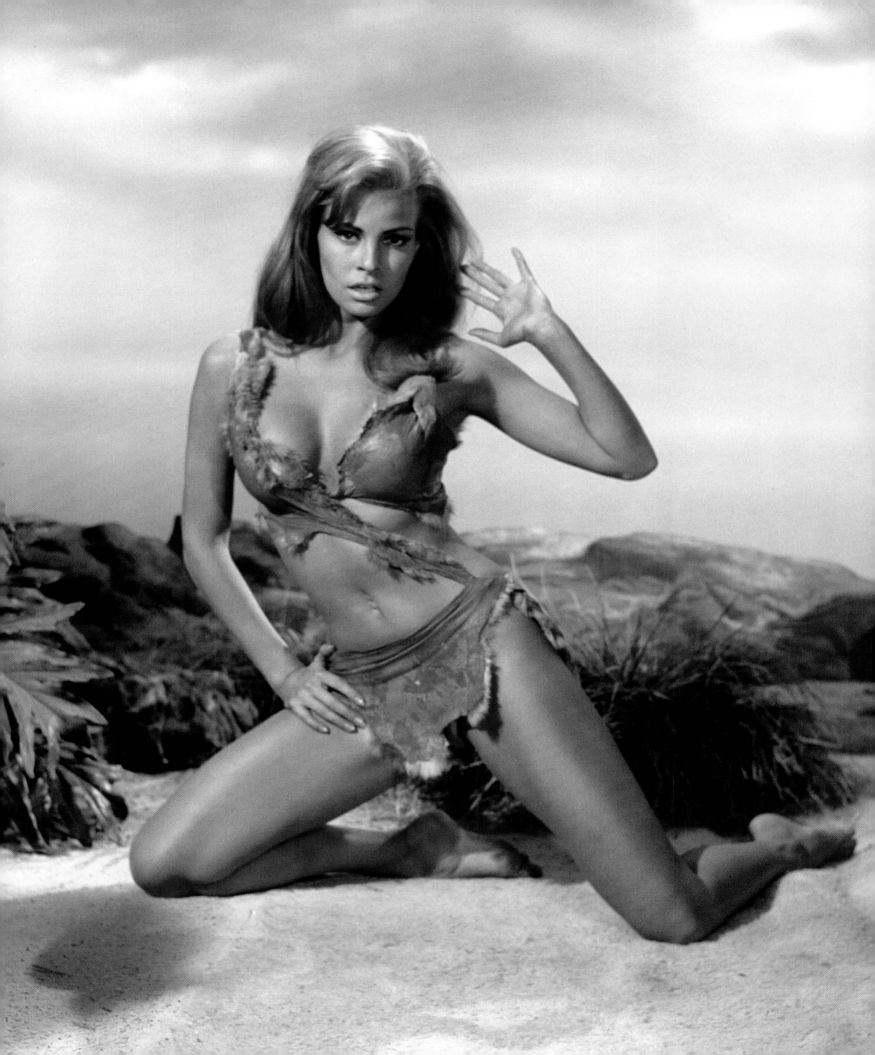

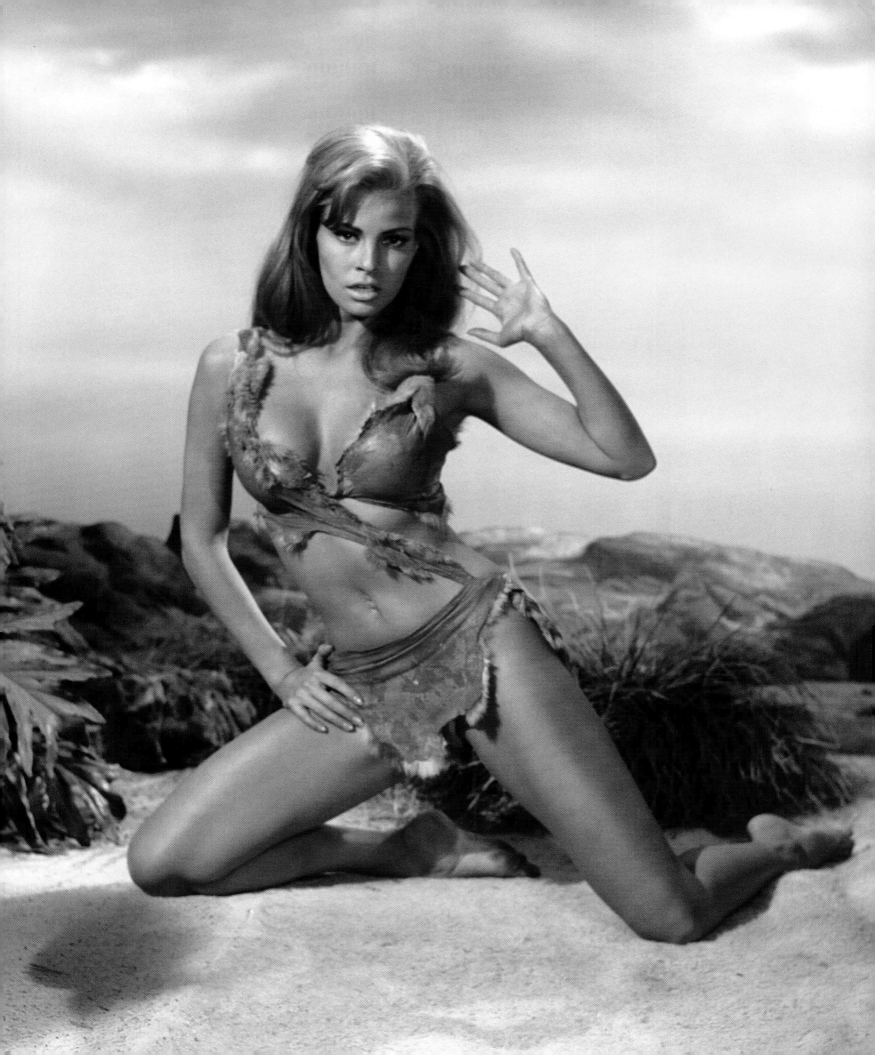

"PRACTICALLY" every glamorous young actress in Britain worked for Hammer, if only as a walk on," says Brian Clemens, who worked for the company as a writer, producer and director in the early 1970s.

Since their establishment in 1934 Hammer have employed hundreds of actresses as everything from supporting artists to stars. This book has highlighted 50 of the best known ladies to grace the company's films, but featured roles were given to many others who are not as closely associated with the studio. Some remain well known, while others have faded into obscurity.

DAWN ADDAMS
THE TWO FACES OF DR JEKYLL, THE VAMPIRE LOVERS

This elegant actress played Henry Jekyll's unfaithful wife Kitty (pictured here with Paul Allen, played by Christopher Lee) in

Hammer's misjudged *The Two Faces of Dr Jekyll* (1960). Frequently cast in aristocratic roles, she returned to Hammer ten years later for a brief turn as the Countess in *The Vampire Lovers* (1970). The film's director Roy Ward Baker also cast her in Amicus' *The Vault of Horror* (1973) but the remainder of her career was dominated by television. In 1983 she joined the regular cast of the BBC's derided soap opera *Triangle*. She died of cancer in 1985, aged just 54.

——— ∽ ———

NIKÉ ARRIGHI
THE DEVIL RIDES OUT, COUNTESS DRACULA

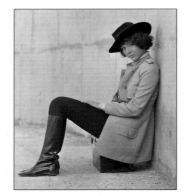

Niké Arrighi had the good fortune to be cast in some of the most acclaimed cult television of the 1960s. She is the airship attendant in the BBC's stylish adaptation of EM Forster's *The Machine Stops* (part of the *Out of the Unknown* anthology series) and played a gypsy who encounters the errant Number 6 (Patrick McGoohan) in the eerie *Prisoner* episode 'Many Happy Returns'. She had another small role as a gypsy in Hammer's *Countess Dracula* (1971) but had received the biggest break of her career in 1967 when Hammer cast her as Tanith, the vulnerable quarry of Mocata (Charles Gray) in *The Devil Rides Out*.

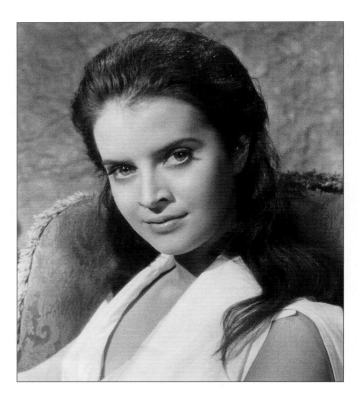

ISOBEL BLACK
THE KISS OF THE VAMPIRE, TWINS OF EVIL

The daughter of novelist and scriptwriter Ian Stuart Black, Isobel made her film debut as Tania, one of Ravna's disciples, in *The Kiss of the Vampire* (filmed in 1962). The scene where she longingly claws at the earth above the grave of Zimmer's daughter is perhaps the most macabre in the entire movie. She met her husband, director and producer James Gatward, while appearing as a regular in the BBC's boardroom drama *The Troubleshooters* from 1967 to 1968. She later played the hapless schoolmistress Ingrid in Hammer's *Twins of Evil* (1971). "Ingrid's such a sweet character I'm almost sorry she comes to such a sticky end," she said at the time.

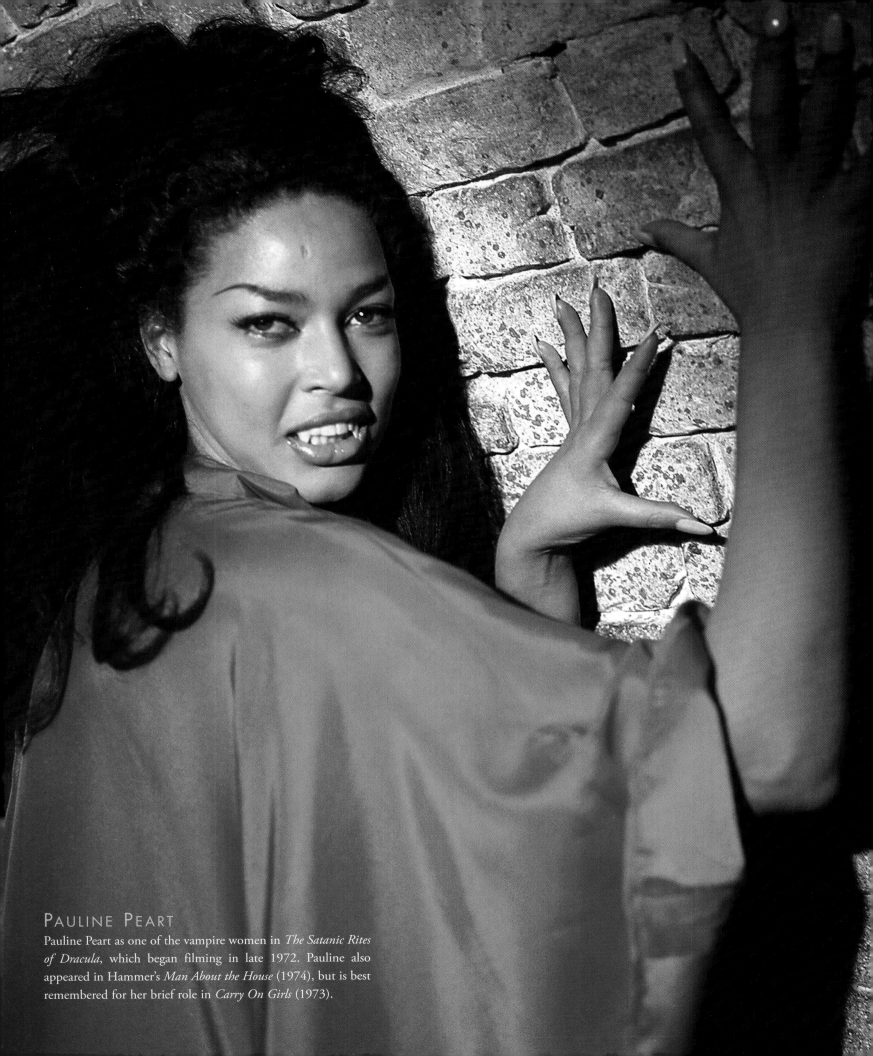

PAULINE PEART

Pauline Peart as one of the vampire women in *The Satanic Rites of Dracula*, which began filming in late 1972. Pauline also appeared in Hammer's *Man About the House* (1974), but is best remembered for her brief role in *Carry On Girls* (1973).

NAOMI CHANCE
WINGS OF DANGER, THE GAMBLER AND THE LADY, BLOOD ORANGE, THE SAINT'S RETURN

Naomi Chance was born in 1930 and attended the Central School of Speech and Drama before Hammer launched her career with her first four credited roles in the early 1950s. One of the company's most prolific leading ladies of the period, her film career never really took off and she achieved greater success in television, regularly appearing in the series based on *The Third Man* and soap opera *The Newcomers*. She was married to *Goldfinger* director Guy Hamilton. "She is very talented," Hammer producer Anthony Hinds reportedly said of her, "but her trouble is she won't sell herself." She died in 2003.

————∞————

DIANE CILENTO
WINGS OF DANGER, THE FULL TREATMENT

The star of two undistinguished Hammer films, Australian actress Diane Cilento had more important roles in *The Admirable Crichton* (1957) and *Tom Jones*, for which she was Oscar-nominated in 1964. In 1973 she appeared as the unco-operative schoolteacher Miss Rose in *The Wicker Man* and 12 years later married the film's writer Anthony Shaffer. They were together until his death in 2001. Since the 1980s she has owned and managed an open-air theatre in the Daintree Rainforest, Queensland. Her autobiography *My Nine Lives*, which included controversial allegations about her previous husband Sean Connery, was published in 2006.

Above:
Diane Cilento, Michael Carreras and Naomi Chance at a 1952 party to promote *Wings of Danger*.

LIZ FRASER
WATCH IT SAILOR!

Born Elizabeth Winch in 1933, Liz Fraser has enjoyed a diverse career in British films that includes roles in such classics as *I'm All Right Jack* (1959), *Up the Junction* (1968) and *The Great Rock 'n' Roll Swindle* (1980). The glamour girl in three of the earliest Carry On films – *Regardless*, *Cruising* and *Cabby* – it was her reputation as a comic actress that led Hammer to cast her alongside Graham Stark (also pictured) and Vera Day in *Watch It Sailor!* (1961). In 1975 Liz made a belated return to the Peter Rogers/Gerald Thomas comedies in *Carry On Behind*, and later made a number of appearances in the even bawdier *Confessions* and *Adventures* films.

————∞————

SHIRLEY GREY
THE MYSTERY OF THE MARY CELESTE

Shirley Grey was born Agnes Zetterstrand in Naugatuck, Connecticut, in 1902. She made her professional stage debut in 1920 and at the end of the decade won a contract with RKO. She made numerous movies from the late 1920s onwards, and her starring role alongside Bela Lugosi in Hammer's *The Mystery of the Mary Celeste* (filmed in 1935) came at the very end of her short but prolific film career. She was married and divorced three times, latterly to her Hammer co-star Arthur Margetson, and her only son was killed in action in the Second World War. She died in 1981.

MARCIA FOX

Born in Lincoln but raised in Kenya, Marcia Fox worked as an air hostess for BOAC before deciding to become an actress. In Hammer's *Creatures the World Forgot* (1971) she played the unnamed mute girl adopted by the old crone (Rosalie Crutchley) and taught the ways of witchcraft. Marcia's final film role came in 1974 when she appeared in Clive Donner's *Vampira*. She played an air hostess.

GAY HAMILTON
A CHALLENGE FOR ROBIN HOOD, 'MATAKITAS IS COMING'

As the plucky Lady Marion Fitzwarren, Gay Hamilton appeared alongside Barrie Ingham (also pictured) in *A Challenge for Robin Hood* (1967), Hammer's most accomplished retelling of the Sherwood Forest legend. This was her first credited film role, and she soon returned to Hammer to appear in 'Matakitas is Coming',

an episode of the anthology series *Journey to the Unknown*. In 1974 she became a regular in BBC police drama *Softly Softly* and the following year appeared in Stanley Kubrick's *Barry Lyndon*. She is still in demand at the BBC, and in 2008 completed a stint in the daytime soap *Doctors*.

—∽—

IMOGEN HASSALL
WHEN DINOSAURS RULED THE EARTH

In the late 1960s the pneumatic Imogen Hassall vied with fellow party girl Julie Ege for tabloid column inches and the dubious title 'Queen of the Premieres'. Director Val Guest cast her as cavegirl Ayak in Hammer's *When Dinosaurs Ruled the Earth* (filmed in 1968) and later in his barely seen pop musical *Toomorrow* (1970). Imogen craved recognition for her talents as a dramatic actress, but made her most memorable mark with an astonishing performance as the initially repressed Jenny Grubb in *Carry On Loving* (1970). Frustrated by the lack of progress in her career she committed suicide with an overdose of barbiturates in November 1980. She was 38.

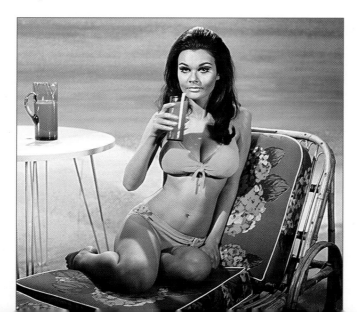

HY HAZELL
CELIA, THE LADY CRAVED EXCITEMENT

Hyacinth Hazel O'Higgins – a popular face in post-war pantomimes, revues and musicals – was born in 1922 and made her West End debut in *On Your Toes* at the Palace Theatre in 1937. She began her film career in 1947 and Hammer gave her the title role in the comedy thriller *Celia* two years later. She was heavily promoted by the company but made only one further film for them, starring in the knockabout comedy *The Lady Craved Excitement* in 1950. Her final film was *Every Home Should Have One*, also featuring Julie Ege and released in 1970. She tragically died in May that year, choking to death on a piece of steak in a restaurant.

—∽—

GILLIAN HILLS
DEMONS OF THE MIND

Gillian Hills was born in Cairo in 1944 and discovered by Roger Vadim, who cast her in his version of *Les liaisons dangereuses* in 1959. Later that year she starred in the British cult classic *Beat Girl*, but maintained a busy career as a singer and actress in France

until returning to London in 1966 for a notoriously racy performance in *Blowup*. She was similarly uninhibited in *A Clockwork Orange* (1971). By the time she filmed Hammer's *Demons of the Mind* in summer 1971 she was spending half the year at art college. In 1975 she retired from acting to become an illustrator in New York. She now lives in England and is married to rock music manager Stewart Young.

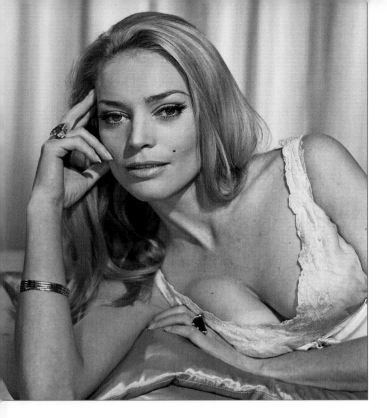

JANE LAPOTAIRE
CRESCENDO

Jane Lapotaire made her debut in Hammer's *Crescendo*, filmed in 1969. A swimming pool sequence earned her the distinction of being the first actress to be seen entirely naked in a Hammer movie when the film was released the following year. Jane's lengthy CV includes British and American stage performances in the title role of *Piaf*, the latter of which won her a Tony award in 1981. In 2000 she suffered a near-fatal cerebral haemorrhage and wrote about the experience in *Time Out of Mind* (2003). Her other books include *Out of Order* (1999) and her autobiography *Everybody's Daughter, Nobody's Child* (2007).

———∽———

MAGGIE KIMBERLY
THE MUMMY'S SHROUD

Maggie Simons was a model and actress whose parents owned Molly's Café near Elstree Studios in Borehamwood. Maggie's life was transformed when she married the Fourth Earl of Kimberley in 1961. The couple divorced in 1965, after which she resumed her acting career with a slightly different spelling of her married name. In 1966 Maggie played the posh linguist Claire de Sangre in *The Mummy's Shroud* and stripped to her bra for publicity shots showing her menaced by the bandaged fiend. She made her final film appearance in *Witchfinder General* (1968) and now lives in Florida.

———∽———

ANGHARAD REES
HANDS OF THE RIPPER

Hammer producer Aida Young spotted Welsh actress Angharad Rees in the television play *But Now They Are Fled* and she started filming *Hands of the Ripper* in January 1971. In 1973 she married actor Christopher Cazenove (later to guest star in *Hammer House of Horror* and *Hammer House of Mystery and Suspense*) and two years later joined the cast of the BBC's historical drama *Poldark*. From 1975 to 1977 she played Demelza in the phenomenally popular series, and maintained a prolific television career for more than 20 years afterwards. She was appointed a CBE in 2004 and remarried, to construction magnate David McAlpine, the following year.

Below:
Angharad Rees (left) with Eric Porter and Jane Merrow in *Hands of the Ripper* (1971).

HILDEGARD KNEF
THE LOST CONTINENT

German actress, chanteuse and writer Hildegard Knef was born in 1925 and made her first films during the war. Following the Soviet occupation of Berlin she escaped a prisoner of war camp and launched a stage career. In 1951 she caused a scandal by appearing naked in *Die Sünderin* (*The Sinner*) but her fame and notoriety in Germany counted for little when she subsequently tried to break America. More popular in Europe, her performance as Eva in Hammer's outlandish fantasy *The Lost Continent* (1968) was one of only a handful of roles in English-language films. She returned to Berlin after the reunification and died there in 2002.

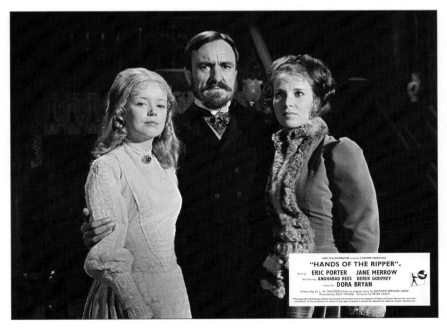

LIZABETH SCOTT
STOLEN FACE

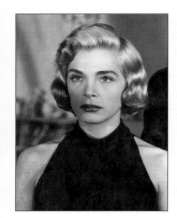

Born Emma Matzo in 1922, the enigmatic Lizabeth Scott was one of the most celebrated American stars imported by Hammer. Famously dubbed 'The Threat' by Paramount, she caused something of a sensation among the crew at Riverside Studios when she arrived to begin work on *Stolen Face* in October 1951. Well known for her femme fatale roles in such noir thrillers as *The Strange Love of Martha Ivers* (1946) and *Dead Reckoning* (1947), she was top-billed by Hammer and arrived with costumes designed for her by Hollywood legend Edith Head. Her career slowed down in the late 1950s and she gave her farewell performance in *Pulp* (1972).

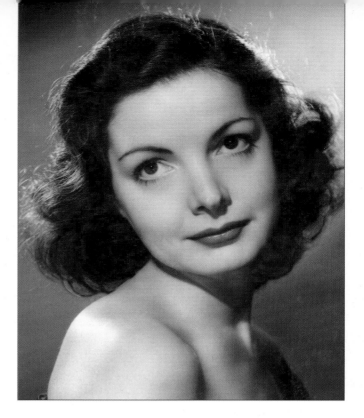

HEATHER SEARS
THE PHANTOM OF THE OPERA

Born in London in 1935, Heather Sears made her first Royal Court appearance opposite Richard Pasco and Alan Bates in the groundbreaking *Look Back in Anger*. Soon after Joan Crawford chose her to play the challenging title role in *The Story of Esther Costello* (1957). She followed this with prominent roles in the seminal *Room at the Top*, directed by her mentor Jack Clayton in 1958, and Jack Cardiff's *Sons and Lovers* (1960). She starred as opera singer Christine Charles in Hammer's *The Phantom of the Opera* in 1961 but her family took priority over her career in the coming years. She had effectively retired by the 1970s and died, aged 58, in 1994.

ELIZABETH SELLARS
CLOUDBURST, THE MUMMY'S SHROUD

Elizabeth Sellars has the unique distinction of appearing in the first and last movies that Hammer produced at Bray Studios. She was 27 when she was cast in *Cloudburst*, which started shooting at the new facility in January 1951. Elizabeth remembers "being thrilled at the chance of playing opposite Robert Preston," and "the excitement of a completely new studio being developed from an ancient house." She returned to Bray in September 1966 to play the wife of doomed industrialist Stanley Preston (John Phillips) in *The Mummy's Shroud*. Her other notable roles include *The Barefoot Contessa* (1954) and ITV's *A Voyage Round My Father* (1982).

Below: Heather Sears with director Terence Fisher during the filming of *The Phantom of the Opera* (1962).

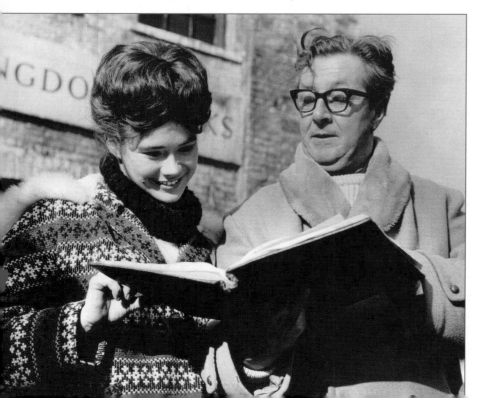

SUSAN STRASBERG
TASTE OF FEAR

The daughter of admired acting coach Lee Strasberg, Susan was born in New York in 1938. Her early successes included *The Diary of Anne Frank* on Broadway, and the Italian Holocaust drama *Kapò* (1959). In 1960 she came to England to star as the beleaguered Penny Appleby in Hammer's first suspense thriller, *Taste of Fear*. Unfortunately for producer and writer Jimmy Sangster (also pictured) she was accompanied by her mother, whom she would defer to after each take. The situation became so intolerable that Sangster asked Mrs Strasberg to leave. Susan's career continued to flourish until ill health forced her retirement. She died of breast cancer in 1999.

MELISSA STRIBLING
DRACULA, 'THE NEW PEOPLE'

Melissa Stribling was born in Scotland in 1927 and was married to the distinguished British film director Basil Dearden. She appeared in a number of her husband's films, including *The League of Gentlemen* (1960), but achieved lasting recognition for her sturdy portrayal of Mina in Hammer's *Dracula* (the accompanying picture shows her at the film's première in May 1958). She returned to the genre with minor roles in the *Journey to the Unknown* episode 'The New People' and the low budget *Crucible of Terror* (1971). Her husband was killed in a car crash in 1971, and she died in 1992. Their son, James Dearden, was the director of the Nick Leeson biopic *Rogue Trader* (1999).

—∞—

ELAINE TAYLOR
THE ANNIVERSARY

The sensitive Shirley Blair was played by June Ritchie in the 1966 West End production of *The Anniversary*, but Elaine Taylor took the role when Hammer produced their faithful adaptation the following year. Shirley is memorably victimised when the waspish Mrs Taggart (Bette Davis), who draws attention to her unsightly ears, and is shocked to discover that Mrs T has found a disturbing way to keep an eye on her and Tom (Christian Roberts) while they are in bed. A busy television actress for around five years after the release of *The Anniversary*, Elaine now lives in New England with her husband, the actor Christopher Plummer.

CAROL WHITE
SLAVE GIRLS

Born in London in 1941, Carol White was popularly known as 'the Battersea Bardot' and had spent over ten years in bit parts and other minor roles before challenging the ruthless Queen Kari (Martine Beswick) in Hammer's *Slave Girls* (1966). It's hard to imagine a greater contrast between this and Carol's next performance, in the title role of Ken Loach's harrowing television drama *Cathy Come Home* (1966). Loach subsequently cast her in *Poor Cow* (1967), but a disastrous move to America and a series of failed relationships led her into drink and drug abuse. She rarely worked after the early 1970s and died of liver failure in 1991, aged just 50.

BILLIE WHITELAW
HELL IS A CITY

No stranger to gritty realism and movie glamour, Val Guest got the best of both worlds when he cast Billie Whitelaw as Chloe, the wife of bookie Gus Hawkins (Donald Pleasence) in police drama *Hell is a City* (1960). The assault on Chloe by Don Starling (John Crawford) revealed the first (fleeting) nudity permitted by censors in a British print of a Hammer film. More importantly for Billie, the role earned her a BAFTA nomination as Most Promising Newcomer in 1961. The British Academy would later recognise her outstanding performances in *Twisted Nerve* (1968), *The Omen* (1977), *The Krays* (1990) and others. She was appointed a CBE in 1991. ∞

———∞———

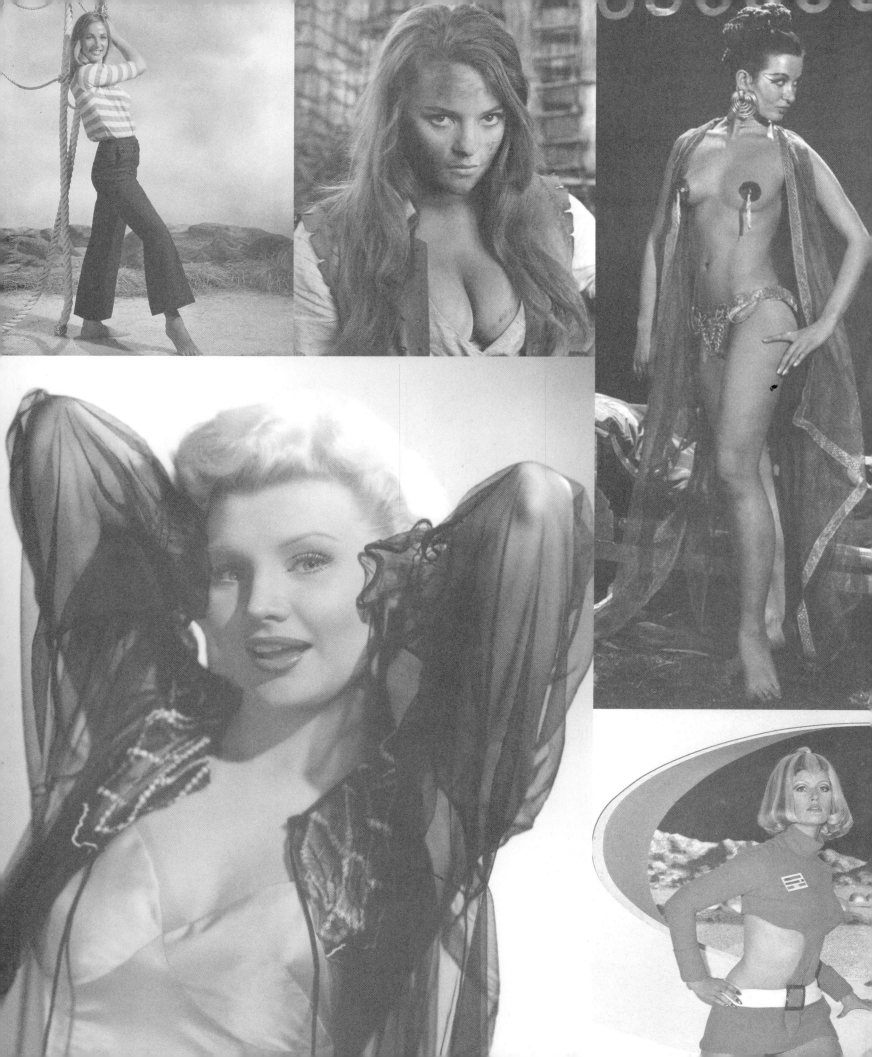